HUMMINGBIRD
IN UNDERWORLD

HUMMINGBIRD IN UNDERWORLD

Teaching in a Men's Prison

To Ingegerd—

with warmest wishes

A MEMOIR

Deborah Tobola

DEBORAH TOBOLA

SHE WRITES PRESS

Published July 2019
Printed in the United States of America
Print ISBN: 978-1-63152-505-6
E-ISBN: 978-1-63152-506-3
Library of Congress Control Number: 2019931881

For information, address:
She Writes Press
1569 Solano Ave #546
Berkeley, CA 94707

She Writes Press is a division of SparkPoint Studio, LLC.

Names and identifying characteristics have been changed to
protect the privacy of certain individuals.

In memory of my father, Charles,
and in honor of my mother, Joanne,
and for my tribe

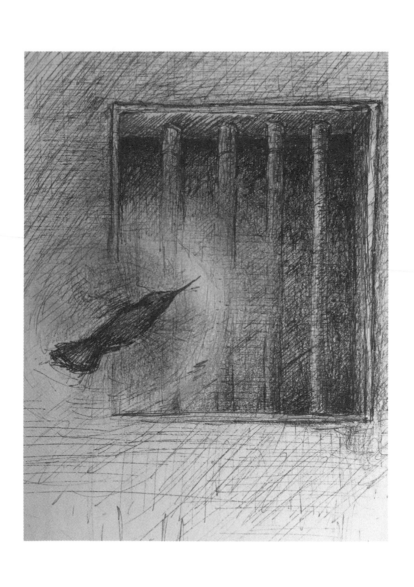

CONTENTS

I

THE JOINT

Is it memory or imagination, the clink of silverware, the smiling man dressed in blue, serving us food? The prison cafeteria offered cheap meals for staff and their family members, so my father decided to bring my mother, my sister Bonnie, and me to try it out. This was my first meal away from home, and Bonnie's too. I was three and Bonnie was two. I don't know if it was the food, the atmosphere, or the novelty of eating in a place with white tablecloths, but my parents told me later that I said, "Daddy, I like eating at the Joint!"

My parents met in 1954, when they were both driving convertibles, going opposite directions on Liberty Boulevard in Huntington Park, a suburb of Los Angeles. At the stoplight, my father took one look at my mother, the breeze whispering through her long dark hair, and was enchanted. She's told me since then that she was wearing a floral print halter dress. Her mother had loaned her the Plymouth convertible so she could go to a bon voyage party for a man she worked with who had joined the Navy.

My father followed her home, parked his Pontiac convertible across the street from her house, and called out to her until she agreed to have coffee with him. They went to the Clock, a drive-in restaurant on nearby Long Beach Boulevard, famous for the Chubby Champ double-decker hamburger, which cost forty-five cents then.

(Fries were another fifteen.) They didn't sit in his convertible and wait for a car hop, but went inside and ordered coffee. They sat there all night, drinking coffee and talking. By sunrise, they were in love.

When she got home, my mother had to sneak into the house and gingerly slide into bed next to her mother, praying that she wouldn't awaken. My mother and my grandmother, Nonny, shared a two-bedroom house with a friend of Nonny's, so my mother and Nonny shared a bed. I imagine that Nonny was not really asleep. She must have known there was a man in this equation. Her daughter was a good girl, not the kind who would worry her mother by coming home at the crack of dawn.

And my mother felt guilty for her indiscretion—as heady as it was—because when she told Nonny about my father, she couldn't say how she met him. Instead she said that he was a patient of the dentist she worked for. And at first, Nonny didn't approve of Dad. Her Swedish family had immigrated when Nonny was two, arriving at Ellis Island and moving to Massachusetts. She grew up near Boston and was accustomed to East Coast city people, who were more refined than my father, a ranch boy from a desert town in California.

My father had escaped a life of manual labor when he left the ranch to enlist in the Marine Corps in 1950, earning a Purple Heart and a Bronze Star. One letter he wrote home from "somewhere in Korea" ended up on the front page of his hometown paper, the *Antelope Valley Ledger-Gazette*, with the editor's note: "The Marine has put into words thoughts which have probably gone through the minds of many other American boys serving their country overseas."

The letter to Grandma ends with, "Perhaps the most important thing of all, let them see how the people of a country like this live. They beg for the C rations we can't stand. Their homes are made of mud and grass and crawl with bugs. They are puny and stink from filth. It wouldn't hurt our younger generation to see the crud and corruption . . . and then appreciate the soft life they have been living.

Well, Mom, I guess I had better stop this or I'll be drafting grammar school kids." My father was twenty when he wrote this letter, a member of the younger generation himself.

After he returned home, he enrolled in Antelope Valley College on the GI Bill and played football there. That's what he was doing when my mother met him. They made a striking couple. My mother resembled an actress of the time, Debra Paget, best known for her roles in *The Ten Commandments* and *Love Me Tender*. My father, sandy-haired and freckled, looked a little like *Route 66* star Martin Milner. He called her his "Little Flower." She thought he might be president someday.

The football teams at USC, Pepperdine, and California Polytechnic State University all wanted my father to play for them. He chose to transfer to Cal Poly. Eight months after my parents met, during AV Junior College's spring break, my parents were married. They took a weekend honeymoon at Carmel by the Sea and made their way to their new home.

Cal Poly is located in San Luis Obispo, a small town on California's Central Coast, halfway between San Francisco and Los Angeles. After they got married and before any of us were born, my parents lived downtown on Chorro Street, where they rented part of an adobe house with a Victorian façade that had been divided into apartments. The building, now in a prime retail location, has gone through many incarnations since those days in the mid-fifties. At one time, it housed the Democratic Headquarters, and later, an art gallery. Now it's a real estate office, with a yarn shop in the back.

Kitty-corner to the building is a little red restaurant called Mee Heng Low Chop Suey, still popular with locals. The Chinese restaurant tormented my parents. Sometimes Mom and Dad couldn't resist the smells of Chinese food that wafted into their bedroom window from across the alley. They'd bring home a feast in white cartons from the restaurant my father called Me Hung Low, which made my

mother laugh, she says. Just before I was born, they moved out of San Luis Obispo and into a little house in the nearby beach town of Los Osos.

My father was majoring in social sciences at Cal Poly and working at a series of menial jobs, until he was hired to be a guard at the California Men's Colony, a state prison located just down the road from the university. Although he was good at his job, Dad confessed to my mother that he liked the inmates better than the guards. One prisoner's proposal became a family story and it always made us laugh. Dago Red wanted to continue his relationship with Dad on the outside. "Chuck, I'm getting outta here pretty soon. I'm planning a big job and I want to cut you in on the deal," Dago Red said. "You gotta woman? Can she drive?" It didn't take much of a leap to imagine my father pulling a job. But my mother, proper, law-abiding, and afraid of driving on the freeway, would never make a Bonnie to my father's Clyde.

My mother was in labor with me for more than twenty-four hours, long enough for my father to go to work at the prison and search for an escaped inmate (not Dago Red), and long enough for her doctor, who raised horses, to go home and feed the animals (twice). I was born on the evening of November 11, 1955. For ten days every year, my sister Bonnie and I are the same age. She was born a year later on November 1.

After Bonnie was born, we moved again to Shell Beach, another beach town on the Central Coast. I loved the beach and its smells: tang of fish, bite of salt, sweet suntan lotion. The sun looked big and yellow, just like in my storybooks. There were treasures in the sand: shells, starfish, seaweed. The ocean offered many possibilities: run down to the crashing surf, get scared, and run back up the beach; sit by the sea and dig tunnels, or stand perfectly still and let the water wash away the sand under my feet until everything seemed to spin around me.

In 1958, my sister Terri was born. That year, the Shell Beach postmaster was planning his retirement and asked my father if he was interested in taking the job. It would have been a sweet gig, a government job in a little beach town. Or he could have stayed at the prison. Even though his responsibilities increased with the birth of each new child, he was willing to trade job security for adventure.

In 1960, Dad earned his degree in liberal arts, a major which had allowed him to take courses in literature, music, politics, and religion. That same year, my brother, Brad, was born. Dad quit working at the prison and moved our family thirty miles south to a new tract home in Orcutt. He'd gotten a job at Vandenberg Air Force Base, working in a warehouse. He was quickly promoted to an office job, which my mother remembers as an engineering liaison. Ironically, engineering is a top major at Cal Poly, but my father opted for liberal arts because he was a thinker and a dreamer.

Moving frequently became a pattern for our family, as well as acquiring new vehicles to take us to the next destination. By 1960, the convertible was long gone. Dad had traded it in for a Ford coupe, which was later traded in for a slightly larger Mercury Lynx. Finally my father found the perfect family car, a bronze Rambler station wagon.

In 1962, the Rambler transported us to our next destination— Fresno, a mean town in California's agricultural heartland. We moved into a new suburban tract where all the houses looked alike. In the high heat of summer, the sidewalks sizzled when you spit on them.

Running behind our house was a vacant field, and behind that railroad tracks. I was eight by that time, so my mother let me stay up later than the other kids to watch *The Beverly Hillbillies* and other exotic programs while we waited for my father to come home. One late night, there was a knock at the back door and in the small square window, a bum's face appeared, mouth open, finger pointing to the

small, dark hole of his mouth. My mother, trembling, shook her head no. She stayed at the window until she saw him move to the next house with lights on.

We had a problem: we were broke. My father had given up his job at the Air Force base after a guy he met told him about a great opportunity selling vacuum cleaners. My father went for it, and was assigned Fresno and its surroundings as his territory. Within six months, he realized he'd made a big mistake. I heard my parents talking about it on those nights he came home late. "A college degree and I'm selling rugsuckers," he said. "Don't worry, we'll work it out," Mom replied.

But I worried about it. What could I do? What would Nancy Drew do? She'd find a solution. The vacuum cleaners were sleek turquoise machines called Revelations. They looked like something out of the future. I'd seen Dad show Mom how you could dump a pile of dirt on the carpet and "watch that baby suck it up." In Dad's brochures, there were pictures of the Revelations themselves and before-and-after pictures of a rug. Anyone would want one.

One summer day not long after I learned of the problem, I decided to take action. I waited until everybody was busy—Bonnie, Terri, and Brad watching *Felix the Cat* and sucking on Fizzies, Mom ironing—and I left the darkened, air-conditioned living room and slipped out-side. I'd snuck some of the brochures and stuffed them in the waist-band of my shorts, under my shirt. I started at the house across the street. The woman answered the door and smiled. "Hi, we're broke. Would you like to buy one of my dad's vacuum cleaners?" I asked. Her smile froze. She shook her head and closed the door.

I visited five or six more houses, feeling less confident at every door. Not even a mother with a very dirty floor was interested. Only a few were even willing to take a brochure. I went home finally, tast-ing my father's defeat. When he came home that night, I told him that our neighbors weren't buying any. My mother looked stricken at

this news. She, after all, lived here, while my father drove away each morning and came back after dark. Dad laughed and patted me on the head. "That's my girl!"

I was definitely Daddy's girl, even though I was the only one without a nickname. He called Bonnie "Cissy" and Terri "Cookie Belly" and for some reason Brad was "Herkemcyer." My father always brought home stories about the world beyond our house. When he walked in the door, it was like a movie changing from black-and-white to color.

Dad was a singer and a whistler, serenading my mother with, "If ever I would leave you, it wouldn't be in summer . . ." from *Camelot*. He entertained us with, "If I were a rich man, yabba dibby dibby dibby dibby dibby dibby dum . . ." One of his favorite songs was Roger Miller's "King of the Road"—"Trailers for sale or rent, rooms to let fifty cents. No phone, no pool, no pets. I ain't got no cigarettes . . ." My father's brand of cigarettes was Camel non-filters. His brand of whiskey was Early Times.

Dad sang to Terri about carrying Terri to the ferry because Terri couldn't carry anymore. He sang to Bonnie, who had naturally curly hair, about a little girl with a little curl right in the middle of her forehead. He sang another song about a girl wearing an itsy-bitsy teenie-weenie yellow polka-dot bikini.

But my favorite song started with, "My hand on myself, vat is dis here? Dis is my shvet-boxer, my Mama dear. Shvet-boxer, shvet-boxer, nicky-nicky-nicky-new. Dat's what I learned in der school!" He pointed to his forehead when he said schvet-boxer, and gently tugged on my cowlick when he sang nicky-nicky-nicky-new. The song continued with eye-seer, nose-blower, mouth-feeder, adding each new body part to the chorus, all the way down to foot-stomper. I liked the story in this song better than the ferry song, the little girl with a curl song, the polka-dot bikini song. It was about a kid in a new school, trying to learn the right words for things. That would be me. And

although I didn't know much about it then, that would be the people on my father's side of the family who had emigrated from Bohemia.

Our neighbors never saw us leave. In the middle of the night, my father and my grandfather loaded our furniture and clothes into a U-Haul trailer, the Rambler, and my grandfather's car. My grandfather had driven up from the Mojave Desert to help us. I was glad we were not going "down below," which sounded like another way to say hell (which we weren't allowed to say), but meant the city of Los Angeles. We weren't going to hell or LA. Instead, we headed for Lancaster, the town my father had grown up in, in the Mojave Desert. We would stay with my grandparents while Dad tried to get on at Edwards Air Force Base in nearby Rosamond.

Mom and the other kids went in the Rambler while Dad and I rode in the cab of the truck pulling the trailer, the vacuum cleaner at our feet, its hose snaking between us. We were traveling farther away from the beaches of the Central Coast. I wouldn't return there until decades later, to take a job at the Joint, the same prison my father had worked in. He'd been dead for ten years by then. All I had left were memories. And DNA.

II

LIGHTHOUSE

It's 2000, a new century, and I'm a few weeks into my dream job. I've been hired to run Arts in Corrections, the fine arts program at the California Men's Colony in San Luis Obispo. Since I was born here forty-five years ago, it has become a desirable place to live, a charming city that Oprah would proclaim "the happiest city in America" in years to come. So while I am beginning a new chapter in my life, I am also circling back.

The little girl on Shell Beach, the one who tried to sell vacuum cleaners in Fresno, had come of age in the '70s. I graduated from high school in 1973, the year that the Paris Peace Accords were signed, ending the Vietnam War. It was the year that Richard Nixon was inaugurated and Spiro Agnew resigned, the year that Roe v. Wade was decided by the Supreme Court. It was the year of the Native American occupation of Wounded Knee in South Dakota. The year that *American Graffiti* premiered and the Eagles released "Desperado."

I entered adulthood just as the second wave of the women's movement, inspired by the civil rights movement, took hold. Just in time for the young woman who wanted to come home with stories about her workplace, instead of standing at an ironing board.

The decades since haven't been easy. I've worked as a waitress,

telephone operator, journalist, legislative aide, adjunct professor, and freelance writer. My first teenage marriage was later annulled. I married again and became a mother. My son Joseph was four when his father Bram was killed in a motorcycle accident, two years after we divorced. My third marriage produced my son Dylan. I married Dylan's father in 1985 and we divorced in 1991, a year after my father's death.

I guess you'd say I'm a Bohemian, in all senses of the definition: a descendant of Czechs, once a kingdom in Central Europe; a person (such as a writer or artist) living an unconventional life; and a vagabond or wanderer. I studied at the University of Montana for my undergraduate degree in English and at the University of Arizona for a master of fine arts in creative writing. I've moved from Alaska to take this job at the prison. Joseph graduated from high school two years ago and is now out on his own. Dylan is with his father in Anchorage, starting his first year of high school. Suddenly I'm unencumbered. I rent an apartment in Morro Bay, ready to plunge into my new occupation, which offers stability and benefits like health insurance and a pension, not typical of my former employment.

Working in prison might not be most people's idea of a dream job, but I know what I'm getting into. I had five years of teaching inmates under my belt, in prisons in Tehachapi and Delano. When I was first hired as a creative writing teacher, I'd had some trepidation going into prison. Although I'd apparently liked eating at the joint when I was a toddler, my adult notion of prisoners was informed by books, movies, and television shows. I imagined I would walk down a dark corridor leading to my classroom, dodging caged men thrusting their muscled tattooed arms through the bars to grab me.

Instead, on my first day of work at the California Correctional Institute in Tehachapi, an officer escorted me to a portable classroom with men who were all dressed in blue work shirts and jeans. Although most of my students did sport tattoos, they were polite,

respectful men who were eager to learn. Except for their prison blues, they appeared to be indistinguishable from men on the outside.

And like students on the outside, many thought that poems must rhyme. When I told jumpy Fireman—I always imagined he was an arsonist—that I would try to break him out of his self-imposed prison of rhyme, he took it well, saying, "Okay, Ms. T," although I could see a vein pulsing in his neck. One gifted student, Renaissance Man, seemed to be more educated than I, with only a master's degree in fine arts. He was trilingual, slipping in and out of English, Spanish, and French, and used words like *susurration*. His gritty street poems were suffused with Aztec history, combining an almost scientific precision of detail with a dreamlike otherworldliness. On the other end of the spectrum was Huck, barely literate, an enthusiastic student who listened intently, but didn't write anything down for months. When he finally brought a poem to class and read it haltingly, the other students burst into applause.

I looked forward to my prison workshops, which were far more rewarding than the beginning composition classes I'd been teaching at the community college. Unlike my college students, who were required to take composition, my inmate students came to class because they wanted to learn.

After a year of teaching inmates, I stopped teaching in college and took on more prison classes. By then I loved my prison workshops. *I got this*, I told myself. After all, I grew up in a rough-around-the-edges working-class family. I could hold my own around hell-raising Bohunk men on my father's side of the family. And I had a survivor's instinct, skirting danger as I made my way in the world. Until I went to college, I had no idea that "Bohunk" was an ethnic slur, reserved for Bohemians, Hungarians, and other undesirable Eastern European immigrants. I thought it was a term of endearment. The Bohunks were not well-mannered and predictable.

We were coming off the Grapevine, careening through the curves on the road to the Bohunk side of the family, "the uncouth," my Swedish grandmother said. We were all drunk—Dad on scotch, Mom on fear, and us kids on impending drama. Dad honked the horn in the driveway and the whole house came running out, shouting. We were hugged and kissed, tossed half in the air. They shoved another drink into Dad's hand before we even got to the porch, and we kids opened our presents out there on the gravel.

My sisters and I got new nightgowns: pastel blue, pink, and green with angel sleeves. We ran inside to put them on, took turns perching on the toilet to see in the medicine chest mirror. At once the men began: "Goddamn Republicans! Goddamn Ronnie Reagan!" They praised the Teamsters, cursed all pipefitters, pounded their fists on the table where I sat eating Grandpa's sauerkraut straight from a coffee cup. "She's a real Bohunk, that one," someone said, and suddenly it erupted.

Grandpa wanted to go to the Elks or the topless, but Dad said, "Goddamn it, we just got here." And then Uncle Don said, "Let's stay home, Dad" and Grandpa said, "What do you know, you sorry sonofabitch, you voted for Reagan for governor!" And then Dad was saying, "All you kids in the car." And we were whisked outside by Aunt Patsy, who hid us in the bushes.

She said, "Shhhhhh!" while Dad yelled, "Where the hell are those goddamn kids?" My brother and I giggled; my sisters held their breath and each other's hands. I lifted my arms and spread my sleeves, pretending I was invisible, pretending I could see inside the house, even though I was standing out in the bushes, nipples hardening in the chilly dark.

Dad and Uncle Don were fighting and Mom and Grandma were

screaming, "Stop or we'll call the police! Chuck, the neighbors will hear!" Grandpa was putting his lard belly and his straight-line mouth between them and they almost hit him, but they stopped, and he was shaking his finger at them, turning his back, gesturing them away with a closed fist. Then Dad started to cry and Uncle Don said something funny and Grandpa cackled and they were all hugging each other.

Back in the bushes, I laughed and twirled, arms out catching handfuls of cold air. My sisters glared, appalled at my glee, afraid to walk back into the house. But Aunt Patsy knew it was time, downed her Coors, tossed the can in the bushes, and wiped her mouth with the back of her hand. "Let's go."

My sisters glided sideways toward the door, but I flew ahead. The men were laughing and crying, hugging each other, saying "sonofa-bitch." They drew me into their circle and closed it. I cried too, alive with their terrible love.

This Christmas family reunion is as vivid today as it was when I was eleven. By then I knew that other families were calmer, more genteel, like the families on TV. The Bohunks didn't scare me, the way they did my sisters. I was the only girl in the family they claimed as one of them. I learned the ways of their world, talking politics, pounding my fist on the table, entertaining people with stories. Perfect training for a career working with rough men given to outbursts verging on violence.

So when a job opening comes up at the California Men's Colony, I interview and am hired as an artist/facilitator. Each artist/facilitator designs a program based on his or her art discipline—mine is poetry. In addition to teaching, the artist/facilitators hire and supervise teaching artists, as well as an inmate work crew. Each of the

thirty-three prisons in California has its own artist/facilitator. I don't care if I'm one of the few women in this position. For the first time in my life as a working artist, I have a building and a budget . . . and I don't have to fundraise or write grants for it. I just have to show up and run things. Who could ask for more?

Although all California prisons are run by a massive bureaucracy in Sacramento, governed by the same laws and regulations, an inmate's quality of life largely depends upon the prison in which he or she is housed. For this reason, most inmates do not want to do time at Pelican Bay, a steel and concrete supermax prison on the coast of California near the Oregon border. Pelican Bay houses the state's most dangerous criminals; half of its inmates are confined in Security Housing Units, or SHUs, for twenty-two and a half hours a day. A SHU (pronounced "shoe") is a windowless six-by-ten-foot cell with a small grated slot for the transfer of food.

The California Men's Colony is at the other end of the spectrum. Called "the Cadillac of California prisons" by outsiders, it's been nicknamed "Camp Snoopy" by the inmates. CMC has two facilities: the East, which has cells and houses higher-level security inmates, and the West, where the Arts in Corrections building is located, and where my father worked when I was born.

In the 1950s, the state of California leased a former National Guard training site adjacent to the East Facility, converting its barracks into prison dorms. Except for fences, towers, and razor wire, the West resembles a small campus, beautifully landscaped and populated by turkeys, deer, raccoons, vultures, seagulls, and cats, along with the felons and prison staff. The Men's Colony is a "soft prison," home to gang dropouts, sex offenders, white-collar criminals, and the occasional celebrity—Christian Brando, Suge Knight, Ike Turner, and Timothy Leary among them.

CMC is also a "programming prison," meaning that instead of constant lockdowns because of violence from warring gangs, inmates

count on being able to move from their dorms to a variety of educational and vocational classes, chapel services, twelve-step meetings, and Arts in Corrections, which occupies most of a building in the Education complex, behind a fence accessed through a guard shack with a metal detector.

One of the first things I do is have the inside of the building painted a cool sky blue. The prison has a vocational painting program and they send a crew over to transform the space, room by room. There's a large space in the back of the building, used as an art studio. My office is in the hallway that connects the art studio to the large multipurpose space in the front of the building. This is where classes are held and will eventually double as a theater space.

I work a ten-four shift at the prison, Monday through Thursday from 10:00 a.m. to 9:00 p.m. My shift straddles the officers' second watch (6:00 a.m. to 2:00 p.m.) and third watch (2:00 p.m. to 10:00 p.m.). There are fewer officers around on third watch. All of the teachers leave at 4:00 p.m. For the next five hours, I'm the only staff person with inmates behind the locked gate.

Because they're looking to hire a community resources manager, the person who will supervise me, I'm oriented to my new position by a correctional captain who's gotten in trouble and has been assigned this temporary job as punishment. Most of my on-the-job training will come from inmates. As they say in the Department of Corrections, the inmates know the rules better than the staff. The inmates learn the rules so that (a) they know what they can get away with and (b) they know what staff can get away with.

During my first week of orientation, I go to the office of Mr. Robinson, the chief deputy warden who was instrumental in hiring me. He's a big black man with a wide smile and a kind manner. I want him, and all the correctional staff, to have a good impression of me. They don't need to know about the special qualifications I have for the job—aside from my artistic accomplishments—which are the

escapades of the Bohunk side of the family. My father went to jail for drunk driving, and my uncle for "drunk walking," as we called his "drunk in public" arrest. And many other men in my family have seen the inside of jail cells too, for the same kinds of charges. I want the people I work with to think I'm a nice woman from a law-abiding family, an asset to the institution.

In this get-to-know-you chat, Mr. Robinson asks about my family, then about my teaching experience. I'm nervous and for some reason I tell Mr. Robinson about how I've always been a teacher, even as a child. I tell him that one day I tried to teach my sisters a lesson about bees. There was a dead bee on the sidewalk and I told them that honey comes from bees. I told them I was going to squeeze the honey out of the bee, then we could lick it from my fingers. But no honey came out. Instead, the bee's stinger went into my finger. I screamed bloody murder, running all the way home, my sisters trailing behind me, crying too. Mr. Robinson looks at me quizzically, nodding. He's a good listener. *Oh my God, why did I tell him that story?* I'm thinking, as soon as the words are out of my mouth.

His office contains artwork created by inmates; there are paintings hanging on the wall and a sculpture on a cabinet behind his desk. To change the subject, I say "Oh, I love the lighthouse," gesturing to the sculpture. He gets a funny look on his face. "It's not a lighthouse," he says. "It's a guard tower." Then he smiles. "Of course," I say, blushing and returning his smile. But I'm thinking, *What am I doing here?* That thought is quickly followed by, *I will build a lighthouse. Arts in Corrections will be a lighthouse shining in the darkness.* For the rest of my time working in prison, I will alternate between these two poles—the what-am-I-doing-here and the lighthouse.

One person who helps guide me is Emily, the teacher assigned to teach inmates who are under twenty-one. I meet her my first week at work. Instantly I know that we will become friends. She is an artistic person herself and spent her youth hanging out with Jim Morrison

and Taj Mahal, hobnobbing with Janis Joplin and Mick Jagger and Peter Coyote. She's kind of like Forrest Gump, landing in the right place at the right time of the counterculture—except she is very smart.

It is Emily who tells me that I can go to the Records Office and check out the files of inmates I might want to hire for my work crew. I do that, about a week after I've already hired my lead clerk, based on an interview with him. When I read his file, I discover that I've hired a rapist. Not a he said/she said rapist, but the kind who climbs into your bedroom in the middle of the night and puts his hand over your mouth so no one can hear you scream. Do I want to be locked up with this guy ten hours a day with officers checking infrequently on my building after the sun goes down? No.

I'm trying to figure out how to get rid of him, which isn't so easy in prison. Once an inmate is hired into a good paying job (and Arts in Corrections is one of the highest paying jobs, with clerks making $42.50 a month, and the lead clerk earning $52.50), you have to have a reason to dismiss him. If you don't, he can file a 602, an inmate grievance form that goes up the chain of command—even to the warden's office—until it is resolved. I don't need a 602 in my first month on the job.

I am saved by the bell—or rather the alarm, which goes off due to my own clumsiness when I step out of my building on this fresh spring day to have a cigarette. I promptly lose my footing and end up—splat—on the walkway, landing on my wrist. I'm not sure who sounds the alarm, but the prison's Fire Department is there in minutes. I am loaded onto a fire engine and driven out of the Education complex, out of the prison, and into a San Luis Obispo hospital. I wait an excruciatingly long time before a doctor sees me and mercifully, gives me pain medication and schedules surgery on my fractured wrist. Mr. Robinson comes to the hospital to see me after my surgery. When he asks me how I feel, I smile at him woozily. "Dancing isn't my art form."

III

THE BLUE BUILDING

This is my eighth day back on the job after several weeks of light duty in the institution's mailroom. I am determined to be more careful, especially with concrete steps and hiring workers. Thankfully, in my absence, all four of my inmate workers have been reassigned to other positions, so I get to start over, this time reading inmates' files *before* I offer them a job.

It's a long way from the West Facility's parking lot to the Arts in Corrections building inside. I have already sensed that a poet in prison is somewhat like a canary in a coal mine. We feel things first. In what becomes a daily ritual, I take a few moments in my car to psych myself up before entering the passageway between my two worlds.

The gate slams behind me. To get from the parking lot into the prison, I walk the dog run, a quarter mile of concrete enclosed in a parenthesis of fences, past a snatch of cop-killer rap radio and shirtless convicts in sweatpants playing basketball or jonesing on the dorm porch. Some stare at me; to others, I do not exist, me in my tropical print dress and Jackie O shades. I am guilty of freedom. Civilization is a thin veneer here, rubbed in by uniforms, towers, guns.

Sometimes the longing to be free gets snagged on razor wire, like a scrap of white T-shirt. I walk silently and staring straight ahead to

the end of the dog run, where I flash my ID and check out my alarm, which I will hit if there's trouble. Inside, the PA system's omniscient prison narrator announces who will do what and when, but I am hearing misery's persistent whisper turn into a low collective moan, a rumble that comes from the belly of the earth, the sound a mother would make if she were the earth.

Inmates might call the West Facility Camp Snoopy, but it reminds me of Mayberry, a pleasant town with trees, flowers, birds and cats, and vintage '50s buildings, enclosed by chain-link fences and razor wire. Mayberry with hundreds of guys dressed in blue denim pants and light blue work shirts.

I check in at the beginning of my shift at the Watch Office, on the lower floor of Administration, which everyone here calls the Blue Building. Today I see an inmate polishing the floor with an old-fashioned electric waxing machine. "Be careful, ma'am," the Blue Building worker says. I smile and nod, careful not to walk on his fresh wax. His politeness is the norm. Most inmates are in the habit of using "ma'am" and "sir" when addressing staff.

A few days ago, I hired my lead clerk, who'd gotten an endorsement from Mr. Robinson. That carried a lot of weight with me, of course. This inmate, Urkel, had worked for my predecessor before he retired. Presumably he got his prison nickname because he's a tall nerdy black guy, like the character on *Family Matters*. I learned from his C-file before I hired him that Urkel is in prison for committing a series of robberies in which he pretended he had a gun, which according to the law, is the same as really having a gun.

Urkel's geekiness is immediately revealed. He boasts that he was trained on all of the graphic computers in the Arts in Corrections building, pointing out program manuals of software he has mastered. He knows film editing and sound mixing and is especially fond of animation.

"My favorite movie is *Antz*," he tells me.

"*Ants?*" I repeat. "I've never heard of it."

Clearly exasperated, he replies, "It's a computer-animated classic!"

Whatever, I want to say, but don't.

Urkel knows what all twenty-seven of my keys unlock in the building—every door, every closet and cabinet. He asks me to unlock the computer disk cabinet so he can show me some of his animation work. I take the keys from the pocket of my khaki pants, grasping a small one. "No, Ms. Tobola, that's the key to the painting locker. *This* is the key to the computer disk cabinet," he instructs me by pointing. He keeps a respectful distance, but did he just roll his eyes, or did I just imagine that he did?

That night I dream that I take my keys from my pocket and set them down. The next thing I know, Urkel is dangling them before me, a smug smile on his face. The next day I go to the hardware store and buy a lanyard. The lanyard is attached to my belt. The keys never leave my body after that.

Urkel is—there is no other word for it—smarmy. Not a good fit for me, but I need him. He possesses the institutional memory of this building, the resources locked away in closets, cupboards, and cabinets, the programs that were offered here in the past, the inmates who trespassed upon it. There is no staff person who has the equivalent knowledge. I'm stuck with him for the time being.

The Education Department has decreed that a staff member cannot be alone with an inmate—especially a female staff member in this male prison. While Arts in Corrections is not a part of Education, the building is in their domain. I must hire another inmate immediately. I choose Smiley, a painter who's a friend of Urkel's. He could be called Smirky—I think that fits him better. Smiley is guilty of L&L—lewd and lascivious acts with a minor. He's a child molester. But he's paroling in a few months, which will give me time to find a more appropriate worker.

At lunch, I tell Emily about my new hire.

"At least he's short," Emily observes.

"He's not that short," I reply.

"I'm not talking about his height. I'm talking about his parole date."

"Oh, right." I'm still learning the lingo. "That's one reason I hired him."

"You're going to end up hiring more child molesters. The prison is full of them," she says.

Teachers like Emily usually have two clerks, who help with paperwork, setting up the classroom, and tutoring students. My situation is a little different. I am looking for inmate workers who have an aptitude, or at least an interest in one of the arts disciplines offered in Arts in Corrections.

The West Facility is a "soft" yard. Inmates who need protection end up here. Child molesters are on top of the list of inmates who need protection, followed by rapists, gang dropouts, former law enforcement personnel, and celebrities.

Nevertheless, I determine that my next hire will be a normal guy. As normal as possible in this place. Someone with a good heart who went astray somehow, whose crime is regrettable—but not horrible. So when a lanky red-haired, freckled guy comes into my office to apply for a position, I'm thinking, *He looks normal—what am I missing?* He tells me the other inmates call him Opie, and I think, *Of course you're Opie! We're in Mayberry!* I ask him about his background and he tells me he was a university student before he was arrested and convicted of robbery.

When I check his file, I discover he's telling the truth. The cops dubbed him "the gentleman robber" because he asked if he could return his mother's car before they hauled him off to jail. "She needs it for work in the morning," he explained. University student/robber? As I read, I discover that his addiction to heroin spurred him to rob his place of employment, a pizza parlor. He

lifted money out of the cash drawer and hoped his boss wouldn't notice. He's not the same kind of robber as Urkel. Or like the thieves I encountered as a child.

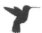

It was dark inside the theater. The floor slanted downhill. I'd chosen seats about halfway to the screen. Brad was on one side of me and Terri on the other; Bonnie sat beside Terri. I'd just had my eighth birthday. We were living with Grandma and Grandpa Tobola "just for now," Mom said, in their small house on Genoa Street in Lancaster. We were saving money to move into our own house. The neighborhood in Fresno seemed years away, although we'd only been in Lancaster a few months. It was crowded at Grandma and Grandpa's, but I liked being there, seeing Grandma every day.

It was Grandma's idea to let me take everybody to the show. Although the theater was just around the corner and down one block, this was a big deal. I was in charge of my sisters and my brother, and I'd been given Grandma's clear plastic coin purse with the green zipper.

As I settled myself in my seat, shrugging off my jacket, I dropped the coin purse and it slid down the floor. A few rows back from the screen were three teenage boys. I saw them pick it up, look back to where we were sitting, and then open it, unfolding dollar bills. They knew it was mine because I was staring at them, with a panicked look on my face. I leaned over and told Bonnie.

"Go get it," she said. I knew I must, because of all of the adults back home who were trusting me to be in charge of our first outing alone. But I was scared of the boys and now they were talking loud, teasing me.

"I'm going to get Red Hots," one said.

"Nah," another joked. "Let's just keep it for next week."

I screwed up my courage and walked down the aisle to where they were sitting.

"I dropped my money and I need it back," I said in a voice barely above a whisper.

"What money? Did you see any money?" one of them asked the others, who shrugged.

"Get out of here. We don't know what you're talking about."

Now I was almost crying. I'd paid our way in, but hadn't bought the candy yet. I'd already told Bonnie and Terri and Brad that we would wait until intermission. That was so Brad, who was three, would behave during the first movie. And then he'd have something to do during the second movie.

When I got back to our seats, I told Bonnie to sit between Terri and Brad. "I'll be back in a few minutes," I told her. As I found my way back up the aisle, the light from the movie machine flickered before me, dusting the heads of people in their seats, people who were not trying to keep from crying because their money got stolen. It's not that I was embarrassed about crying, but I didn't want to scare my sisters and brother. Already I was doing what Mom and Grandma told me not to do: I'd left them alone. But what other choice was there?

I pushed open the doors, rushed past the snack bar, and opened the heavy doors leading outside. I ran all the way home, crying as I went. By the time I burst in the door, I was near hysteria. I choked out the story: some big boys stole Grandma's coin purse after I dropped it and they wouldn't give it back and it had all our money in it and I hadn't even bought the candy yet. Because it was Sunday, Dad and Grandpa were doing nothing. That is, Grandpa had a pot of oxtail soup going, and he and Dad were sitting around the kitchen table drinking and talking politics. As soon as I stopped to breathe, they were out of their chairs.

"Sons a bitches," Grandpa said.

"Come on," said Dad. "Show us who they are."

Now I was skipping back to the theater with Dad and Grandpa following me, Grandpa muttering "punks," and Dad saying, "We'll show them not to tease little girls." It seemed I was floating just above the sidewalk, touching down just now and then. My anguish evaporated like the broth of Grandpa's soup. I'd done the right thing, running home to tell. Not only that, but this was important enough for the men to leave their cooking and politics. They didn't like to see me upset because they knew how seriously I took things.

They barged into the theater and down the aisle and Dad said, in a too-loud voice, "Where are they?" I could see the boys get nervous as we got closer, hunching down in their seats to try to make themselves invisible. But I stopped just before we got to their row and pointed.

"There." I had no mercy for them. Dad stood over them.

"Now what the hell is this? My daughter comes home crying and tells me some big kids took her money."

"We didn't take no money, sir," the one in the middle said, the same one who talked about buying himself some Red Hots. Dad looked back at me. I nodded.

"What did you say, you sorry little sonofabitch?"

"Give it to him," said the one farthest away from us and the one in the middle gingerly produced the coin purse. It was empty.

"Where's the goddamn money?" Grandpa barked.

This scared them even more and suddenly all three were digging in their pockets to produce the stolen loot. When it was deposited back into Grandma's purse, we turned to leave.

Dad said, "You ought to be ashamed of yourselves, picking on little kids."

"Yessir," they stammered in unison.

"Tell us if you have any more trouble," Dad said, still within the punks' earshot, as we walked back up the aisle.

I went straight to the candy counter and waved to them as

they opened the door, letting in bright noonday sun as they went. Triumphantly, I walked back to my seat and savored the moment, along with my chocolate nonpareils. I was stirred by the galloping music as the credits rolled. In the movie, some cowboys got buried alive and were eaten by red ants. In real life, I was on the side of the good guys and we won.

Later my father called them "juvenile delinquents" and said they'd end up in jail if they didn't change their ways.

I am sure that Opie was not a juvenile delinquent as a teenager. He is the perfect example of a young man who wouldn't have been sent to prison before California's prison-building boom, which began in the mid-1980s. He had no prior record, clearly had a drug problem, and was—most importantly—white and middle-class. A judge might have given him restitution and probation, or offered him the option to join the military instead of joining the inmate population. One in every one hundred American adults is incarcerated in a jail or prison, and the vast majority of them have substance abuse problems. That doesn't mean they are locked up for drug possession. It means that substance abuse underlies their criminal activity.

Changes in sentencing laws in the late 1970s took away the emphasis on rehabilitation and judges' discretion, replacing these with mandatory sentences for specific crimes. That fueled the if-you-build-it-they-will-come prison-building spree, which made the California Correctional Peace Officers Association (CCPOA), the prison guards' union, the most powerful union in the state. I am grateful I am not working in one of those newer prisons, which are metal and concrete monoliths with no sign of vegetation or wildlife.

I happen to start my job at a time when CCPOA's power is peaking. Apparently, the union calls the shots with Governor Gray Davis. The

governor just vetoed a bill that would have provided substance abuse treatment for nonviolent offenders on parole instead of sending them back to prison. It would have saved taxpayers $600 million a year, but CCPOA wanted that money for themselves, in the form of returning inmates. In a few years, the governor will give these union members an astonishing 33 percent raise. Rehabilitation is still a dirty word among many custody staff who are eager for more prisons, more power, more raises.

I don't use the word *rehabilitation* as much as I use the word *redemption*. Rehabilitation sounds like something that is done to you, while redemption is something you seek out, and hopefully find. I think Opie is grateful for his new work assignment, which resembles his university classroom experience.

He is the writing clerk. While Urkel and Smiley busy themselves with computer graphics and painting, respectively, Opie practices creative writing. He's already written one poem, which I critiqued as he listened thoughtfully. Like the other clerks, he is getting paid to learn. Although the prison pay scale is notoriously low, Arts in Corrections positions have one of the highest wages at thirty-five cents an hour, forty-five cents for the lead clerk (Urkel).

Opie will also act as my teaching assistant. My first workshop will start next week. I am offering Creativity 101, an introduction to the new Arts in Corrections program, with creative writing as its focus. A dozen students have signed up. In the first class, we'll study a poem by Seamus Heaney. I ask Opie to read it aloud and then we study the poem.

"What about these lines? Heaney says '. . . once in a lifetime / The longed-for tidal wave / Of justice can rise up, / And hope and history rhyme'?" I ask him. "Do you believe that is true?"

"I think so," he says after a moment. "But I'm not sure. I mean, it makes me think of Martin Luther King . . . and I say, yes, it's true. But then I look around here and . . . There are a lot of black guys here. Maybe the tide rises and falls?"

"Will you get copies of these for me at the Blue Building?" I ask Opie.

I hand him a stack of poems and a slip of paper with my signature and the number of copies requested. At the last minute, I add an article from the *Los Angeles Times* about Crips gang cofounder Stanley "Tookie" Williams being nominated for a Nobel Peace Prize after he wrote a series of anti-gang children's books. There was a furor in the LA law enforcement community over the nomination. But I figure I can get away with it. After all, we're not in LA—we're in Mayberry.

However, when Opie returns from the Blue Building twenty minutes later, he's rattled. He tells me, "The sergeant grabbed it. He didn't care about the poems. He read maybe one sentence of the article and said, 'What the hell?' So I said, "It *is* curious. It brings up questions like, Is redemption possible? And he said, 'Yeah. Get the hell out of here.' I could tell he was really pissed off."

I'm thinking this may be the first time the word *redemption* has been uttered in the Watch Office, maybe even the whole Blue Building, since the West Facility opened when my father worked there in 1954. The gentleman robber and I are going to get along just fine.

IV

THE REAL WORLD

Inmates are always talking about "the real world" as if they are not in it. It is as if they lose all the vestiges of the world as they know it the minute they hit the prison gates. I argue that the real world is the one you find yourself in, but they resist that notion.

Did the convicts at CMC when my father worked there in the 1950s talk about the real world too? Back then the West Facility was called "the old men's prison." It was opened specifically to house aging and ailing prisoners, who were transferred there from the seven other state prisons. A *Los Angeles Times* reporter visited in 1964 and called the inmates "the country gentlemen of the convict crowd." He described inmates in polo shirts playing tennis, golf, and shuffleboard.

Since then, the state of California has added twenty-five prisons. Inmates do not wear polo shirts, but prison blues, light blue work shirts or smocks and dark blue jeans with neon yellow "CDCR Prisoner" stenciled on the clothing.

When people enter prison, they are given a new identity. They are assigned a prison ID number, an alphabetical letter followed by five digits. When I began teaching in prison in the early 1990s, some of my students had *B* numbers. By the time I left CMC, at the end of 2008, I had students with *V* numbers.

Along with his new identity, an inmate is classified and assigned a point score, to determine his custody level. A classification committee examines each inmate's crime and whether violence was used. They factor in other characteristics, including the inmate's age, marital status, gang affiliation, and history of prior incarceration. Level I inmates have fewer than nineteen points, while Level IV inmates have been assigned sixty or more points. Sex crimes and violent crimes are considered the most dangerous offenses.

Because the West Facility is a Level I/II, you might expect the dorms on each of its four yards to be filled with shoplifters and bad check writers, the Boy Scouts of California's criminal justice system. But that's not exactly how it works.

Inmates' points are not static. Every year they undergo reclassification. Points are lowered for good behavior. Points don't tell you anything about an inmate's crime. There are a lot of well-behaved sex offenders on the West Facility.

It's a different story on the East Facility, which is a Level III prison with cells instead of dorms, cement enclosed quads instead of yards. The East houses a hospital and two mental health units. One quad is reserved for mentally ill inmates. And the East houses lifers, who, generally speaking, are better citizens than their younger counterparts, especially when it comes to programs. Prison is their permanent home and lifers want to protect what they value in their home.

Although the Arts in Corrections building is located on the West Facility, the program serves inmates on the East Facility as well. In a way, it's like having two jobs rolled into one. Because the East is a higher custody level, it's like a different institution. I've learned that what works on the West won't necessarily fly on the East. For example, before I started my poetry class on the East, the captain insisted I read him one of my own poems. I searched in my book bag, saw my end-of-the-twentieth-century rant, "Whatever the Market Will Bear," which contained the lines: "The prison on one end of town /

and the crank lab on the other vie for consumer dollars / working in a cooperative venture with local law enforcement / to keep the state afloat with a raison d'être." My students on the West called it my Wal-Mart poem because the poem ends—and the century ends—in the parking lot of the illuminated marketplace.

No way could I read that. Luckily, I found a sonnet about swimming in a canal in Florida as a child, encountering a sea cow. That seemed harmless enough. The captain didn't offer a critique, just nodded his head once. Then he signed the memo giving me permission to teach poetry in his prison.

On the West, we have classes in creative writing, drumming, singing, mural painting, and guitar. On the East, it's poetry, abstract art, and guitar. Two Arts in Corrections students on the East—a painter and a poet—each won first place in a statewide prison art contest. That's not surprising. Inmates on the East have longer sentences, more time to devote to their art.

A painter, Salvador, goes by Sal. He is taking both the poetry class and the painting class. Like many inmates, he came into the system as a juvenile and was later transferred to an adult prison. At San Quentin, he took part in the murder of another inmate and received a life sentence. I didn't know any of this when I first met him. What I did notice right away was this short, slender man's ability to savor every moment. I am accustomed to inmates on the West, where I spend most of my time, complaining about their circumstances. Many complain about the rules, the food, the other inmates, the custody staff, noise in the dorms. And most are short-timers—they will be paroling soon.

Yet here is a lifer, who got locked up when he was a kid, who will never get out, who lives in a cell instead of a dorm and has more hoops to jump through because he's on a higher-level institution, and I have never heard him complain. I could tell he was disappointed when he learned that the new painting teacher was an abstract artist.

Like many prison artists, he tends toward realism. Good artists in prison can earn money—or soups, or coffee—by making cards for other inmates to send home to their wives, mothers, and children. But Sal is in it for the art itself. And he is good. Another inmate might decide to skip the abstract art class, but Sal signs up anyway. Years later, he will tell me that the techniques he learned were a turning point for him, ushering in a new artistic style.

Of course Sal and I have little idea when he shows up to poetry class for the first time that he will in fact get released—one of the few California lifers who is granted parole in the first decade of the twenty-first century. Or that we will become friends and creative collaborators, traveling all over California with Poetic Justice Project, performing plays. That one day he will introduce me at a poetry event by reading homework I assigned in prison. "Write a poem about redemption without using the word redemption." But that is another story.

When I was I child, I once imagined going to prison. We were moving again, this time from California to Florida, where my father would supervise the building of missile launch pads at Cape Canaveral. The cross-country adventure in our gold Ford Galaxy was a trip measured not in miles, but in the number of times my father yelled at us for clicking the backseat ashtrays. We rotated which of us had the favored front seat position between Dad and Mom while the other three shared the backseat—where we were tempted by the built-in ashtrays with tight-springed lids. They clicked at the slightest touch. After a while, they seemed to click if we just looked at them.

My father wanted to make the trip in five or six days, so he resisted unnecessary stops, once instructing Brad to pee into a Coke bottle, an event that we taunted him about for the rest of his childhood.

Dad did make a few side trips, however. Some, like the Vicksburg National Cemetery in Mississippi, were for him: he was a history buff. But other stops, like the Petrified Forest and the Painted Desert, were for us. For me, though, the Petrified Forest took on a different connotation than dead wood.

Bonnie was a packrat, a hoarder, a collector of treasures. She kept a shoebox under her bed and into it went marbles, coins, paper doll clothes, trolls, sequins. It fascinated me, this collection. Why couldn't I see what she saw in these everyday objects? Why didn't I have the urge to collect, preserve? But I didn't. It simply never occurred to me. Except at the Petrified Forest when I was swept up in the grandeur of a desert littered with colorful rocks of all sizes.

There were signs posted all over the place: WARNING! STEALING PETRIFIED WOOD IS A FEDERAL OFFENSE. When Brad, who was five, asked Dad what the signs said, he explained that if everybody took petrified wood, pretty soon there would *be* no petrified forest. I watched Bonnie, who was holding a small piece of wood, which was really a rock, in her balled-up fist. She pretended to look around and then slipped it into her pocket. At first, I acted like a big sister. "Bonnie," I hissed. "You better not."

She took it out of her pocket and showed it to me. It was pretty neat, all right, striped like a miniature Grand Canyon. It was so little no one would miss it. "I have to have it," she said. And suddenly, I had to have one too. I picked up a small rock and showed it to her. Then we both surreptitiously—we thought—slipped them into the pockets of our shorts.

I went to look at a giant petrified log embellished with purple, gold, and orange swirls. I didn't see what Bonnie did before Dad rounded us up to head back to the car. But Brad had been watching us the whole time.

Leaving the forest, we had to pass by a guard in a little booth. There was a car ahead of us. I was fingering my rock when Brad piped

up from the front seat in his sing-songy tattletale voice: "Dad. Debby stole a rock."

I looked over at Bonnie. She turned her pockets inside out.

"I put mine back," she whispered.

Then suddenly we were at the booth and the guard was putting his face almost in Dad's window and asking, "Anybody here have petrified wood?"

Dad didn't say anything. Instead, he turned very slowly around in his seat and searched the faces of each of us in the back. I didn't move a muscle. I envisioned myself in a black-and-white striped uniform, like the jail uniforms in cartoons. I would never see Florida because I'd be in jail while the rest of the family was swimming and wrestling alligators and having a good time. And all because I wanted to own a piece of natural history. It's a stupid little rock that could have come from anywhere! Regret flooded me, colored me pink.

I must have been holding my breath because when Dad turned back to the guard and said, "Nope, no wood in here," I exhaled. He laughed for miles, with Mom, Brad, Terri, and even Bonnie joining in. Finally, I did too, punctuating the laughter with, "Dad! It's not funny!"

Bonnie's desire for pretty things never left her, nor did my wish to possess history. But we both lost our appetite for stealing as my father pulled away from the guard booth in the Petrified Forest.

Along with the full moon, the beginning of May 2001 brings a stabbing on Unit I, after a soccer game, which results in a one-week lockdown. All of my work crew lives on Unit I, so it is eerily peaceful. I use the time to complete my three-year arts plan and catch up on all the paperwork that's stacked up. I've learned that the best time to tackle complex administrative tasks is when inmates are absent.

The Unit I stabbing is immediately followed by an inmate trying to kill himself by slitting his throat on Unit III, a fatal heart attack on Unit I, and an escape on Unit IV, which has the lowest level security in the entire prison. CMC is one of five prisons in California that train inmates to fight fires. Inmates on Unit IV, also called Camp Yard, have more freedom, often leaving the prison to fight fires or to work in parks or alongside highways. They are fed better—steaks, I've heard, instead of pre-fab rations—because of the physical demands of their work.

The camper, the inmate who escaped from Unit IV probably just walked away from whatever he was doing that day—maybe picking up trash on the beach—and hitched a ride into town. Rumor has it that he was a year into a two-year sentence for credit card fraud. After he escaped, he stole his ex-wife's car and was apprehended at a nearby Target store. I would learn that it was fairly common for an inmate nearing parole to do something that would forestall his release. He might injure another inmate, get caught with drugs or a cell phone, or try to escape as this inmate had. I would come to realize, over the years, that some inmates were afraid to parole. They would be sent back to the same troubled neighborhood they had come from. Or they had few job skills and slim prospects for making a legal living. Or they had become so used to prison, it was home to them. They were institutionalized.

When the lockdown lifts and my workers and students return to Arts in Corrections, we talk about the camper who just added more time to his sentence. I say to my creative writing class, "At least he wasn't shopping at Wal-Mart." That gets a few laughs.

I've just passed my one-year anniversary working at the prison and it's time to showcase what's been going on in Arts in Corrections. As an institution artist/facilitator, I teach my own classes, as well as recruit and train professional artists who are willing to work in the prison. These artists must pass a background check, attend training,

submit a tuberculosis test, and provide a detailed inventory of the supplies and equipment they need to instruct inmates.

I have big plans. My creative writing students on the West will write a play, and we'll incorporate students from the other classes—visual art, guitar, drumming, singing—in the collaborative performance. We will hold it in the Arts in Corrections building, in the large multipurpose room.

I know better than to ask to use the stage in the Blue Building. I'm afraid I have not endeared myself to the watch lieutenant and sergeant who work there during second watch, from 6:00 a.m. to 2:00 p.m., because of my last event, a lunchtime performance by the reconstituted doo-wop group the Drifters.

Back in the old men's prison days, the Blue Building's auditorium was used on inmate movie nights and the stage featured live performances. Who knows, the original Drifters could have performed there back in the day. Now the auditorium is used as a workroom, sort of a clerical pool for inmates who work for the captain, lieutenant, and sergeant in the Blue Building. The stage is stacked with extra supplies and folding chairs.

Because of the number of inmates who wanted to attend the performance, I figured why not hold the concert in the Blue Building? There was plenty of grumbling by custody staff on the day of the concert, but Mr. Robinson had given the okay, so what could they do?

More than one hundred inmates gathered to hear the musicians play "Under the Boardwalk," "Up on the Roof," "This Magic Moment," and other doo-wop classics. My singing teacher and friend, Carmen, was invited onstage with her students. They joined the Drifters in a rendition of "On Broadway." One of the Drifters grabbed the microphone out of the hand of one of the inmates, accusing him of trying to steal his job. Smiling, the Drifter handed him the microphone back, and the student, an older black man known as Hollywood, got his fifteen minutes, singing "You Send Me" with the Drifters backing

him up. The inmate audience went wild at this—one of their own stealing the spotlight from the stars. It was an exhilarating performance for all involved—except the lieutenant. He let me know that the stage in the Blue Building would not be available again for any performance. The music was not bad, he admitted, but he didn't like a hundred inmates in his building.

Trouble with our upcoming show begins in my own class. I'm trying to get a group of poets to agree on a concept and then we'll write the script. One of the students wants to write about aliens. I nix that idea. For weeks we flounder. No one can embrace any idea but his own. The deadline looms. All of the other arts teachers and students are waiting for the "script." There isn't one.

Smiley has been talking about a baby crow that fell out of his nest just outside our building, and how the parent crows are frantic to find him. I do what artists have done since the beginning of time, I'm sure—put two random concepts together and voilà! We're going to do a play about the real world and the baby crow. One of my students says, "I don't get it, Ms. Tobola."

Before I can reply, another student jumps in, "The crow is a metaphor for the kid who's going home. Right, Ms. T?"

"Yes," I said emphatically. "You get an A for the day. We can never underestimate the power of metaphor!"

Our play, *Crow*, is about Junior, a young inmate who has been incarcerated since he was fourteen, graduating from the Youth Authority to an adult prison. This premise mirrors the situation of the inmate playing the lead. Junior asks his elders what to expect in the "real world," and they all give him different advice. As he makes the rounds, Junior is interrupted by an inmate who gives him updates on the progress of the baby crow that fell out of his nest. After the crow is nursed back to health by the inmates in the Native American sweat lodge, he's not sure where to go. Should he fly back to his parents' nest or out into the real world?

Our backdrop features crows flying around a prison yard at night, created by the art teacher and his students. We never do get the script on paper. It's more of an improv piece, punctuated by conga drumbeats and songs. I'm a little nervous about this because one of the performers, Jerry, a man with a gentle voice and a history of violence, is somewhat unpredictable with what he says when we're rehearsing.

When we perform for the first time, Mr. Robinson is in the audience along with the Education students and staff. About halfway through the performance, Junior stops near Jerry and asks what to expect in the real world. Jerry raves about the world outside the prison. He says he can't wait to parole and get himself some "hot . . . hot . . . hot . . ." I hold my breath, exhaling only when I hear Jerry say "chocolate."

My favorite moment is when Hollywood sings "If I Were a Rich Man." I'd asked Carmen if any of her students could sing that song, because we had the perfect spot for it in our unscripted play. So when Junior asks Hollywood about the real world, the older man urges the youngster to invest in oil and then breaks into the *Fiddler on the Roof* classic, joined by two other older inmates. The three old guys sing and dance around the kid, snapping their fingers.

We perform *Crow* a few times for inmates in Education, and then again for outside guests. It's a hit. A reporter and photographer come to the public performance, and *Crow* is the lead story in the entertainment section of the local paper.

One inmate sends me an Inmate Request for Interview, which is the form inmates use to communicate with staff. This man, Pico, thanks me for letting him participate in *Crow*, saying that in the past, his low self-esteem and fear kept him "in a box of a barrio boy." I save the note in the bottom drawer of my desk, evidence that Arts in Corrections is a lighthouse shining in the darkness.

V

DREAM PRISON

One evening a student in my poetry class asks if I would be interested in accepting the donation of a dollhouse he's constructed out of scrap drywall in his vocational education class. He wants to send it home to his daughter, he says, but they won't let him. I've learned a few things in the fourteen months I've been on the job and I know that inmates cannot own anything made from state materials. The state owns everything except what inmates can purchase at the Canteen. That's why prison artists—in the absence of a program like Arts in Corrections—use candy wrappers to create jewelry and handkerchiefs as miniature canvases. Candy and handkerchiefs are available at the Canteen, the inmate mini-mart.

"Sure," I say, "we'll take it." The next day I take my work crew of three inmates over to Vocational Drywall and we put the thing on a dolly and wheel it back to our building. More than a few correctional officers are amused at the sight. It barely fits through the back door of our building. It's a big, boxy affair with a cutaway roof. It doesn't look like any dollhouse I've seen, including my favorite "Debbie's Dream House," which Grandma Tobola bought me the Christmas before we moved to Florida. I didn't really play with dolls—I just wanted my own house. My dream house required batteries: for the chiming

doorbell, light-up fireplace, and living room lamp. My favorite features were the turquoise sink and tub in the bathroom.

"This looks more like an institutional building than a dollhouse," I tell my workers.

Urkel sighs. "Waste of time," he mutters. "What are we gonna do with this?"

Smiley just smiles.

I look at Opie, who is assisting me in the poetry class, and say, "Dream Prison." Perhaps that gift from my grandmother when I was eight years old imprinted on me. Why have a house when you could have a "dream house" or a prison when you could have a "dream prison?"

When I introduced the concept in poetry class, one student observes, "A dream prison is no prison at all."

"Of course," I counter. "But since our society has decided that we have to have prisons, how could we make them better? Can we design a model prison? What would it look like? How would it function?"

I challenge the poets in my class to come up with a better alternative to the institution they are housed in. I'm thinking of the Dream Prison as a figment of collective imagination.

Soon, ideas abound: the prison would grow food and livestock, making it self-sufficient (and getting rid of the objectionable institutional fare); officers would be trained as teachers or social workers, and carry no weapons; there would be living units with separate bedrooms and a communal kitchen and living space; college courses would be offered; meditation groups would meet each morning; acupuncture would be on the medical menu; an IT center would train inmates in emerging technologies.

Actually, we don't need to imagine this because this Dream Prison has already been designed, built, and is up and running in other countries—notably in Scandinavian countries. Prisons there look like luxury hotels compared to prisons here. And Sweden, Norway,

Denmark, and Finland have far lower incarceration rates—and recidivism rates—than the United States. The Nordic philosophy is much different from the American lock-them-up-and-throw-away-the-key mindset.

In Norway, there are no life sentences—twenty-one years is the max. Rehabilitation, not punishment, is the emphasis. Prison staff members encourage introspection and interaction (even between staff and inmates). They want inmates to learn new skills that will enable them to stay out of prison. Many inmates leave daily for work or study. They see their families; they just can't live with them. The Nordic sensibility aims to make prison as comfortable as possible, and to employ staff who are as helpful as possible. In the end, there is not much to complain about—except what you did to get there.

Unfortunately, it's nothing like that here. We are in a war zone. The Prison Industrial Complex needs more and more bodies to keep growing. It's paying the salaries, not only of correctional staff, but of a lot of associated industries, including food supply, telephone, health care, clothing, and transportation. And my program, Arts in Corrections.

The officers have nothing personal against most inmates. They are just CDC numbers, not really people. The officers' mantra is "You got nothin' comin'," meaning whatever you did to end up here, you deserve what you're getting. You are *persona non grata*. Paroling inmates are often told, "Bring a friend when you come back."

This is not an atmosphere that encourages inmates to take stock of their lives, to make amends, to embark on self-improvement. I want Arts in Corrections to provide a space for dreaming, which is necessary for transformation to occur. And transformation is the desired outcome, isn't it? I want Arts in Corrections to provide a place for men to imagine a different future. Imagining a different future is something I have experience with.

Merritt Island, Florida, is a paradise: you can walk to water from
anywhere. We were surrounded by vivid names: the Banana River,
Cocoa Beach, Cape Canaveral. Even the stores had wonderful names.
Instead of going to the 7-Eleven, we loaded up on candy at the neigh-
borhood U-Tote-Em. We bought ice cream cones at Dipper Dan's and
went grocery shopping at the Winn-Dixie.

Cocoa Beach was the most glamorous of our neighboring com-
munities, because it was the television home of the popular *I Dream
of Jeannie* show. Jeannie both fascinated and repelled me. She was a
genie who lived in a bottle with plush pillows inside. She had enough
magic to get herself in and out of the bottle by crossing her arms in
front of her, snapping her head, and blinking her eyes. But she didn't
have enough magic to make the astronaut, Tony, marry her, which
seemed to be her fondest desire. Because Tony had found the bottle,
he was her master. "Master, master . . ." Jeannie was always saying,
and, "Oh, *master!*"

I loved her clothes: pantaloons made of scarves, a velvet vest, and
a matching velvet hat with scarves flowing from it. I loved her home
in the bottle and the magic she possessed. I hated the way she wasted
all her magic on the astronaut, though, and especially the way she
waited on him and called him master. She also pouted and threw
tantrums when she didn't get what she wanted. Even I'd outgrown
that, and I was only nine.

If Jeannie married Tony, then what would happen? Would she have
a bunch of kids, like Mom did? Would he stay out drinking every
night and golfing on weekends and fight with her when he came
home? Would she ever get mad at him and hit him with a wooden
spoon while he's on the phone, long-distance to his father? And would
Tony say, "Just a minute, Dad," put down the phone, and put his fist

through the wall, right when the Beatles were singing "I Wanna Hold Your Hand" on *The Ed Sullivan Show*? Would Jeannie then cover the hole with a calendar, until Tony got around to spackling it?

As a kid, I was in the habit of narrating my life inside my head in third person, like I was a character in a book. I did this on the way to school sometimes. The kids on the turquoise bus that took us from the Manor House apartments to school thought I was funny-looking. My deep-set eyes peered out of a face still round with baby fat; my white-blonde hair was bowl-cut. "Eskimo girl, Eskimo girl," they chanted. *She ignored them, pretending they were talking about somebody else.*

I wasn't sure what an Eskimo girl looked like exactly until I opened a book called *Children from Other Lands,* which showed a dark-haired, dark-skinned girl sucking on a peppermint stick that matched her peppermint-striped white parka. I looked nothing like her. I also looked nothing like the girls at school who were thought to be pretty. They had round eyes, never slanted ones.

If I were Jeannie, I could blink myself out of the bus every time the kids started teasing me. If I were Jeannie, I would also have to live in a bottle and say master. If I were my mother, I wouldn't have any magic, just a hole in the wall.

I imagined a different future. If I were an Eskimo girl, I'd have a beautiful parka and live in other lands, lands where nobody had a TV or a telephone or even a wooden spoon. *And she held that thought, sucking on her peppermint stick, warm inside her parka.*

One student in my prison poetry class is clearly gifted. Emily sent Alejandro to me after she discovered him working on a poem in her class for under-twenty-one inmates. He had started writing in juvenile hall. "The very people who took my life away gave it back to me

when they put a tablet and pen into my hands," he'd written about that experience. Since then, he's read every book he could get his hands on.

He's just twenty and still has baby fat. He has a round, soulful face. I can't imagine him committing any crime at all. His poems are marvelous—simple yet profound, with a sense of wonder not extinguished by his years in the system. I tell him he is a natural-born poet.

Opie will be paroling in a few months and I urge Alejandro to apply for the job when it comes open. "You belong here," I tell him.

"But I need to learn a trade. So I can support my family when I get out," he says. He is thinking of taking a job at Vocational Auto Body.

"I don't know, Miss Tobola," he says. "I would love to work here, but I have kids. Why should I come to work here when I could learn a skill that I could support my family with?"

I can't answer him right away. Instead I write a poem and give it to him.

To a Poet in Prison

The craft of poetry is not unlike auto body repair after all.
With the right tools—torches, words—you can transform
a rusted wreck of a world into a shiny new ride.
Get you some paint, glass and chrome and make it real.

The craft is not the question: It's the art that matters.
What separates the poet from the guy who slaps
a new coat of paint on an idea is more mysterious,
more urgent. The art of poetry has nothing to do

with making a living; it has to do with making a soul
and making the world soul larger. It's a calling
and an answering. The poet is a poet no matter where
he finds himself, no matter what befalls him.

He writes because it is the only thing he can do
when all around him others do too much or too little.
He writes because, whether he knows it or not,
he is in dialogue with God, translating the aching world,

making sense of things too terrible or beautiful
to believe, serving them up for others to take in,
word by word. Even the young poet knows
that his gift is a burden, that what he weaves

is a fragile basket of words to hold the world.
He takes things hard, though his words may evoke
the softer world, where truth is a moonflower
blooming in the dark hollow of the throat.

The poet knows no easy way out, carefully
assembling his vehicle, your transportation, stopping,
stepping back, looking through the tinted blue
at you, and through, and back at you.

Alejandro takes the job at Arts in Corrections. I tell him his duties
include making my coffee.

"Zen and the art of poetry," I explain.

"Okay," he says.

Another job duty is to keep asking the right questions, like why
he should work here instead of Auto Body. And I encourage him to
write poems in his native tongue.

"I don't know Spanish," he says, "just a little Spanglish."

"Well, Spanglish then," I reply.

Alejandro's gift is recognized by his peers in our poetry class, and
by the teachers who have heard him recite his poetry. Zola, the GED

teacher, requests that Alejandro read a poem at our annual high school graduation ceremony. When this request comes, I declare him Poet Laureate of the West. I explain to Alejandro that poets laureate write poems for special occasions, such as graduations and presidential inaugurations. He nods gravely, then smiles. A few months shy of my two-year anniversary at the prison, I'm preparing for a ten-day vacation to Alaska. I assemble my work crew to give them instructions before I leave.

"Stay out of trouble. If you see trouble coming your way, go somewhere else," I say this to all of them, but I'm looking at Alejandro, with his round, open face and shaved head. Is it an awareness of his situation or a sixth sense? Alejandro has a needle's chance in a haystack of making it: an illegal immigrant on strike two, he would have to make all the right decisions for the rest of his life *and* have luck on his side.

When I return to my apartment in Morro Bay, on a Sunday, I'm still unpacking when the phone rings. Emily tells me, "Alejandro got rolled up. It doesn't look like he'll be back."

Alejandro was now in the Hole, formally known as Administrative Segregation, or Ad Seg. Emily tells me that he started a fight on Unit One, attacking another inmate with an ink pen as a weapon. This is so patently idiotic that it can't be true. But two of my other workers—one of them Urkel—swear to me the next day that they saw the whole thing go down. It would be years before I learned what really happened.

Alejandro is put in the Locked Observation Unit, or LOU—on suicide watch. Urkel speculates that he's just manipulating the system, getting out of the mix for a few days. He asserts that Alejandro is not suicidal, but in need of protection. Indeed, there are few safe havens in prison. The hospital is one of them.

It turns out that Alejandro knew he'd be going soon. He erased the poems he'd been working on from the memory of the word processor

he'd been using. Maybe he heard a member of an enemy gang had put a hit out on him and decided it was time to roll it up. Looking back, it did seem strange that he didn't want to check out books from the little Arts in Corrections library the day before I left for vacation. We'd just gotten our order in and most of it was poetry. He apparently knew that his "down time" was going to really be *down* time.

Although his poems were gone, he left behind a quote from Myra Brooks Welch:

It's easy, perhaps, to die for a dream
with banners unfurled—and be forgiving
It's the hardest part to follow the gleam
when scorned by the world—and go on living

I am not familiar with this poet. I hope the gleam means a life of freedom from gang life. While he is on suicide watch, I can't help but picture him: a baby-faced thug who's pledged his allegiance to domestic terrorists, huddled in the corner of a darkened cell with poems glowing inside him.

Blood in, blood out, that's what they say about the Mexican gangs. You can't, à la Bartleby the Scrivener, wake up one day and say, "I prefer not to." If I were in Alejandro's place, I *would* be suicidal. But maybe he'll have a full-on conversion, reclaim his lapsed Catholic faith, or be born again. Maybe he'll never get out of the joint, or die trying to run with, or run away from, his gang. Of course I'd like to go to the East Facility, where the LOU is, and check things out for myself, ask him what happened. But I can't. If I show that kind of interest in an inmate, even one of my workers, it will be construed as overfamiliarity. So I write Alejandro's final work report, attach it to his timesheet, and add my letter of recommendation:

To Whom It May Concern:
Alejandro is a poet.

Six months later, I run into him. I've brought in an LA comedian to do stand-up on every yard on the East and the West, plus a staff show. I'm on the D Quad of the East Facility, where mentally ill inmates live. I'm cringing at the comedian's racier jokes—we're in a prison full of sex offenders. Then I hear a "Miss Tobola, Miss Tobola" to my right. There's Alejandro with longer, wavy hair. I want to hug him, like a mother who hasn't seen her son for months, but of course I don't. He smiles.

"Are you okay?" I ask him.

Nodding, he says, "I'm staying here as long as I can."

Alejandro is now housed in D Quad, with inmates who suffer from mental and physical disabilities. He is safer here than in the general population.

I tell him his poems are still being read. During our poetry festival, an inmate on the West read one of Alejandro's poems. Zora, the GED teacher, requested his graduation poem be read again for next year's ceremony. A poet can go away, but his work remains.

Alejandro says he isn't writing, but he's reading Neruda. "He's like my best friend now."

This makes me happy because I had introduced him to the great Chilean poet, bringing in a bilingual edition of *The Capitan's Verses* for him to study.

"I told them I hear voices," he says.

"All poets hear voices," I reply.

The doctors must realize he's not crazy. Maybe they're trying to help him, offering him refuge from gang violence. I send a silent prayer to the Medical and Psych staff on the East Facility. *If you can save anyone, please save him.*

VI

911

My partner Art calls me early on September 11, 2001. "Turn on the TV," he says. "Two planes just crashed into the World Trade Center."

"What? Is this the end of the world?" I ask him.

"I don't know."

If it is the end of the world, Art is one of the handful of people I'd be in communion with on our way out. The others would be my sons, my mother, and my siblings. Art and I first met twenty-two years ago, at a party at the China Lake Naval Weapons Center in Ridgecrest, a small city in the Mojave Desert. I was a newspaper reporter at the *Daily Independent*. I also edited the Women's Center newsletter and had recently written an article about using a yogurt douche for curing vaginal yeast infections.

Art had said the article had caused quite a stir in the conservative military town.

"Where else would you put it?" I'd replied, somewhat taken aback.

"A lot of men read the Women's Center newsletter," he'd said.

"Oh well. Maybe they can let their wives know."

Art had an appetite for unconventional women and despite, or because of, my rather wild upbringing, I craved stable men. But they had to be smart, kind, and funny. We'd both ended up moving to

Alaska within months and back to California within a year of each other. Although we'd had different partners, we'd been constants in each other's lives and finally we ended up together, although not always in the same town. Now I'm in Morro Bay and Art lives in the Kern River Valley, about fifty miles northeast of Bakersfield. He's a grant writer and consultant who specializes in funding housing for homeless people.

My television, which I rarely watch, is on the fritz. After Art's phone call, I do what I usually do in the morning. I listen to NPR. I have no visuals of the attack, just Bob Edwards's supernaturally calm voice and my imagination, as he narrates the continuing devastation. Somehow it seems more wrenching than pictures on TV. Edwards interviews an eyewitness, a cook from a restaurant two blocks away, who says he saw papers flying everywhere and then people falling or jumping out of the first tower. A man a mile away tells Edwards he can feel the heat from that distance. Another man says he is a block away from the World Trade Center and trapped in his eleventh-floor apartment. Gray dust from the collapsing tower has turned day into night, he says in a shaky voice.

End of the world or not, I have to report to work.

At the entrance to the dog run, the officer says nothing about the morning's events. When I get to Control, I check out my "personal alarm device," which resembles a garage door opener, and attach it to my belt. Custody acts like it's another day in the joint. Not even a shared look of grief or horror. Nothing. This shakes me up because, in prison, everything is an emergency. A missing tool, an inmate not showing up to his work assignment, inmates "grouping" on the yard, the regular audits of the institution, the teacher who orders a pizza for his class (and gets fired and walked off, or escorted from the institution in a ritual of public humiliation) are all emergencies. But now, after a terrorist attack on New York, the heart of culture and finance, the home of the Statue of Liberty and Ellis Island, the officers are

stone-faced. *This is an emergency*, something inside me screams. But I say nothing. Not until my inmate work crew arrives at the Arts in Corrections building do I witness any human reaction to the events of the morning.

When Urkel and Preacher arrive, they are visibly distressed. Opie and Smiley have paroled and Alejandro is still on the East Facility, so it's Urkel and my new worker Preacher, who is studying divinity through a mail-order curriculum. He has already lined up church appearances and speaking engagements after he paroles. Preacher fills the visual artist slot in my work crew, and although painting is not his first calling, he has some talent. I am on the lookout for my next creative writing clerk—the most important position.

The prison grapevine is as fast as the Internet, it seems. They know all about what happened. But they want to see it for themselves. Urkel asks if he can turn on the TV. We watch. I am mesmerized not by footage of the plane crashes, but by the people determined to find survivors.

I watch a guy in a bright blue hard hat dig in the rubble. He digs and digs. He won't stop, as if digging could turn back the clock, rewind the terrible tape—people screaming, leaping out of this life, towers burning, jets jackknifing. The images repeat, repeat, backward, forward, out of order—repeat into belief. The man digging is not looking for the black box, container of evil. He knows what evil looks like, sounds like, smells like. Digging—chef's résumé, passport, pair of hands bound by wire, stocks and bonds, box cutter, fireman's jacket. No more survivors. They've disappeared into spectral light when the wind rained papers from the sky and the papers turned into angels and the angels turned into people and back into angels again. After I release my workers for lunch, I turn off the television and go into my office, take my sack lunch out of the mini-fridge, sit at my desk, and cry.

My first glimmerings that the world could be this scary came

when I was ten years old. Then, like now, people divided by ethnicity and belief warred against each other. There were bad people who did unspeakable things, like murder and kidnapping, given the chance. And no matter how much singing filled your world, terror lurked at the edges.

Everything I wasn't Stephanie Stinnet was. Blonde, big-eyed, and pretty in the classic American way, Stephanie came from a large Catholic family, with ten kids and a mother who looked exactly like Mother Superior on *The Flying Nun*. Stephanie had equally beautiful older sisters, one of whom was an airline stewardess. She had a bunch of crew-cut towheaded brothers; I couldn't keep track of them all.

Stephanie told great stories, like the one about the little girl across the street who told her parents she was going to live with God in Heaven. And then she got run over by a car and died and became an angel. I knew very little about angels, or God, or Heaven. We didn't go to church. But the Stinnets went faithfully every Sunday and on holidays, with the girls and women wearing white gloves and things that resembled doilies on top of their heads.

Stephanie wasn't only my best friend, she was who I wanted to be. Not just because of how pretty she was, and her big family and her knowledge of saints and virgins, but because she could sing. "The hills are alive with the sound of music," we sang, spinning around in dresses with tight bodices and full skirts, our arms stretched out. We spent a lot of time singing, imitating Julie Andrews, dreaming of womanhood. Would Stephanie be a nun or an airline stewardess? Would I write stories in my attic or run an orphanage? Definitely my first child's name would be Jo, just like Louisa May Alcott's hero in *Little Women*.

I couldn't sing like Stephanie. My voice wandered around in the

neighborhood of alto, unable to find its bearings. Or, as my grand-
mother Nonny put it, "Somebody in this room can't carry a tune in a
bucket." When Stephanie opened her mouth, out came a clear, pure
soprano. She was good enough to be on *The Ed Sullivan Show*, if only
someone would discover her.

Stephanie and I were in Advanced-Sixth at Merritt Island Launch
Area (MILA) Elementary. That meant we were at the top of the sixth-
grade class. We noticed and discussed the fact that there were Negroes
in our school, but none of them were in Advanced. Only one was in
High-Regular, the class just below ours. Roland was almost six feet
tall and played sports. So even though Negroes went to our school,
we never saw them once the bell rang, except for Roland occasionally,
when Advanced and High-Regular went to an assembly together, or
had joint music and art.

In our class, there was a girl named Sally. Sally was an only child,
she explained, because her mother was afraid to have any more
babies. Stephanie found this puzzling, as her four-foot, eleven-inch
mother, a ten-time veteran of the delivery room, had never expressed
any fears about having babies. "No, not that," Sally said. "It's because
you never know if your great-grandfather or somebody a long time
ago had a baby with a Negro, and you could have a part-Negro baby
because of them."

Stephanie and I were astounded by Sally's story, and her later
revelation that she would have no children, to her mother's relief.
Stephanie and I disapproved of Sally's mother and of Sally herself.
What was the big deal about Negroes? We tried to figure it out. I told
her that moving from California to Florida, we drove through Selma,
Alabama, and there were hundreds of Negroes on the street, and
some white people too, trying to change the law so Negroes could
vote. When I'd asked my mother why Negroes couldn't vote, she'd
told me many white people thought that Negroes shouldn't be treated
the same, because of the color of their skin.

Stephanie and I figured that people like Sally and her mother didn't think Negroes were really people, unless they were unusual, like Roland, who was going to be a football star, according to our classmates. We heard things about Negroes having to use different drinking fountains and restrooms. We saw people, adults, openly hostile to Negroes in public places. More often, white people ignored Negroes, looked right through them. We were two blonde-haired white girls from the West and the Midwest, strangers to the South. But we knew the lay of the land. We also knew in our hearts what was right.

It happened one morning when we were on safety patrol together, wearing our white police hats and waving our orange flags so little kids could cross the street. I took this job too seriously, it's true, so weighted with the responsibility of the safe crossing of my young charges that sometimes I held them on the curb for too many minutes, waiting until not a car was in sight before I shepherded them between the fat white lines of the crosswalk. Part of my problem was Stephanie's fault, really: the image of the angel-girl hovered in my mind, and a foreknowledge of the suffering that parents and siblings felt when angels ascended. Eventually, the administration had to speak to me about my conscientiousness, as they put it. Perhaps the kidnapping helped focus them.

One morning, we saw a man drive a sedan slowly down the street, right past us. That wasn't unusual. Cars were supposed to slow down next to the school. But we witnessed an incredible thing. Inside the car, in the passenger's seat, was a Negro. It would be unusual enough to see a white man driving a car with a Negro passenger. But this was worse: the Negro man's head lolled back on the seat, as if he were asleep, or unconscious or *murdered*. Stephanie and I took down the license plate number.

We briefly discussed the possibilities and quickly arrived at the conclusion that this was foul play. Obviously, the white man had

kidnapped the Negro. If it wasn't too late—if he wasn't already dead, we could save him. When the first bell rang, signaling the end of our shift, we ran to the principal's office, arriving out of breath and agitated. We reported the crime, giving the license plate number and a description of the car. We were thanked and sent to our classroom. We never heard another word.

It just so happens that kidnapping was my worst fear. All of my nightmares featured a man in dark clothes trying to kidnap my mother, my sisters, my brother, and me. Once I dreamed that a kidnapper was tracking us through the White Front store. In the dreams, I had to save us. Either the adults weren't aware of the danger, or they didn't know what to do. I had to devise escape plans, shortcuts. I had to outthink the menacing man. If my father had been there, he would have saved us. But he never appeared in these dreams. So it was always up to me.

My mother gave us the usual warnings about strangers, but she didn't overdo it. Nevertheless I had a terror I couldn't explain. The problem with kidnappers was you couldn't tell them apart from regular people. In fact, they posed as regular people to lure children into black sedans, often offering them candy. What did they do with the children after they got them? Took them to vacant lots. After that, who knew? I didn't want to find out. I didn't want to be an angel.

Stephanie's family lived in a suburban housing tract about three-quarters of a mile from the Manor House Apartments, where we lived. I walked over in the afternoon and we did the usual things: talked, sang, cartwheeled, listened to records. Just before dinner, I left for home. But I got turned around in the tract and by the time I got to the highway, I was completely disoriented and walked in the wrong direction, farther and farther from home. Around dusk, feeling the panic rise from my stomach to my throat, I crossed the highway and went to a gas station. On the verge of tears, I asked the teenage boy who manned the pumps if I could use the phone.

"Got a dime?" he asked.

"No," I quavered.

"Sorry."

Ding-ding—a car pulled up to the pump and he walked away. I got back out on the highway and walked, crying in great heaving sobs, as it got darker and darker. Then the dreaded happened. A car pulled off the road beside me. It was the end of my life, I knew it. The car, a white station wagon, stopped, and a woman rolled down her window.

"Are you lost?" she asked, not in a friendly way, but not unfriendly either.

I nodded, unable to speak.

"Get in," she said. "I'll take you home."

I became hysterical, shaking my head.

"Get in," she said, again, impatiently.

"I'm not allowed to take rides from strangers," I stammered, backing away from her and her car.

Finally, she got out of the car, grabbed my arm, and guided me to her car. She made me get in the front passenger seat. The Negro and the angel were on my mind. Did they feel like this, right before they were to die?

"Look," she said. "I'm not kidnapping you. Look in the backseat. My car is full of groceries. I'm a mother. I have two kids, one about your age."

I thought of how kidnappers pretended they were just nice people trying to help you. It gave an edge to my hysteria.

"I'm taking you home," she said.

And she did, me crying all the way, even as she asked where I lived, even as she escorted me to the door of our apartment, knocking and saying to my mother, "Well, you sure have trained her well."

It was both a compliment and a criticism. What could my mother say? I recounted my journey, still sobbing, telling her about how quickly

the dusk turned to darkness, about the boy at the gas station and the groceries in the woman's car. I told my mother what I could, leaving out the angel and the Negro and the vacant lot of my imagination.

The next day, Urkel goes to the East Facility for a medical appointment. He returns with the news that during a national emergency, such as 9/11—which we are all calling it now—inmates can be executed.

"Where did you hear that?" I ask him.

"From a guy in Education," he says. "He said his teacher told the whole class, while they were watching the Twin Towers fall." Education classes include English as a Second Language, Adult Basic Education, and General Equivalency Diploma (GED) classes, along with my friend Emily's under-twenty-one program.

"That is not true," I tell Urkel. How could a teacher announce that to a class? I have no idea what the contingency plans are for inmates during a national emergency, but I am pretty sure mass execution is not one of them. I am not entirely sure, however. Someone like me—a non-custody staff member—would never hear about such contingencies.

"They should give us early release to go over and fight," Urkel says.

"Fight where?" I ask him. "We're not at war."

"Yet," he replies.

Preacher's patriotism is piqued, too. He starts on a painting of a fireman at Ground Zero. In the coming weeks in my poetry class, as well as the music and art classes I've added, I will hear inmates talk about how they wish they could fight for their country.

Urkel is right, of course. Within a month of 9/11, we are at war.

The announcement comes over the prison PA and lands in the middle of poetry workshop. No words, just whistling—a vexing teakettle, a Piccolo Pete. The officers have their metaphors too and

their institutional sense of humor. They are telling us that the United States has dropped its first bombs on Afghanistan.

In prison we are not unfamiliar with war. People get rolled up, locked down, walked off every day. Divisions nest deep inside us like multiplying Matryoshka dolls. On the yard, Norteños and Sureños are enemies, sex offenders have to fend for themselves, and everyone hates rats.

It's us against them: inmates and staff, officers and civilians, men and women, administration and field. Sometimes people cross the line: there's a teacher meaner than the goon squad, a convict who acts like a cop. We have to watch our backs. Before tonight, we who could leave, could leave the war inside the fence. Now it's loose again in the whole bloody world.

VII
MILK AND COOKIES

In the two years I've been working inside the iron city, I've discovered that there's a sickness, a cynicism that settles like fog around things. My job involves affirming my students' humanity. But I must do this without appearing soft or weak. The correctional officers call inmate programs like Education or Arts in Corrections "hug-a-thug." Criminals don't deserve programs. It is victims we should be concerned about, not these guys.

Arts in Corrections may be the most despised program in prison. Arts programs in schools have been cut. Officers' children go without art, music, and theater, but prisoners cash in on cultural capital. Media attention to the program and the prisoners in it makes matters worse. Newspaper and radio coverage should be directed not toward the scum of the earth, but toward the officers who, according to their union, walk the toughest beat in the state.

Some days there's so much hate I can almost see the hate-waves, can almost feel them touching the back of my neck, whispering in my ear, urging me to disappear. It's radioactive. Radios squawk, talk, coo distaste.

The officers in the Education complex are a different breed. I feel like we are on the same side—correction, as opposed to punishment. I wave to Officer Torkelson and Officer Zuniga before I unlock the door to my building on a brilliant spring morning. My work crew

files in after me. We sit down at the table in the main classroom for a brief meeting. We've been rehearsing for Poetry on the Road, a touring poetry show that will go from classroom to classroom in the Education complex. Some poetry students will recite their own work and some have chosen the work of famous poets.

"Our local radio station is coming to cover Poetry on the Road," I tell my crew. Even Urkel's eyes light up. He's not in the poetry class, but this is big news. If Arts in Correction is a lighthouse in the darkness, this is a perfect way to shine the light to other inmates and beyond. Many students in Education have heard rap songs, but probably not a poem recited without music behind it. And our local radio listeners will be surprised, I'm sure, by the beauty and the depth of the poems they hear.

"Okay, let's get to work," I say. I start unlocking doors and cabinets. The lighthouse dims as soon as I open the door to the computer room. I discover two of the machines are missing. Heart racing, I unlock the computer cabinets to perform a quick inventory. I can't see anything else gone, just the computers. Then I see a note that says the computers are on the East Facility for inspection.

I call my new boss, Ruth, the community resources manager. I've been here for two years and I'm grateful to have a supervisor who has come up through Education, who knows the value of inmate programs. She calls me back within minutes. "You're being investigated," she says, sympathetically.

"What?"

"The computer guy thinks that your inmates know more than you do about your systems. He asked the Goon Squad to seize them."

She means the Investigative Services Unit—both inmates and staff call them the Goon Squad, or Goonies for short. The institution's computer department will keep the computers until they determine if any wrongdoing has occurred. Inmate misuse of computers usually involves the Internet, but we have no Internet in our building. In

the past, however, inmates have somehow managed to make uncon-
nected computers connected. This is what the computer guy must
fear. He thinks Urkel is smarter than I am and that he's managed to
somehow make our graphic computers go live on the worldwide web.

Immediately I start to second-guess myself. Surely scandal and
punishment await me. Maybe Urkel had seen me typing in my pass-
word. Maybe I hadn't been careful enough. When a film editing
system crashed recently, I'd typed in the password and allowed him
to reinstall a program that had failed, instead of waiting for the com-
puter guy's people to make a visit to the West Facility to do it.

"The monkeys are running the zoo," my father said when people
in authority lost control. Usually he said that to my mother about
us kids when we got wild. Sometimes he said it about construction
workers on the job site. I do not want to be guilty of losing control. I
know Urkel dreams of taking my place in some parallel universe. But
I do not want inmates running Arts in Corrections.

At lunch, I meet Emily and we walk to the East Facility with her
friend—and my new friend—Liza, the supervisor of the Education
Department. Liza is a petite, freckled redhead, transplanted from
New York. She's a warmhearted, generous person who is outspoken
about her politics and scathing in her assessment of our workplace.
One of her favorite epitaphs is *idiot*—and she uses it frequently, with
no regard to the rank of the staff she's branding.

When I'm with Liza, I feel like we're Thelma and Louise—about to
do something radical.

"I'm being investigated," I confide.

"Oh, honey, I'm sorry," Liza says, rubbing my arm.

I smile weakly. What am I doing here, really? This is no place for
a woman like me, a woman who was once a bookish, sensitive girl.

Raven-like jabber and high-pitched cries entered my room through the open window. Kids playing down in the courtyard. I heard them, but their language did not decode itself. Instead, I listened to the soft strains of the piano that Beth played, and the exclamations of joy from Jo and Meg and Amy, and their praise of next-door neighbor Laurence—Laurie—and his rich grandfather who had given sweet and sickly Beth the piano. I cried because I'd read *Little Women* before and I knew that Beth would die and Laurie would fall in love with Amy instead of Jo, and Meg would leave home to marry.

Mom passed by and popped her head inside the room. "Still reading?"

"Umm hmmm," I replied. Sometimes I came here—to the room I shared with my sisters—up to the top bunk, with an apple or cookies and a book, and I'd fall into it. I'd go to Victorian New England, the Civil War south, Russia, France, and I'd stay in there and wouldn't even see the light steal away or the dusk sneak in. My mother would flip on the light when that happened and tell me not to read in the dark.

"I didn't know I was," I'd say.

If our apartment caught on fire—say Brad was playing with matches—and I knew all the people were safe, Mom and Dad and Bonnie-Terri-and-Brad, and our dog Josephine, and our hamster Henry, and I could grab only one thing, what would it be? This book, *Little Women*, the unabridged version, hardback covered with green flowered cloth. It was a gift from my mother's cousin Judee. I brought it home from our visit to Mom's family in Massachusetts. There was a magic about it, because it was old; Judee got it when she was a girl. And it was from Massachusetts, the very place Louisa May Alcott lived and wrote about! I could not touch the book without a little thrill of history coming into me.

But if I had time, I'd also grab the yellow paperback abridged *Little Women*, because the pictures of Jo and Meg and Beth and Amy

on the cover looked like the pictures in my mind. And they kind
of looked like us. I was astonished at how similar the March girls
were to my sisters and me. Bonnie was Meg, the luxury-loving sister,
always wanting what the family can't afford. Terri was Amy, beauti-
ful and a little spoiled, because she was the youngest girl.

Both of them had a little bit of Beth in them: Bonnie was so good-
hearted, her name even *meant* good! And she loved animals. That's
how we got the hamsters, Herman, who Brad squished to death—
accidentally—chasing him down the hall, and Henry. And she could
work on Dad's soft spot about dogs, so we always had a dog in the
house. Terri was like Beth, too, fragile, sensitive, almost ethereal. Me,
I was Jo, the wild one, the writer, the independent one, although in
my imagination, I looked more like Amy.

And I would grab the poem Nonny wrote me. First I'd sent her a
letter, telling her that soon we would be moving back to California,
and that I was working on a book of stories. I enclosed my new poem,
"A Bird Finds a Home," which began, "In the ruins of Rome / A bird
finds a home / In the palms of Aphrodite / Overlooking the statue of
Apollo / high and mighty." It was a sad poem, because the bird had a
broken leg and, eventually, it froze to death, which caused Aphrodite
to cry, even though she was a statue and statues can't cry. I asked
Nonny to really criticize it, because she wrote poems too. And she
was very good at criticizing.

The letter I received in response was written in verse:

> I can't begin to tell you
> how very pleased I was
> To get your darling letter
> and all the news, because
>
> We miss you most sincerely
> but happy now to hear

That soon you may be packing
and be back with us this year.

I truly hope I'll have the chance
(and will, by hook or crook)
To read the story that you wrote
just think—your very own book

I'll bet it's good—you write real well
we're all so proud of you
To be so smart is simply swell
so excel in all you do

Your poem was sweet
and clever, too
And this I must confess
writing poetry is a fad
And one I like the best.

So Debby, dear—my thanks to you
for brightening up my day
I loved the poems and picture, too
and now I'll have to say

So long, for now, and remember me
to Bonnie, Terri and Brad
And, of course, last but not least,
your wonderful Mummy and Dad.

Nonny liked my poem, so it must have been good. She thought of
me as a writer, that's why she sent me my own stationery, which had
"Debby's Daily Doin's" engraved on the top of each sheet. It was one

of my favorite birthday presents. I really was like Jo. Even Nonny thought so.

My love for *Little Women* wasn't just because I can see my family in it. Until I read the book, I didn't know there were stories like that— that someone wrote about girls and the families they grew up in. It gave me an appetite and Mom took me to the library and I found everything written by Louisa May Alcott. And when I was finished with all of those books, I read the story of her life, so much like the life she describes in *Little Women*. And then I read the stories of other lives, Clara Barton, a brave nurse. Anna Pavlova, a prima ballerina. Marie Curie, who discovered radium.

To Dance, To Dream was the story of Anna Pavlova's life. I dreamed about my life. I wanted to be like them. I wanted to do something important in the world. I wanted to be brave and strong and independent. I dreamed and dreamed.

I'm not sure what the investigation involves, aside from running tests on the computers. Will they interview people? Inmates? I try not to worry about it. Urkel mopes around because his toys—or tools—are gone. But today is Poetry on the Road. Our poets assemble in Arts in Corrections, most of them wearing freshly pressed blue shirts, tucked in. Schedule in hand, I usher them out and lock the door behind me.

The poets perform in three classrooms, riding Neruda's river on a little boat of nostalgia, riding on a craft of black pride, riding in a shipwreck of loss and longing. Some poets make the other prisoners laugh, some cause the teachers to pause and look up. We pass the guard shack with its metal detector the prisoners must pass through daily.

"What about us? What if we want to hear poetry too?" Officer Torkelson asks.

Still high on performing, the poets look anxiously at one another, step back. Slowly, they form a semicircle around the shack, each stepping forward when it's his turn. The new student paws at the ground, fairly snorting his contempt. Like a prizefighter, he delivers his punches with fluid elegance, reciting from Che Guevara: "Don't think that they can make us tremble, armed with gifts and decorations. We want a rifle, bullets, a stick. Nothing more." Officer Zuniga raises an eyebrow.

When another poet exhorts the guards not to "go gentle into that good night," silence hangs on to *night* and for a split second, the business of prison—inmates shouting, a barked order, wheels and welding torches and prison intercom—fades to this silence held by guards and poets, who have never talked, never listened this way. Stiff thank yous and the poets turn away, relieved to be done.

"Wait a minute," says Officer Torkelson. He bends down for a big box; he invites each poet to take a carton of milk and a cookie. Recalling the lines he's just recited, the fighter cries, "I don't want no milk and cookies! I ain't their bitch!"

The other poets pull him aside, tell him to eat. Later, he will christen himself Big Bad Ass Poet, walk the yard reciting his own words, taking his listeners to the raw wilderness he discovers inside. But now he takes one bite of cookie, an uneasy communion in the chapel of the metal detector, guards watching as he eats.

VIII

LOCKDOWN

I run into Alejandro on the East Facility one morning near the Watch Office. It's been almost two years since he was rolled up and sent here from the West. He tells me he's being deported to Mexico. His mother brought him to this country as a baby, so he is an illegal immigrant. I look at him, worry in my eyes. He doesn't know anyone in Mexico, doesn't speak the language. What's going to happen to him? "I'll be all right," he says, adding, "I wish I could hug you."

"Me too," I say. I want to give him a mother's hug, to envelop him in an embrace that transmits hope, courage, faith. If I had known his whole story at that point, I would have hugged him. But since we were in the corridor outside the Watch Office, two things would have happened if I had. He would have been gaffled up—roughly seized and handcuffed—and sent to the Hole. And I would have been "walked off"—escorted off the prison grounds in a humiliating march, for "overfamiliarity," an infraction (and sometimes a crime, depending on *how* overfamiliar you are) that teachers and people like me are continually warned about.

I do not hug Alejandro. Instead I take a step back. "Keep writing," I say. "Promise you'll keep writing."

When I get back to my office on the West, I call Emily and tell her I saw Alejandro. "Are you coming for lunch?" I ask her. She usually

does. We eat and talk writing and art and prison politics and real-world politics on our lunch break, which coincides with when the inmates are at chow. We could be eating in the Education break room, with a gang of teachers, but we'd rather eat in my office in Arts in Corrections, surrounded by inmate art and books, with a view of the hummingbird that frequents the blue potato vine just outside my window.

As soon as I hang up, my boss Ruth calls me and tells me my computers are on the way back. The investigation is finished. They— the Goon Squad and the computer guy—found no serious wrongdoing on my part. The fact that I had Urkel reinstall a crashed program from a disk without the computer guy's oversight was an infraction, but they found no porn, no Internet activity, no alterations of programs. The monkeys haven't been running the zoo after all. We will get our computers back just in time to make an institutional film about the nonsmoking policy that will soon hit the prison and cause untold tribulation.

A few weeks ago I heard through the prison grapevine that the inmates who worked for the computer guy were in the Hole. They were sent there after an audit by a team from Sacramento. Every year all departments in the prison are audited. This audit found that the computer guy's inmates, who were the *only* inmates who had Internet access, had downloaded porn and somehow gotten into our staff payroll information. So they all went to the Hole. I'm sure the computer guy did not get in trouble. What would the institution do without him? He is probably the only staff member who cannot be replaced with a snap of the fingers. Including the warden.

I am interviewing for a new creative writing clerk. By now, more than two years into my job, Arts in Corrections has gained some cachet.

Many inmates apply for job openings, partly because of the pay but also because of the vibe. Even Mr. Robinson, the chief deputy warden, said he noticed a spiritual energy when he stepped into the building. Yes, Arts in Corrections is a lighthouse in a sea of darkness.

Razor, a student in my poetry class, wants to work for me. He subscribes to the *New Yorker*, memorizes his favorite poems, but he scares other inmates. He radiates an intensity that pulses through the skin of his workingman's frame.

One morning Razor comes to the Arts in Corrections building for his job interview. Hanging from a bulletin board in the classroom is a quote of his from an assignment in Creativity 101. Razor took that class back in my first days teaching, and he has taken the poetry class ever since.

The question I asked the students was "What do I ask of art?" Razor's written response was: "I ask to be *shown* something new, to be *taught* something remarkable, extraordinary, something imposing, maybe even majestic, primarily about myself. I want and I seek earnestly, almost desperately some thing decidedly unique and special and intelligent from within myself, some thing that must—*must*—be percolating from a soul that is, say dank by dint of despair too much; to see, to understand a light, an illumination, an elucidation of this too often aphotic (having no light) sorry-assed quandary we all are voluntarily party to, party of, this kettle of fish more commonly known as the human condition."

"Wow!" I said after he read it aloud to the class. "This is poetry."

When Razor wrote "dank by dint of despair too much," I knew he was alluding to Etheridge Knight, whose poetry I'd brought into class. A celebrated black poet, Knight began writing in Indiana State Prison in 1960 after being convicted of robbery (to support a drug habit). I brought Knight's poem "Various Protestations from Various People" to our class. It begins, "Esther say I drink too much. / Mama say pray dont think too much, / My shrink he say I feel too much, /

And the cops say I steal too much . . ." I especially appreciated this choice because Razor might otherwise seem like the stereotypical redneck, a long-haul trucker who probably wore a cowboy hat before he came here, but his passion for the word, for good poetry, transcends race. In prison that is a big deal.

Razor gets $50 a month in his vocational job, but he says he'll take a cut in pay to read poetry, police the art department, and memorize whatever beauty he can find here. If my only criteria for hiring a creative writing clerk were a passion for poetry, I'd hire him on the spot. And I like him. But it's more complicated than that.

After Razor leaves, Urkel shakes his head like an admonishing elder, although he's ten years younger than me. Urkel tells me that Razor is angry because he has ten more years to serve. "Get over it!" Urkel says, adding, "He's lucky. He got off easy, for what he did."

"What did he do?" I ask.

"Double murder. He shot his wife, got in his truck, and drove three hundred miles and shot her boyfriend."

In my family, it was the equivalent of the shot heard 'round the world. It was the Christmas Eve before we moved to Florida. Was it the same Christmas Eve that Grandpa, my dad's father, in Santa Claus garb, held dozens of children on his lap and passed out presents at the Elks Club? How many children felt Santa's hands clutch their private parts as he asked, "Have you been good? What do you want Santa to bring you?" Or maybe he did that only to his grandchildren.

He did it to me, Bonnie, and Terri, and it hurt. He pulled us onto his lap and rubbed us roughly. And it wasn't just at Christmastime. I put up with it because I wanted him to like me best. My sisters didn't care if he liked them and they avoided him, following our mother's advice, "Don't sit on his lap and don't tell your dad." She said this

after Bonnie told her what Grandpa did when she sat on his lap. We were to avoid my grandfather and not talk about what he did, the same advice my mother had gotten when she was a girl and a man in a wheelchair wanted her to sit in his lap so he could fondle her.

The reason she didn't want us to tell Dad, I understood later, was that she was afraid my father would kill my grandfather. Or if not kill him, hurt him badly. These kinds of things were handled in the family back then. It wasn't against the law to fondle a relative. So Grandpa wouldn't have gone to prison for sexually violating his granddaughters. But my father could have gone to prison for assaulting or murdering his father.

When this happened, we were still living with my dad's parents on Genoa Street in Lancaster. Recently Grandma had found me in my nightgown in the kitchen in the middle of the night. She was a night wanderer, awakened by pain from arthritis. Her translucent skin and coppery hair glowed in the reflection of the kitchen nightlight. "What are you doing?" she asked, realizing I'd been sleepwalking again. Then I became fully awake, mute, puzzled. Somehow I'd climbed onto the kitchen counter during my journey. I'd clutched the curtains. At least I didn't jump on the bed and wake up my sisters like I did last time. Grandma took me back to bed and tenderly tucked me in.

During this time, I just thought, *Grandpa can do whatever he wants because he's Grandpa.* Grandpa was charismatic and funny, but he had a mean streak too. He was known for his cooking and his parties, where he lavished friends with food and booze. Grandpa drank beer, but there was always a bottle of Beefeater's gin on the kitchen counter and a six-pack of Schweppes tonic in the refrigerator. At home he was king. He owned everything and everyone, especially girls and women. Even women who were related to him by marriage, not blood.

There was a fault line in our family, a clash of imported immigrant

cultures. My maternal grandmother, Nonny, was born in Sweden and came to America in 1912 as three-year-old Marta. Everyone on that side of the family had wonderful, exotic names like Maja, Signe, and Dagmar. For some reason my grandmother changed her name to Martha when she got older.

My father's grandparents had come over from Bohemia five years earlier than my Swedish relatives. Dad called my mother's family the Matriarchy. Nonny's mother, Big Nonny, had immigrated with her sisters and their husbands along with her own husband and two children. They all settled in and around Boston. Big Nonny's husband worked in the shipyards and before long they were able to purchase a large home. They grew vegetables and raised chickens, pigs, and goats. Apparently Big Nonny called the shots, but in an elegant, understated way.

We never saw Big Nonny and her sisters and their families because they lived on the East Coast. My mother and Nonny had moved to California in 1953, a year before my parents met. So we didn't get to actually see women running the show. But it was in our DNA. One thing I learned early on from my mother was that there is never an excuse for bad manners. The Bohemian side of the family wasn't as concerned about manners.

I did not recognize my mother's quiet strength and wisdom for a long time. It was overshadowed by my father's confidence and joie de vivre. He and I met on the plane of dreams and ideas, while my mother devoted herself to the pragmatic details of survival—graciously. Early on I realized that Bonnie and Terri were part of the Matriarchy, while Brad and I were claimed by the Patriarchy, the rough-and-tumble Eastern Europeans. Unlike my sisters, I wasn't afraid of the men when they had loud arguments about politics. I was drawn to their stories, peppered with fist-pounding and profanities. Brad belonged there because he was a boy and I because I was Daddy's girl and Grandpa's favorite granddaughter. He cried when I was born.

He said I looked just like his mother, Anna. According to my father, his grandmother Anna would chase him and my uncle Don with a broom, swearing in Czech, "You kids, you goddamn kids!"

The Patriarchy demanded obedience to men. It didn't matter if the man was drunk or sober, if he was about to quit a good job to go sell vacuum cleaners in Fresno, if he wanted to trade in a perfectly good car for a shinier model. The men's word was law. Maybe I wanted that kind of authority for myself. I wanted to be the one out selling vacuum cleaners instead of the one home vacuuming. I wanted to be the one who came home with stories about the world outside our home.

When Grandma Tobola tried to teach me, at eight years old, how to make beds with "hospital corners," I told her I didn't need to know. "I'm not the type," I said. All of the adults thought this was hilarious. I was a girl, so of course I was the type. Period. But even at a young age, I sensed a different destiny than that of my mother and Grandma. My alliance with the men in the family put me in a difficult position. In most ways I identified with them more than the women. And they treated me like one of them, called me a Bohunk, which they never called Bonnie or Terri. I was the only girl accepted into the tribe.

But when it came to sitting on Grandpa's lap, I lost my individuality. I was no one. I could be any girl with something to fondle. And my grandfather's violation wasn't just momentary. It would reach down through decades and leave an imprint on my intimate relationships. If love meant losing my sense of self, a part of me would always remain on guard.

December in the southern California desert is cold and clear, sometimes with a dusting of snow. Look anywhere and it's flat. My mother's brother, Uncle Dick, and his family, lived in Lancaster too. We'd all been invited to my aunt and uncle's house for Christmas Eve dessert. My aunt Diane was different than the other women in the family. That night I learned just how different. I liked going to

their house. I admired Aunt Diane. She was a nurse and wore all white, from head to foot, when she went to work. If she told you to do something, you did it. Uncle Dick was funny, always kidding around. I loved to watch him make my mother laugh. Uncle Dick and Aunt Diane had two kids, Kimmie, my brother's age, and David, a baby.

The dessert was some kind of cake with dribbles of chocolate on it. I'd never seen anything like it before and helped myself to seconds. All of the adults were happy, drinking and laughing and talking. And then came the Slap. There was a mistletoe hanging from a red ribbon attached to the living room ceiling. They were standing under it when Aunt Diane slapped Grandpa across the face and called him a dirty old man. Later I heard someone say, "He slipped her the tongue." I didn't know what that meant, but I did know that Grandpa did things that he should be slapped for. I couldn't slap him because I was a kid. Only an adult could do it. But no one was brave enough—except for Aunt Diane.

After the Slap, everything changed. For a split second, no one moved, like a freeze frame in a movie. I stood transfixed. When I'd read *Little Women* earlier that year, I'd realized, *Oh, you can do this. You can write about girls.* But now it was, *Oh, you can do this. You can slap a man who breaks into you.*

Suddenly the spell was broken and the adults started moving again. The party was over. We left.

After she slapped Grandpa, suspicion about Aunt Diane turned to accusation, condemnation, and finally conviction. First, there was the problem of her job: it wasn't just a job, it was a career and she kept getting promoted, from nurse to head nurse, to psychiatric RN. Then there was the fact that Uncle Dick made the kids' breakfasts and lunches. Uncle Dick worked days at the Air Force base and Aunt Diane worked swing shifts, so it made sense. But it wasn't natural. Of course everyone knew who wore the pants in the family, pussy-whipped they called it. The men said they felt sorry for Uncle Dick.

Aunt Diane was also interested in things like hypnosis, yoga, and meditation. Worse, she became close with a large caftan-wearing woman named Dora. Her weird hobbies, her strange alliance with a woman outside the family, her lack of maternal instinct, her earning capacity, her ambition—there was plenty of evidence against her, according to the men. After she slapped Grandpa, the men decided she was a lesbian. The women remained silent.

I figured it out after a while. Aunt Diane wasn't "the type" either. She wasn't going to just "go along with the program," as my father would say about cowardly men on the job. And why should she? Even if she was a nurse, I doubt she made the bed with hospital corners. Maybe Uncle Dick made the beds. And if he did, what was wrong with that? Aunt Diane became my hero. She wouldn't just avoid Grandpa and not say anything. She was the author of the Slap, the act that filled my lungs with air and helped me to learn the sound of my own voice.

Maybe I should hire Razor. Some of the teachers say that murderers make the best workers. The reasoning goes that most murders are crimes of passion, not premeditated killings. A murderer isn't necessarily a man with a criminal lifestyle. Maybe he just made one bad mistake. Or in Razor's case, two bad mistakes.

Would it be that bad if the other inmates were a little intimidated? After all, the inmates who work for me know that part of their job is to make sure students don't walk off with supplies, get into fights, or do anything that threatens the program. Razor would be pretty good at that.

After I release my work crew for chow, I go to the prison records office to look at Razor's jacket. In prison a jacket means one of three things: an institution-issue denim coat, an inmate's C-file, or the story he tells to other inmates about why he's in prison.

I look over Razor's C-file and take in the details of his crimes, which kill the appetite for anything a body could desire. Is this the right file? I check the photo in the back to make sure. It's Razor's bulldog face, younger and with more hair.

I turn to the police report, a short story, third-person omniscient cop-narrator. All the action happens in the tight frame of Razor's arrest, with frequent flashbacks. Like all tragedies, the past foretells the future. If only his father hadn't touched him. Caught, he confesses everything. There are no murders here. It's sexual abuse. Reading, I become his daughters, ashamed, afraid, as he bullies and bribes. My gut clenches. I want to throw up. I want to cry. If only he were a double murderer.

Razor's story of why he's in prison could be admirable to other inmates. "Hell yeah, I'd kill the bitch too!" But the truth is much sadder. What about his daughters? They are not dead, except for the part of them that trusts men wholeheartedly.

I step out of the records room and into a neon noon. Everything is dead. There are no inmates to be seen. The yard is eerily quiet. I unlock the gate and then the building and then my office. It's a ghost prison, inmates disappeared into dorms. I call Officer Torkelson, who confirms a lockdown. "What happened?" I ask him.

"Somebody saw a guy in blue jeans and a work shirt walking along the highway, so they called an emergency count."

As if any man in blue jeans and a work shirt could be one of ours.

IX

BLOSSOM

I did not hire Razor for the creative writing position, a decision I would come to regret in the next few years. Despite my feelings about his crime, I am certain that what would end up happening in the program would not have happened if he had been working for me. Instead I hire Damian, a radio shock jock from New Jersey. The inmates call him DJ. He's a minor celebrity at CMC, although I have never heard of him. I don't listen to that kind of radio.

In my interview with him, he tells me he's in for rape, but he didn't do it. A vindictive woman accused him of the crime. He took it to a jury trial and lost. Maybe he figures that I'll check his file, so he preempts me by telling me first. When I do read his C-file, it's full of letters from fans, family members, friends, and colleagues.

DJ is short and squat, a bulldog of a man, with a big mouth. His blond hair is buzzed into a crew cut. He is very smart and a good writer. But his penchant for making smart-ass comments does not go over well with me. Yesterday one of my poetry students, Snappy, got a pass from his teacher to come to Arts in Corrections to talk to me.

"I have to drop out of class," he tells me.

"Why? Your writing is getting better and better. You just won third-place in the poetry contest!"

"That's the problem," Snappy tells me. He's a young Hispanic inmate who works for Vocational Landscaping. He loves his job, which unlike some vocational programs—shoe repair, for example—can lead to a job on the outside. "You know those certificates we got?"

I nod. Each first- through third-place winner got a certificate with his name and the title of his poem.

"Yeah, well the guys in the dorm are ragging on me. They said you go into Arts in Corrections *Snappy* and you come out *Blossom*. Now they're all calling me Blossom. I can't do this no more."

"I'm sorry to hear this. Let me know if you change your mind."

DJ has overheard the conversation and after Snappy leaves, he says, "No big loss. He's a few cans short of a six-pack anyway."

"Look, you're not on the radio anymore," I tell him. "We want to make people feel welcome here, not drive them away. Remember when your mother said, 'If you can't say something nice, don't say anything at all'?"

"My mother never said that."

"Well mine did. You ought to try it."

For the next few weeks he practices an hour a day of self-imposed silence. I don't know how much it helps him, but it's a relief for me and the four-man crew, which also includes Thad Hakamada, the painting clerk. Thad's C-file is as thick as a phone book, reflecting almost thirty years in prison.

Thad got addicted to cocaine as a young man and supported his habit by stealing. A short, slight Filipino man with graying hair, he's soft-spoken and polite. He's a skilled artist and a steadying influence on the younger, more impetuous inmates, especially Urkel and DJ.

"Urkel is just a horrible, horrible person," Tab announces as he comes into my office. I hired Tab a month ago to be my music clerk. He's a slender, balding gay man who I can't send to the Blue Building because the lieutenant there read him the riot act after he filed a 602 (the form inmates use to complain about prison conditions, decisions,

or staff). Apparently the lieutenant called him a fucking inmate and told him never to set foot in there again. So he won't.

Now he sits across from my desk, adjusts his wire-rimmed glasses, and makes a confession. "I don't really belong here," he says. It's not the first time I've heard a version of this and it won't be the last. Who wants to think he belongs in a state prison? Tab goes on at length about his work as a pianist in an upscale nightclub in San Francisco, his education and upbringing, how his mother works as a matchmaker for the city's elite, how he didn't know the young man he slept with was *that* young, how . . . he doesn't really belong here.

I listen and then scribble something down on a tablet of sticky notes, tear off a sheet, and give it to him. "Every time that thought enters your head, read this," I say. He reads it aloud, "And yet, here I am." He sighs, stares at a spot behind my head, and finally nods.

Tab has taken my "be here now" note to heart and he takes his job seriously, which showed last week when the Arts in Corrections Music Ensemble performed at the graduation ceremony on the West. They did three songs by Santana, Keb Mo, and Bob Dylan— "Corazon Espinado," "Better Man," and "I Shall Be Released," representing the three primary races in prison. I insisted on "I Shall Be Released," which featured bilingual solo verses by white, black, and Hispanic inmates, a great sax solo, and all of the band members singing the chorus. I was so proud of these men I was on the verge of tears. And then Tab made me cry.

After their last song, one of the teachers asked the bandleader to introduce the musicians. Tab stepped from the piano to the microphone and started crying. He wasn't crying with pride at how he'd gotten this ragtag ensemble of musicians to sound like a professional band, like I was. No, he was crying because he was moved by the accomplishment of the students receiving GEDs and vocational certificates. "I know a lot of them never would have done that on the outside," he told me later.

Tab got a lot of razzing for his graduation day tears, especially from DJ. "I'm sorry, I'm a wuss," he told his workmates. Urkel rolled his eyes. DJ smirked. Thad said, "Hey, don't worry about it."

I tell my work crew that they will be getting "S" time for a few days—days off authorized by the institution for times when workers cannot report to their workplaces for various reasons. I've been called to a meeting in Sacramento with all of the other artist/facilitators in the state. The men all look disappointed. They like coming to work.

I've heard that the meeting has to do with the budget. I know it's bad. The news has been full of California's dire financial straits. University tuition is rising while K–12 school funding is getting slashed. The state is broke, but not too broke to give correctional officers a 7 percent raise, the first in a five-year compensation plan that will increase their wages by 37 percent.

I am lucky to still have a job. That's the message my colleagues and I receive in Sacramento. I take it to heart. Now Dylan is with me, finishing school at Morro Bay High. I've asked my mother, who just retired from the Los Angeles County Department of Public Social Services in Lancaster to come and help me out. We find a large house near the beach for an affordable rent and just in time. Our household recently expanded even more when my son Joseph arrived with his girlfriend and their new baby to stay for a time. My grandson and I begin a tradition of greeting each new day with a litany of good mornings—to the sky; to the sun; to the trees; to the flowers; to Rascal, the dog; to the cereal and the cereal bowl; to the music on the radio . . . It was a bookend to *Goodnight Moon*, which I read him, as well as his father and his uncle before him. I need to keep this ship afloat in Morro Bay.

We are told that effective immediately, Arts in Corrections has no

budget for contract artists, the artists who teach classes. Previously a stand-alone program, Arts in Corrections will now be part of Education. We artist/facilitators have two weeks to implement a new program called Bridging, an independent study program which involves meeting with fifty-four random inmates weekly and sending them back to their dorms with homework assignments. We are responsible for creating the curriculum and launching the program. Then the teachers will also take on Bridging. So we will create the blueprint, launch it, work out the kinks, and then the teachers will come in.

I don't know which bureaucrat in Sacramento dreamed up this plan, but it accomplishes three things at once. First, letting inmates out early helps with prison overcrowding, which has gotten worse since voters passed the three-strikes law in 1994. The three-strikes law sent anyone with two prior felonies (no matter how minor or how long ago) to prison for twenty-five years to life. Some inmates are serving life sentences for shoplifting, stealing a bicycle, and, in one man's case, a single piece of pizza. The students who participate (show up and do their homework) in Bridging will get "day for day credit" like the students in regular Academic and Vocational classes. For each day they participate, a day will get shaved off their prison sentence. Although Bridging is a band-aid on overcrowding, at least it's a move in the right direction.

Second, it will help the Education Department statewide prove its raison d'être. It's a numbers game—the more inmates Education can run through Academic, Vocational, and Bridging programs, the more indispensable they are to the prison system. The third accomplishment, almost an afterthought, is saving the jobs of artist/facilitators.

Now my friend Liza, the supervisor of Education, is my boss. When I get back from Sacramento, I tell her I can still run Arts in Corrections, offer classes on the West Facility, and do special

events like poetry festivals and concerts. Basically I have the same job as before, but without contract artists, and with the addition of Bridging, which involves more paperwork than actual instruction. Losing contract artists is a huge hit to Arts in Corrections. I have to fire visual artists, musicians, theater teachers, and creative writers (nine in all, who teach weekly on the East and the West). And I have to cancel contracts of visiting artists who would have come from other cities in California to share their gifts with inmates. Earlier this year, the beloved author Victor Villaseñor was a guest artist. He read from his book *Rain of Gold* and answered questions afterward. It is more difficult to engage Mexican inmates in Arts in Corrections because, as in Snappy's case, the arts are seen as "sissy." But the night Victor Villaseñor came, all of that was forgotten. The visiting room, where his reading was held, was filled with Mexican inmates, many of whom thanked me profusely afterward.

Of course contract artists (and most guest artists) are not famous like Victor Villaseñor or the Drifters. But all of them bring with them a much-prized attribute for people doing time (and their overseers), which is that sense of just having breezed in from the Real World, a kind of breathless energy that invigorates the static atmosphere of prison. Now it was just me and the inmates.

Being part of Education is in some ways an uneasy fit. Although my best friends here are Emily and Liza, and I have cordial relationships with most of the teachers and supervisors, I am Cinderella. My stepsisters and stepbrothers have secretaries who write memos for them, make copies, order supplies, reconcile budgets, conduct inventories, and type up inmate chronos, brief reports noting accomplishments or disciplinary action. I do all of that myself. My colleagues and I are actually arts administrators as well as instructors. We are also our own secretaries.

Although not as powerful as CCPOA, teachers have a pretty strong union. Artist/facilitators are part of the Service Employees

International Union, which represents a couple of million people. The thirty artist/facilitators statewide don't have enough juice to get the pay increases our Education colleagues get. By the time I retire, some teachers are making up to $120,000 a year, more than twice as much as artist/facilitators.

"Whoever said it would be easy? Whoever said it would be fair?" That was my father's mantra. It's not easy and it's not fair, but I love my job. At least they're not cutting my supply budget, which means I can keep adding to the literary library I've started in Arts in Corrections. Literary novels, short story collections, and poetry are in short supply in the Education library, which exists only because of a law that mandates inmate access to legal resources—law libraries.

Emily is in my office for lunch and I show her the list of the books I'm ordering: *Man's Search for Meaning, The Old Man and the Sea, Grapes of Wrath, Main Street, One Hundred Years of Solitude, 1984,* and poetry by Stevens, Poe, Plath, Dickinson, Ginsberg, Clifton, Bishop, Neruda, and Yeats.

"Only the best," I say to Emily. "I tell my creative writing students, 'Garbage in, garbage out.' If you want to write well, you have to read well. By the way, did you know the Education library has a lot of Danielle Steel novels?"

"Soft porn," she replies. "Not that I've read any."

"Of course not. But it could be Steel's backstory too, not just the steamy sex scenes. She married two ex-cons."

"Who told you that?" Emily asks.

"An inmate."

"You'd better Google it."

"Check this out." I hand her a poem.

Attention on the Yard

We are all guilty. Ribbons of barbed wire
curled atop fences remind us we cannot
be trusted. A voice from the tower tells us
we can use the phone if someone is willing
to pay. Twilight on the yard: rap radio
slap of dominoes. We watch the homely
librarian leave, locking up her meager store.
One story bleeds into another, all stitched
together by hard luck. Screwed by the system,
we know people who've done worse and
gotten away with it. Seeking bliss
we've created misery—prayed to cocaine
surrendered to methamphetamine
gone down for the high. We have robbed
children of their childhood, women of
their womanhood, men of their manhood.
We have dishonored our families and our tribes
and they have hidden us here. But only for
our own salvation have we given false testimony.
Darkness hovers around us. We are herded
back to our buildings, our narrow bunks,
where we pray for freedom and dream of shedding
the numbers that have replaced our names. Ghosts
of people we've known, people we've been, tremble
in the air above us as we sleep—sleep—
our healing, fleeting voyage back to innocence.

"Good poem. Who wrote it?"

"I wrote it about ten years ago, when I was teaching at the prison in Tehachapi. I brought it into my poetry class last night and one of my students said that he'd already heard this poem. His bunkie wrote it."

We laugh.

"Yeah, I'll Google Danielle Steel," I tell her. "But even if it's true, and she's the favorite author of inmates worldwide, I will not order Danielle Steel or any other romance novels for the Arts in Corrections library."

It was Uncle Don who wrote my epitaph when I was twelve. We'd just returned from Florida and were living again with Grandma and Grandpa in Lancaster. They'd moved to a different house. One day I was lying on the couch reading when Uncle Don passed by me, on his way from the bathroom to the kitchen table, where the men were gathered.

"Whaddya doin' Deb?" he asked me good-naturedly.

"Reading," I mumbled.

"Whaddya reading?"

"Shakespeare." I knew the moment the word was out of my mouth that it would be kindling for conversational fire.

The kitchen blended into the dining area, which blended into the living room, in the way of 1960s suburban tract houses. When I looked up from my book, I could see all of the actors in the domestic drama, which at times rivaled even Shakespeare's.

"Didja hear that?" Uncle Don said, a little slurry even though it was early afternoon. "Debby's reading Shakespeare!"

"Shakespeare!" Grandpa took up the cry. "Shakespeare!"

I eyed them surreptitiously, curious to see where Shakespeare would lead them, but at the same time my heart was pounding. Anything could happen. I'd seen it a hundred times before. They'd start out with a seemingly innocent subject—income taxes, for example—and end up cussing and yelling and sometimes even fighting.

Sometimes you could see it coming. If someone brought up

Governor Reagan, or Republicans in general, the Teamsters Union, free love, the Viet Nam War, or women's libbers, that meant someone was spoiling for a fight. Then you had time to get ready. For Bonnie and Terri, that meant leaving the vicinity as quickly and as unobtrusively as possible. For me, it meant sticking around to watch and sometimes, if I got caught up in it, throwing in my two cents, even if I wasn't sure of what I was talking about. Brad had to watch because someday he would become part of it. He had to learn the rules.

How different the men were from the women. I knew the women must have disagreements, especially when so many of us were crowded into one house. But if they did, they handled them privately, somewhere in the back of the house and not at the kitchen table. Maybe that's why I gravitated to the men: the need for a kitchen table to pound my fist on during a political argument. Ideas flying around, leaving trails of light. I couldn't resist.

That wasn't why I was reading Shakespeare, exactly. I was reading him because of Louisa May Alcott, whose life I wanted to live. I would grow up to be a writer with an attic room and cut my hair to save my family. Someday I would meet Professor Baher and we'd open an orphanage for boys. Or a version of that. I had to read Shakespeare, the greatest writer who ever lived, in order to become one myself. I had to make sure he hadn't already written what I wanted to write. I didn't know what that was yet—or what I wanted to write—but I would recognize it when I saw it.

"Who the hell is Shakespeare?" Grandpa teased.

Dad was the only other person in the house who'd read Shakespeare. He went easy on me this time.

"It's about time you started reading the good stuff. But I don't want to hear your miserable opinion until you've read Hemingway, Steinbeck . . ."

". . . and Sinclair Lewis, I know," I finished for him.

Then Uncle Don, in a philosophical mood, looked over at Bonnie

and Terri, who were playing double solitaire on the living room floor, and then at me.

"Someday Bonnie and Terri are going to be Miss America," he observed. "And Debby . . . well, she's smart."

Oh my God! Someone had said it out loud. I was crushed and relieved at the same time. I suspected that I would never grow out of my baby fat, that my head would get squarer each day, like Dad's (who we called Fred Flintstone, behind his back), and that my eyes would get more and more deep-set until they virtually disappeared. I'd be so ugly no boy would ever ask me out, no man would ever marry me.

My mother was beautiful; Dad called her "a thing of beauty." He never called her Joanne, her real name. He called her "honey," or her nickname, "Bonnie," which is where my sister got her name. Mom had dark hair and high cheekbones. When she and Dad went out, she put lipstick on and colored her cheeks. I would never be beautiful like her.

My sister Bonnie was pretty, too, with her brown naturally curly hair and heart-shaped face. Terri was beautiful, with big eyes, a pouty little mouth, and hair in between my blonde color and Bonnie's brown. She already had boys following her home from school and she was only in second grade!

But that's not the only thing Uncle Don was saying. In family code he was saying, "Yeah, Bonnie and Terri will grow up and be normal. But watch out for Debby. She's trouble."

"She sure is smart," Grandpa said.

"And you know what the smartest thing about her is?" Dad asked them, looking at me. He paused a moment for dramatic effect and then pointed his finger at me: "Her mouth."

"I must take after you then," I said.

"See what I mean?" he said to Grandpa and Uncle Don.

Which was Dad's way of saying, "If you're smart and you're a

woman, you're better off keeping your mouth shut. But I hope you don't, goddamn it, because you are *my* daughter."

Thus I cultivated my voice and evaded the cult of beauty, becoming immune to anorexia nervosa and urges to pluck my eyebrows or paint the nails of my fingers and toes. It's not that I never worried about being pretty after that—I did. But I knew that I had a different destiny than my sisters. One that involved books and speech and holding my own in a room full of men.

X

BLUE TRAIN

Tab has paroled and Urkel is gone too. I told him to find a new job. He had worn out his welcome, not just with me, but with my other workers as well. Now I have something close to a dream team, at least in terms of talent. Artist Thad and writer DJ have been joined by musical wizard Gabriel and singer Jimbo.

When I first hired him, Gabriel announced his intention to master as many instruments as he could while working in Arts in Corrections. In four months he's learned keyboards, guitar, and drums. I think he might be a musical prodigy. He's shy and funny and there's something of the overgrown kid about him even though he's in his late twenties. Like Alejandro, he brings out my maternal instincts. I was surprised when he told me that he was a father.

The other day he'd said, "Ms. T, listen to this song I wrote for my kids."

And then he played a raucous rock song titled "Here at Camp Snoopy." He told me he didn't want his daughters thinking about him in prison when he was separated from them, so he'd made the song for them.

Jimbo, all three hundred pounds of him, is also musically gifted, but he's a high-maintenance person. I've already had trouble with him. When Tab was bandleader of the Music Ensemble, he told me

that Jimbo was a drama queen with a capital Q. And other inmates in the ensemble were put off by his perfectionism, threatening to quit the ensemble. So I kicked him out. He came back a few weeks later asking for readmission. He's drawn to Arts in Corrections like a bear to a beehive.

I told him I would not allow him back in the ensemble unless the group agreed. "You have a prima donna air about you that other inmates don't appreciate," I said. I can't imagine trying to kill someone over artistic differences. But that's what Jimbo did, according to his C-file. He'd just been signed to a major label and had a dispute with one of the backup singers. Jimbo shot him. Luckily the guy survived. If he hadn't, Jimbo would be doing life without, the inmates' term for life without the possibility of parole.

"When a singer goes off-key, you act like they're torturing you . . . on purpose."

"I know," he said, throwing up his hands, "but I'm a professional singer!"

"Maybe so. But most of our musicians and singers are not professionals. You have to be patient."

"Okay, okay."

"Also, we're about collaboration here, inclusion. It's not helpful for you to say that you won't sing backup to 'Sweet Home Alabama' because it's a racist song."

"But it is."

"What if a white guy won't sing backup to 'What's Going On'—using the same objection? Anyway, you need to do a PR job with the Music Ensemble. You can't come back unless they all want you back."

Jimbo successfully lobbied the ensemble and I had to admit that his musical skills were superb. I had qualms about hiring him, but my misgivings were overridden by his talent.

"You basically need to put a piece of masking tape on your mouth unless you're singing," I told him. We both knew this was impossible.

"Okay, Deborah."

"Your artistic vision will not prevail," I went on. "Mine will. The good of the whole is the bottom line here. And stop addressing me by my first name!"

At one morning meeting, Thad says, "Let's do a play."

"A real play," DJ adds. "Not like *Crow*—that was so lame."

"It was *not* lame. People loved it," I counter. "Did you even see it?"

"No, but I heard about it. What I mean is, let's do a play with a script."

This idea is met with enthusiasm by Gabriel and Jimbo, although Gabriel says, "I don't want to be in it."

"You don't have to be in it," I tell him. "But we don't even know what *it* is yet. Let's brainstorm."

To my amazement, Gabriel suggests we do a play about an alien invasion. He wasn't in the poetry class that brought up aliens when we were brainstorming the play that turned into *Crow* more than two years ago. What is it with aliens around here?

I learned a few things from *Crow*. It helps to decide what your message is before you do anything else. And when brainstorming, follow the energy. If an idea lands with a thud, leave it on the table and go on to the next one. The idea of doing a play that's already written doesn't hold much appeal for me. We have the chance to create the whole production, from page to stage. "What do we want to say?" I ask my work crew.

Ideas fly around the room: *Standing at the crossroads and choosing between good and evil. Can it have magic in it? How to do time. It needs to have a spiritual foundation. Can you be free even when you're in prison? Let's make inmates cry.*

I release my crew for chow and when they return an hour later,

they're still talking about the play. And about the family reunion in Thad's dorm. "An uncle and his nephew," Thad says. "They're having a big spread."

I love the synchronicity in the creative process. With *Crow* we were flailing around for ideas and then someone talked about the baby crow that fell out of his nest and we had a concept for our play.

"That's it!" I exclaim. "What if our main characters are a father and son who meet for the first time in prison?"

At first no one says anything. Is this going to land with a thud? No. No one has ever done this—I am sure of that. I want to yell "Eureka!" but I don't say anything.

Then DJ pipes up, "Yeah! Because the baby mama was pregnant when her old man went to prison."

"And she never brought the kid to see him because he was such a bad example," says Gabriel.

"And when they first become cellies, they don't realize that they're father and son," I add. "They don't have the same last name because she remarried. Or they were never married in the first place."

"Yeah!" Thad says. We're on a roll now, adding details about the circumstances of the main characters, colorful supporting characters, and wrenching plot twists.

We decide to call the play *Blue Train*, symbolizing the seemingly endless stream of blue-clad inmates that enter the system every day. As soon as we settle on the concept, the play almost writes itself. I draft some of my poetry students to participate, and they each write soliloquies for their characters. Of course we will have music, a mix of inmates' originals and what they call Ms. T's hippie music.

By the time I entered high school, our family had moved to Downey, California, one of the many suburbs of Los Angeles. In high school,

my sisters found Jesus and I found sex. I educated myself, using *Open Marriage, The Harrad Experiment,* and *Everything You Always Wanted to Know About Sex But Were Afraid to Ask* as my primary sources. The latter I snuck out of Mom's underwear drawer, where she'd hidden it after Aunt Diane gave it to her. From these books, I learned that monogamy was boring and that it was possible to have multiple orgasms, two facts I already suspected.

It was 1970, and on TV people talked about "free love" and women burned their bras. I was coming of age during the sexual revolution, but I didn't realize that until later. I'd missed the summer of love a few years before because I was still in junior high school and four hundred miles away when it happened. The hippie era was already coming to an end when I started high school. But no matter—to my family, I was a hippie, a perception I did my best to encourage.

Bonnie was the arbiter of taste and fashion in our house. She'd inherited Nonny's sense of style. I went my own way. The bedroom Bonnie and Terri and I shared—three beds in a row, with matching pink-flowered spreads—reflected our diverging orientations to the world. Two-thirds of the room was fluffy: stuffed animals, pom-poms, and pink things. In my third, I hung posters: one with a box of Marlboros containing marijuana cigarettes, the premiere of the Frank Zappa movie *200 Motels,* and a speech that began "The streets of our country are in turmoil, the universities are filled with students rebelling . . ."

Our bedroom broadcast the heartbeat of the house. Here Bonnie twirled her flags and she and Terri practiced cheers: "D-D-D-O-W, N-N-N-E-Y . . ." Here Mick Jagger sang "I can't get no satisfaction" and Frank Zappa called any vegetable (and the vegetables responded to him). Here too Brad helped me practice lines from whatever play I was in: "The asylum? I grew up in an asylum. Rats? Why, my brother Jimmy and I used to play with rats, because we didn't have toys." Inevitably, Brad got carried away and started acting like Jimmy in an asylum, and I, Annie Sullivan, ended up working miracles alone at the mirror.

No one in my family was surprised when I became a "drama kid" in high school. I'd been making up plays all through childhood, which we would perform for our parents, or ideally, when there was company. I adapted *Little Women*, making Brad play Amy because we didn't have enough girls. I was the director, too, of course, so I'd have to jump in and out of character to boss my siblings around.

"Everybody lie down on the carpet," I'd order. "I'm Jo and I'll say, 'Christmas won't be Christmas without any presents.' And Bonnie, you're Meg and you say, 'It's so dreadful to be poor.'" Another play we'd done was called *The Ruby of Death* and it required the use of Mom's ruby ring, along with one of her flouncy dresses, which she never wore anyway. I'd had a hard time corralling Brad because he didn't have the patience for rehearsals. I'd learned that if I gave him the more exciting roles, like the robber in *The Ruby of Death*, things went better.

Willing or unwilling, siblings are subjects in the laboratory of human refinement, those beings on whom you practice all vice and virtue, test the limits of civilization, and find your own tolerance for outrageousness. If you're lucky, you live in a family with an even number of children, so there's always someone on your side—unless you're the only boy with three older sisters, like Brad. Or the only hippie in the family.

When we were younger, Brad and I were often allies because I didn't want to play dolls or store ladies or whatever Bonnie and Terri were playing. Sometimes the four of us played together. When we played pioneers, we put blankets on the sides of the bunk beds to make a covered wagon. Bonnie and Terri sat inside being pioneer ladies while Brad and I put on cowboy hats and sat on the top bunk and rocked the beds back and forth, saying "Giddiup! Haw!" When we played hospital, Brad and I were the doctors, Bonnie and Terri the nurses, and dolls and pets were patients.

And Brad and I had another alliance. We were the bookends

most likely to get in trouble, with Bonnie and Terri living innocently between us. We were our father's children, the spirited, mouthy, rebellious ones.

Unfortunately, I was too cool for my entire family, even Brad. I was a drama student who smoked pot occasionally and cut class regularly to go to King's Coffee Shop to drink coffee and smoke cigarettes with my friends. I listened to the Stones and the Mothers of Invention, and burned strawberry incense in my shared bedroom. Big deal. But Brad, who was eleven at the time, jumped onto the anti-hippie family bandwagon.

We were watching *Dragnet* after school. A hippie-looking young woman had just taken a couple of hits from a joint and then—unbelievably—she put her baby into the oven. "This is unreal!" I announced to the living room. "What a bunch of propaganda! Pot doesn't make you do stuff like that!"

Brad watched until the commercial and then turned to me. "You hippie! You goddamn hippie!" he accused, glaring at me.

"You idiot! You little punk!" I retorted. "First of all, there are no more hippies. This is 1970, you fool. And second of all, you don't know anything about it. And I do."

"Mom!" he cried out. "Debby smokes pot!"

"Oh shut up!"

He was probably getting back at me because I'd almost murdered him the Saturday before. For a good reason. I'd been trying to sleep in. I could usually sleep through fire engines, barking dogs, alarm clocks, anything. The room my sisters and I shared was the master bedroom and had its own bathroom, which also opened on to the utility room, which connected to the kitchen. Someone had left all the doors open and all of a sudden I woke up to the sound of loud crunching, like a dinosaur munching on human bones played over a Dolby sound system.

When I leaped out of bed to discover the source of the noise, I

found Brad with a two-quart yellow Tupperware bowl that must have held half a box of Cap'n Crunch swimming in milk.

"Aaaaaaaaargh!" I screamed at him. "You are the grossest person on the face of the *earth*!"

"What?" He looked honestly bewildered.

"What? I can't believe that you slurp your cereal so loud that you wake people up when they're trying to sleep in on Saturday morning! That's what!"

Then he laughed. It's not often that an eleven-year-old punk has the occasion to accidentally conceive of such an effective torture device. Then I had to chase him around the house, threatening to strangle him, and by the time I almost caught him, we were both laughing and he did his maniac routine, thumbs in ears, fingers wiggling, eyes popped out.

My alliance to this little brother evaporated. It was bad enough that Bonnie and Terri were into all the church stuff and busted me for stealing Mom and Dad's cigarettes and getting hickeys. And Mom and Dad—they were hopelessly out of touch with the world. Now Brad, too!

"You know what you are?" I told him, as the *Dragnet* theme song dum-de-dum-dummed in the background. "See that guy?" I pointed to Jack Webb. "You're like him—you're a little narc. From now on, I'm going to call you Jack."

"At least I'm not a goddamn hippie," he said.

How did I end up in this family? Surely there was some mistake. My real family was somewhere out there looking for me. They all listened to rock and roll and everyone had their own car. They dressed casually but were obviously rich. Maybe they were hippies. Maybe they were just like me.

Between 1980 and 2000, the US prison population increased almost 300 percent. Much of this resulted from the War on Drugs. Men of color, as well as women of all races, saw the highest increases. It seems what prisons do best is create the need for more prisons. Families are destabilized when a parent goes to prison, putting the left-behind children at greater risk for all kinds of trouble, including future incarceration.

The stigma that a stint in prison used to carry has become more like a rite of passage, especially for men growing up in rough urban neighborhoods. As a result, one in three black men can expect to be incarcerated at some point in their lives. And in California, one incarceration is likely to lead to more—the recidivism rate is between 65 and 75 percent. That doesn't always mean a new crime; sometimes it's a "technical" violation, like failing to give your parole officer your new address, missing a meeting, or failing a drug test. But no matter the reason, it has the same devastating effect on families.

Desmond, the actor who plays Chance, the son in *Blue Train*, confesses that the character's story could have been his if his father were in California. Instead, Desmond's dad is doing a life sentence in Tennessee. Maybe that's why his scenes with R&B, his cellmate father, are so moving. A reporter from the local newspaper comes to our first public performance and a caption on the full-page article reads, "It's perhaps the best musical you'll never see: a production by prisoners at the California Men's Colony." The reporter writes that Desmond's voice was so rich that the current *American Idol* star should be grateful that his competition is behind bars.

The success of *Blue Train* has me walking on air. It's that feeling you get when you have produced a work of art that captures the zeitgeist. The play is so good, rings so true, that we've had to keep adding performances, for staff as well as inmates and small groups of community members. I am certain that if our prison were in New York instead of California, we'd be off- or even on Broadway before long.

Audiences are entranced as the story unfolds, punctuated by music. Rap artist Chance has a chip on his shoulder because his father abandoned him when his mother was pregnant. He's not interested in advice or "old-time music" from his cellmate R&B. Immediately upon arriving in prison, Chance gets tangled up with Weasel, a heroin addict who buys the drug on credit from shot caller Fat Dog. Weasel tells Fat Dog the purchase is for Chance.

Just as Chance gets in over his head with Weasel, R&B discovers a photo of Chance's mother in the cell and learns that his cellie is his son. When the due date for the debt comes and goes, R&B learns that Fat Dog has told Weasel to pay up or take Chance out. R&B runs out on the yard to intervene, but he is too late. He discovers his son's body lying on the yard and lies down next to him. An angelic chorus of inmates surrounds the two men as R&B begs God to let him take Chance's place.

In a moment of magical realism, Chance sits up and a voice from the tower (played by Gabriel) barks, "All inmates down on the yard." When an officer comes to investigate, it is R&B's body that's dragged away. The play ends with Chance learning that R&B was his father, and integrating R&B's beloved Marvin Gaye music with his own rap. The cycle starts again when an impetuous young Native American inmate is put in a cell with an older man of the same race.

I got grief from some of the inmates for some of my musical choices, which include "Somewhere Down the Crazy River," by Robbie Robertson, "The Man Comes Around," by Johnnie Cash, and a wrenching version of Dylan's "It's All Over Now, Baby Blue," performed by Weasel before he shanks Chance. Near the opening of the play, in a drug-induced delirium, inmates on the yard break into "Jailhouse Rock." A lot of inmates resisted this, with one complaining bitterly.

"Performing that song in prison is like asking midgets to sing 'Short People Have No Reason to Live.'"

"It stays," I declared. And my instincts were right, which I point out to the cast and crew after our first performance. The audiences laugh and clap during "Jailhouse Rock," are riveted by "The Man Comes Around," and many tear up during "It's All Over Now, Baby Blue." The original music is very good too, but I know that including songs that people love ups the emotional ante.

Reveling in the glory of our success is Beau Butler, who plays R&B. Beau is a tall, charismatic black man with a big voice and a sense of showmanship. People can't help but like Beau, who is called Green Eyes by the other inmates, even though his eyes are blue. I asked him about that once and he said, "It's a black thing, Ms. Tobola. Black people with my color eyes are always called Green Eyes. Only white people are called Blue Eyes."

Although he is an accomplished singer and actor, Beau played college football and was on track for a professional career when he was younger. But he got kicked out of the Oakland Raiders training camp after cocaine claimed him. Now he's a devout Christian in his fifties who's ricocheted between the streets, prison, and church for three decades.

"Ms. Tobola, I wish people on the outside could see this play. It's so good!" he tells me.

"Yeah, especially that guy who plays R&B."

"No, even if I wasn't in it, I'd think the same thing."

Beau is set to parole in a few months. He swears it will be different this time and I believe him.

But when he relapses again, six years later, I will be there to see him fall. It will be after we've performed *Blue Train* on the outside with Poetic Justice Project's cast of formerly incarcerated actors. It will happen, in fact, on tour with our second play *Off the Hook*. Beau will break my heart when he gets on that blue train one more time.

XI

CHOW CALL

Most of the time, institutional life is bleak and boring, days running into each other with numbing uniformity as they stack into years. Aside from programs that shine light, like Arts in Corrections, there is little to celebrate. Animals and food have greater importance here than in the outside world.

Animals take on a magical quality in prison. Especially birds, because they can hang out behind the fences, but they can also fly away if they feel like it. CMC's wildlife is not typical of newer prisons. Our animal population includes deer, possums, turkeys, turkey vultures, and other birds. I am so enchanted I write a poem about them.

Chow Call

Driving onto the prison grounds during chow call,
you stop at a little bridge to wait for a doe
who is guarding her fawns as they cross
the road. She must keep them safe,
away from the outside world and its
speeding highway, safe from the asphalt
dinner plate of the turkey vultures who levitate,
rise from the ground as one, rock as they fly,
circle their dead prey. *To eat dinner and not*

become dinner, that's the point here
the doe instructs. Walking down the dog run,
you spy eight gulls standing sentinel on a dorm roof,
squawking, watching the yard as groups of inmates
are herded to the chow hall for dinner.
They study the blue men and discuss
potato chips. The gulls are fat with contraband
not found on the beach, where they own
vacation homes. They keep an eye on a shadow
of a cat that crawls from under the administration
building and creeps toward a sparrow.
He's a wild kitten, not yet tamed by
kibbles and bits. The grounds are quiet
except for the officer calling chow for
the last dorm, a call answered by a murder
of crows, who crash-land near the kitchen door,
acting Hollywood, loud and glamorous,
talking trash about people, cackling at the cast-
away snacks. A pack of inmates passes
and the crows yell insults at them.
Yard dogs! they taunt, making fun
of the pecking order. *Look at that fish,*
one crow caws and the birds dip their necks
and watch a lonely man shuffle at the tail
of the blue body of men. *See you, see you*
wouldn't want to be you! The man looks back
over his shoulder. He's not sure what they said but
he knows the mocking tone. The crows crack up.
They love chow call. You have to wonder
where they came from.

But it seems that gulls become institutionalized in their own way. I never see crows sitting atop razor wire. They prefer telephone wires or treetops, a higher vantage point. But gulls like to perch on the razor wire. Occasionally I'll see a foot, or part of a gull's foot on the razor wire, souvenir of the gull's struggle to get free. It is not unusual to see a one-legged gull hopping around on the prison grounds.

Not many inmates will say that they like prison, but for some it's hard to leave, or even think about leaving. That's true of Desmond, the gifted singer who played Chance in *Blue Train*. He was weeks away from parole when he got caught with drugs and got more time added onto his sentence. Maybe he didn't have family or a support network ready to help him when he got out. Maybe he was afraid of falling back in with the wrong crowd once he was released back to his community. Maybe he's institutionalized. It's hard to know.

There are many obstacles parolees must immediately face. They need to report right away to the parole office in their community. They must find housing, a means of support, transportation. Perhaps the most frightening prospect is being in charge of their own lives again. A consequence of incarceration is loss of agency. Inmates are told when to get up, report to school or work, eat, go to bed, shower. Small daily responsibilities—paying bills, doing laundry, preparing meals—are taken over by the institution.

Of course inmates do prepare their own meals, called "spreads." Top Ramen, which can be purchased at the inmate Canteen, is the staple from which most meals are constructed. Inmates make ramen-based pizza, tuna fish casserole, burritos, almost anything, using garbage bags instead of pots and pans. Inmates heat water in Canteen-purchased hot pots or with homemade "stingers." For the pizza, the ramen is cooked until mushy and then formed into a disc.

Cheese, tortilla chips, and pepperoni are added. The recipe "sets" until it hardens into a pizza. Spreads are shared with gang associates, among members of the same religious group, or friends. Spreads are a high point of institutional life, just as dinner parties are a high point of life on the outside.

Inmates with money (sent to them by family and friends, mostly, who put funds on their "books," the equivalent of depositing into a savings account) never have to eat in the chow hall. They instead eat spreads out on the yard, or in the dorm, or even in the chapel if they can get away with it. Well-off inmates can have spreads every day. Poorer inmates are not so lucky. Maybe a magnanimous inmate will invite them to a spread. Probably not. People can survive in prison without spreads. They won't starve to death. But they will miss out on one of the civilizing influences in the world, the communion of sharing a meal prepared with love, or if not love, attention to detail.

Chow hall meals are rushed, mechanized affairs. Inmates don't just wander in when they are hungry; they are marched in and out, dorm-by-dorm. There's no lingering over a meal, exchanging stories, admiring the cook's talent. A lot of inmates complain about the food in the chow hall. It seems that the more inmates can create and share food, the better off they are. And probably less likely to become institutionalized.

My father used to say to his children, "I can't wait to break your plate," and with a snap of his wrist he'd toss imaginary china behind his shoulder. We laughed, having no idea what he meant, knowing he could break every plate in the house, and the cups and the glasses too. He could melt all the forks and spoons into a lake of silver lava and there would still be a plate for us.

He could lose his glasses, forget family recipes, marry us off and move to Alaska, grow old and die, and still there would be the meal and the ritual of the meal and him saying, "I'm the meal ticket here." He could die and come back in a dream and in the dream I would take my place at the table, pale moon of my plate before me as he prepared a meal, insisting that I eat "more, more," serving up stories of the world, how it is and how it could be. He would say, "No one leaves here hungry," like he always did when we had company for dinner.

After my father died in 1990, I returned to researching my roots. I was surprised to learn on the Internet that breaking the plate was a Bohemian tradition, symbolizing one less mouth to feed for the bride's parents.

My father's family emigrated from Bohemia, then part of the Austro-Hungarian Empire. Czechoslovakia was created in 1918 after the end of World War I. In 1993 the Czech and Slovaks divorced and became the Czech Republic and Slovakia.

I'd always heard that Grandpa's father, Frank (originally Frantisek), had had a farm accident. No one ever talked about what happened to him beyond that. I imagined him being hit with a plow or being dragged by a horse. My father didn't even know what kind of accident it was. He didn't know much about his grandfather.

The first time I went to the National Archives in Anchorage, where I was living at the time, I found census records for my relatives. In 1901, at age twenty-five, my great-grandfather Frank had immigrated from Bohemia, followed by his wife, Anna, in 1903.

Frank settled in Enola, Nebraska, and as soon as Anna arrived, they began making babies. In the 1910 census, I found Frank and Anna with four children, ages five, four, two, and one. My grandfather was the four-year-old, second born. Then when I looked up the 1920 census, Anna was listed as the head of household. I found Frank in the Madison County Hospital for the Insane. I shrieked in the

National Archives in Anchorage when I discovered this fact. What happened? It would be years before the pieces began to fall into place.

The "farm accident" was actually an assault by a fellow Bohemian, a man named Joseph Kysilka who worked nearby on Frank's brother's farm. It must have been a terrible beating because my great-grandfather was never the same afterward. An article in the *Madison Chronicle*, dated Friday, June 10, 1910, describes the events that took place a few months after the beating, under the headline "Attempted Suicide Has Been Taken to Asylum at Norfolk," with the subhead "Frank Tobola, the Blacksmith at Enola, Declared Insane, Tries to Commit Suicide by Hanging at his Home on Tuesday and Nearly Suicides":

> *Frank Tobola, of Enola, a Bohemian, who has been conducting a blacksmith shop at that place, was brought before the commissioners of insanity at this place on Monday, and was adjudged a fit subject for treatment at the Norfolk hospital for the insane.*
>
> *His condition had been noticed for some time by relatives and others, and it was thought best to have his case investigated by the proper authorities. He was to be taken to the asylum at Norfolk on Tuesday, and during his more lucid moments seemed pleased that such was to be the case, thinking, no doubt, that it might result through the treatment he would receive at the hospital in restoring his mind to its normal condition.*
>
> *Relatives asked to be allowed to take him home with them from here over night before making the trip to Norfolk the next day, and as he was not violent the request was granted. The next morning some of his relatives went to Enola from his home a short distance in the country, and just before their return he started for the barn. His wife saw him, and followed him to see that he did himself no harm.*

*He went into the barn and fastened the door, but she soon
gained admittance, only to find that he had been too quick for
her. A rope which he had probably fastened to a beam overhead
earlier had been slipped around his neck as he stood on a car-
penter's "horse" in the barn, and then he had hastily jumped off,
his feet lacking a foot or so of reaching the floor.*

*When found he had already become black in the face, and
was suffering great agony. His wife hastened to get a butcher
knife with which to cut the rope, but by the time she reached
him the relatives had returned from town and taking the knife
from her, cut him down, and it was there on the floor in the barn
that he was found by Dr. Long who was hastily summoned and
arrived shortly.*

*He was found to be seriously injured and in a serious con-
dition, his neck apparently being partially dislocated by his
fall with the noose around his neck, but not to such an extent
as to paralyze him. He gained consciousness after some time,
and appearing to be somewhat better, was taken to the asylum
Wednesday morning. Though still in a very serious condition, it
is possible that he may recover.*

What the article does not mention is that Anna, ready to climb
onto the sawhorse and cut the rope, was pregnant. One week after
her husband hanged himself, she gave birth to their fifth child, Bessie.

Bound for Bohemia, Joseph Kysilka left town a few weeks after
Frank was committed to the asylum. But he was arrested on the
Fourth of July in Hoboken, New Jersey, on charges of second-degree
murder. According to newspaper accounts, Kysilka shot New York
City hotel clerk Stephen Glaser when Glaser refused to put a nickel
in Kysilka's automatic music box. The *Norfolk Weekly News-Journal*
reported that Kysilka and his music box were a common sight on the
streets of Dodge, Nebraska.

Kysilka was sentenced to thirty years in prison, but paroled after six years. I often wonder how things would have been different for my family if Joseph Kysilka had not beaten my great-grandfather, if my great-grandfather had not been institutionalized. Economically, our family suffered without its breadwinner. Anna's occupation in the 1920 census was taking in laundry. Particularly, I wonder if my grandfather Joseph would have turned out differently if his father had been around. Maybe if he'd had a father at home, he never would have developed what my mother called "wandering hands." I want to believe that Frank would have put an end to that behavior.

My great-grandfather died in the insane asylum at age fifty-four. One of my cousins says her grandmother remembers that after Frank was in there for a number of years, the authorities offered to release him back to his family. He declined, preferring to stay in the place that had become his home.

It seems the longer the sentence, the more difficult the transition to the outside is likely to become. There's one inmate who's been incarcerated for decades. He's not an Arts in Corrections student, but a ubiquitous presence on the West Facility. They call him Pineapple because he's from Hawaii and loves music. Whatever he did, he's been down so long he remembers when Mr. Robinson was a guard, some forty years ago. All these years he's held a piece of the island in his heart, and the knowledge that when he goes home—soon now— there will be a feast, ukulele music, and roast pig.

But for now, it's Pineapple's job to travel with his cart inside the prison's perimeter, collecting papers to recycle. "*Mahalo!*" he cries, his grin missing a few teeth. Then he delivers an editorial on what's right and wrong in the penitentiary, punctuated by classic rock from his radio in the background.

A few months ago, Officer Torkelson took his cart, then sent Pineapple to the paint shop to pick it up. Now he pulls a beauty, a red wagon with wood slats, *Radio Flyer* stenciled on one side. Maybe that's how he's gone home all these years, on the waves of Big Island music that break out of the blue from his radio.

It's not just the inmates who get institutionalized. Staff members too become accustomed to the routines of prison life and the militaristic atmosphere. We learn to never sit with our backs to the door. Because we are responsible for our environment—in my case an entire building—we are hypervigilant, ready to catch a thief in action, verbally de-escalate a conflict between inmates, and call out rude or lewd speech or actions. While we spend our days trying to ignite the sparks of intellect and feeling in our charges, we must be willing to accept failure, and push the alarm button when it happens. I set off my alarm when I discovered that one of the students in an art class, taught by a woman, was masturbating under the table. This was my contract artist's first prison class, and I was in the room supervising when I figured out what he was doing. The inmate was removed from the class, never to return to Arts in Corrections.

I've noticed that most of the women teachers wear what I call "fat lady dresses"—jumpers and shapeless shifts. Partly it's because we are instructed to dress conservatively, and partly it's because most of us are a little overweight. I've gained about fifteen pounds since I started working here four years ago. The weight gain is no mystery. It comes from carbs, which counter the stress of working in a giant cage. When Emily and I have lunch together, we share our favorites. I lean toward pasta and potatoes and she likes scones, crackers, and oatmeal cookies. Today I've brought oxtail soup for both of us.

"Is this really part of a tail?" she asks.

"Yes, but not an ox's. Now they use beef."

She looks dismayed.

"It's okay, you can just have the broth and veggies."

With a spoon, I pick out a small oxtail from her bowl and put it into mine, leaving carrots, potatoes, celery, and onion swimming in the delicious broth. After a few minutes in the microwave, it's ready.

My grandfather, who was a butcher when I was a child, brought home all kinds of delicacies, including cow's tongue, oxtails, and bulls' testicles, also known as Rocky Mountain oysters. He made oxtail soup every winter, a tradition I have continued.

"Mmmm," she says approvingly.

After we're done, we share dessert, retrieved from the bottom drawer of my desk where I keep dark chocolate Toblerone bars. I break off two triangles for each of us.

"How many do you have in there?"

"Four. You know, in case of an emergency."

She laughs. We both know that in prison there will always be an emergency.

We hear the inmate work call over the PA, and Emily gathers her things and heads for the door. Turning, she says, "Nice spread, Tobola. Next time I'll bring something."

XII

WHERE ON EARTH?

The success of *Blue Train* inspires my creative writing clerk, DJ, to write his own play, a sharp satire called *You Don't Say* that's about snitching in prison. Snitching is the worst violation of the convict code, a set of rules that older prisoners—convicts—know and adhere to, and younger prisoners—inmates—have to be schooled in. In some prisons, snitching is an offense punishable by death, stabbing in the neck or vital organs.

I attach a memo to the completed script, asking for approval to do it, and send it up the chain of command all the way to the warden's office. I don't think the warden even reads it because Mr. Robinson calls me into his office in the Blue Building and tells me there's no way on earth we're doing *You Don't Say*.

"It's mean-spirited," he says. "None of the characters is likable. They're all the playwright's punching bags."

"But it's a satire," I counter.

"Inmate audiences are not sophisticated enough for satire, if that's what this is. I'd call it sarcasm." And that's that.

Now I'm really in a bind. A husband-and-wife documentary film-making team, Glenn and Abby, had come to film our cast and crew when we were in the final rehearsals and performances of *Blue Train* last year and said this year they wanted to film our whole process

from audition to performance. In two weeks they'll start making weekly visits from LA to film our current production, whatever that might end up being.

After I leave Mr. Robinson's office and get back to Arts in Corrections, I convene my work crew around the table to brainstorm. "What message do we want to deliver?" I ask. DJ is sulking because his play got nixed, but I tell him and the others that we can't waste time feeling sorry for ourselves. Abby and Glenn are coming to film our play and we need a play!

"So what do we want to say?" I ask again. After much discussion, an agreement is reached. My workers, except DJ, who's silent, want to counter the idea that kindness is weakness, part of the prison code. Inmates are generally careful not to show emotion or go out of the way for others because they don't want to be seen as vulnerable. Vulnerable inmates get preyed upon.

"Let's do a play about aliens," DJ says. I think he's just trying to get a reaction out of me because when Gabriel brought up aliens during our *Blue Train* brainstorming, I vehemently objected. This is the third time now that the idea for an alien play has been floated. But this time I feel more receptive.

"Okay," I say. "When you first arrive at prison, it does feel like you're on another planet, right? Suppose an alien somehow arrives on a prison yard . . . and he doesn't understand where he is."

"Like a little green man or something?" Gabriel asks.

"No, he has to look like everyone else . . . the inmates have to think he's one of them," I reply. "But he's from Venus, the Planet of Love, where kindness is strength, not weakness."

"Oh boy, he's gonna have a hard time in prison," Thad adds.

"How did he end up on the prison yard?" DJ asks.

"I don't know. He has to fall out of the sky or something," I muse.

"They kicked him off his planet, catapulted him into outer space," Gabriel proposes.

"Why?" I ask.

"Because he got into trouble," Gabriel says.

"How can you get in trouble on the Planet of Love?" I ask.

No one says anything for a few minutes.

"Too much love," Jimbo says.

"Yeah, he was a ladies' man," DJ says. "And he was fooling around with the commander's daughter."

I work on the play on my off hours, as well as at work, so that it will be finished and approved by the time Glenn and Abby arrive to film our auditions. Although the lead character, V-00711, looks like an Earthling, he has one distinguishing difference: his skin is violet. When the commander ejects him from Venus, she tells V-00711 that he's at the end of his lifespan and bound for Heaven. Then he's launched into outer space and lands in a place where there's no love and no women. He arrives in the middle of a musical yard show at the prison.

V-00711 thinks the inmates are angels and he just has to prove that he belongs there and he'll get his wings. Immediately, inmates start to con him, give him a hard time, even plan his demise. The inmates speculate about his purple skin. Does he have hepatitis? Is it from working in a meth lab? Eventually they accept the fact that he's purple.

Because Venusians do not believe in violence (or even divorce), V-00711's only "weapon" is that he can transform people through the power of love when he touches them. When he does this, the tinkling of a harp sounds. Suddenly tough guys cry, hug each other, say, "I love you, brother."

When the shot callers, orchestrators of prison violence, figure out that V-00711 is bad for business, they devise a way to take him out—with pruno, booze made in prison from fermenting fruit. It works. V-00711 is rendered powerless, unable to transform others when he's under the influence. But in the meantime, God has appeared to the

commander of Venus and told her to get V-00711 back. She does rescue him, of course, and he brings a couple of homeboys with him. It's a madcap comedy and the best parts are watching the inmates become transformed by love.

Jimbo and Gabriel are both composing music for the show. Jimbo has asked me if it's all right if one of his colleagues in the real world sends a CD to Arts in Corrections. "It will help me with music for our play," he says.

"I don't see why not," I say.

All mail to the institution goes to the mailroom, where correspondence to inmates is screened before it's sent on to them. Sometimes staff mail is opened too, if it looks suspicious. When the CD arrives, I give it to Jimbo and I give Gabriel the soundtrack to *The Barber of Seville*. At the end of the workday, the CDs will go into a locked cabinet in my office. But for now Jimbo and Gabriel take the CDs to different areas in the building to work on their music.

Where on Earth? is full of wordplay as well as physical comedy. There's a part in the script when a character named Cutthroat notices V-00711's skin color and asks him, "Are you a clown or something? All purple. I don't like the way you look."

V-00711 replies that he's not purple, he's violet.

Cutthroat shakes his head. "You're not violent. You're not violent."

I've asked Gabriel to write a song about being violet, not purple. It's the anthem for the Planet of Love.

"I've got it, Ms. T," he says.

I listen to a sweet ditty.

"I love it," I tell him. "Except for the problem with subject-verb agreement."

"What? What's that?"

"Play the chorus again."

We hear, "The ultraviolet rays from the sun makes us all violet, not purple."

"Rays make," I say, "not rays makes."

He doesn't want to change it. I argue with him for at least fifteen minutes while he insists, with a straight face, that if I tamper with it, he'll lose his creative flow. Finally he fixes it.

"We also need a song for Cutthroat," I tell him. Cutthroat is a young barber who gets carried away and murders people in the prison barbershop. He's one of the inmates V-00711 transforms. With *The Barber of Seville* CD, Gabriel samples *Figaro! Figaro! Figaro!* into Cutthroat's rap song. I tell him he's the first American composer I know of to sample opera into rap. "They don't do this here! They only do it in Europe!"

Gabriel smirks. "Arts in Corrections is the bomb, Ms. T. We got it going on."

Apparently we do, because more than seventy inmates have sent requests to audition for the twenty-two roles in our new play. There are almost three thousand inmates on the West Facility, so I figure we have a greater percentage of "citizens" auditioning than the community theater in San Luis Obispo does.

Abby and Glenn faithfully record all of the would-be actors doing cold readings. On the last evening of auditions, I discover the perfect V-00711. Bryan is a tall, skinny white guy who has a kind of laid-back surfer-dude persona—perfect! He has a knack for comedy. His gestures and facial expressions are perfect, despite the fact he has no training. Having him as the lead guarantees that *Where on Earth?* will be a hit. I am delighted. But as Glenn and Abby are packing up their gear in the multipurpose room, DJ and Thad come into my office.

"We don't think you should put Bryan in the play," Thad says.

"Why not? He's perfect!"

DJ makes a zipping gesture over his lips. Thad just shakes his head.

"Come on, what's the problem?"

They aren't about to snitch on another inmate.

"Blindsticka," DJ says.

He's referring to a poem I just wrote after a dragonfly flew into our building. I'd looked up dragonflies on the Internet and came across a site that said an old Swedish word for dragonfly was *blindsticka*. In the old days, children were warned that dragonflies could sew their eyes, ears, and mouths shut. When I told my mother about it, she recalled how her Swedish elders warned the children to say away from dragonflies, which they called "sewing needles." It reminded me of the convict code's first rule: don't snitch. My work crew loved my poem and we even set it to music. Gabriel thought it should be a punk rock song, so I screamed "*blindsticka!*"several times in the chorus, which cracked them up.

Blindsticka

That old convict Blindsticka

buzzes in

disguised as a dragonfly

tattoos replaced by wings

he lights

on the pane of a window

listens to you

If you tell

If you break the spell

Blindsticka will get you!

He'll fly around your head

sew your mouth shut

eyes shut

ears shut

Devil's darning needle.

You won't tell says Blindsticka—

will you? *Will you?*

Because Glenn and Abby have cameras, the public informa-
tion officer, who works for the warden, must be with them at all
times. The PIO (in prison slang), Lt. Mitchell, is not a fan of Arts
in Corrections. Our classes and rehearsals are in the evening, when
inmates are free from work assignments, so she has had to juggle
her schedule in order to be here. But, fan or not, she is professional
and helpful. When I cast the play, she brings me printouts of each
actor's commitment offense so I know who I'm dealing with. Before
her promotion to the warden's office, she was the watch commander
on the West Facility, so many of the inmates know her. At the first
meeting of the cast of twenty-two actors, she tells the men that they
are now on the radar of custody staff. If they are doing something
wrong, stop doing it now.

Afterward I pull Bryan aside. "You heard the lieutenant," I say.
"You have to be squeaky clean." I say this because of DJ and Thad's
warning not to cast him in the play. I don't know what he's doing, if
anything, I just want him to stay with us for this journey, for his own
sake and for the sake of *Where on Earth?*

"Scout's honor," he says with a big grin.

We rehearse three times a week for two months, with Glenn and
Abby filming and Lt. Mitchell escorting them. Lt. Mitchell tells me
the night before our first show that she sees inmates in a different
light after watching our rehearsal process. She's seen them pull
together to create something extraordinary. We both know that's not
the norm in prison.

Yes, Arts in Corrections is a lighthouse in the darkness of prison,
just as I'd hoped when I was first hired. I am glowing from her praise.
And I'm proud of my team, my work crew. They are all brilliant in
their own ways. Flawed, but brilliant. But who isn't flawed? When
Glenn and Abby finish the film, the whole world will have the oppor-
tunity to see how amazing they are.

Shortly after Uncle Don informed the family that I would never be Miss America, our family moved from my grandparents' house in Lancaster to Downey, California, a suburb of Los Angeles, just before I entered the seventh grade. With my head in books half the time, I didn't pay a lot of attention to what was *in*, or socially acceptable. I didn't need to. Bonnie did that for me.

Since we lived about a mile away from the junior high, I rode my bike to school. Bonnie, a year behind me, lobbied Mom to get me to stop. Word had filtered down to Alameda Elementary, her school, that I had this odd practice. Only boys rode their bikes to school.

"Mom, she's the only girl in *the whole school* who rides her bike," Bonnie said. "If she rides it next year, I'll die of embarrassment."

Of course my mother didn't make me stop.

One Saturday morning, my father drove me to school on Saturday to take the MGM test, which had nothing to do with movies.

"Mentally gifted minor," he said after we got the results in the mail. "I'm so proud of you. I took the letter to work."

"You did?" I asked, amazed. "You took it to *work*?"

Dad's work was in construction, and was an endless topic for conversation at our house. No matter what was being built, people got very dramatic in this business, the way Dad told it. There were sneak attack visits by government OSHA people just look-ing for something that would shut down the whole show. Union stewards tried to pull fast ones, including one who started a strike because his German shepherd wasn't allowed on the job site. The dog walked the picket line with his owner, with a sign around his neck that read "Unfair to Zeus." Pipefitters inevitably screwed up and caused the ironworkers, who didn't have the brains they were born with, according to Dad, to walk off the site before they

were finished. It seemed that my father just barely escaped disaster every day at work.

"Yep, I showed it to the guys."

The guys. I had my own set of guys. Usually on Saturdays and sometimes after school, I went to Alameda to play touch football. I always wore my yellow T-shirt and shorts. I was the only girl there, but big deal. I was small for my age but fast. I was good—once I got the ball, no one could catch me.

My father didn't take this seriously the way I thought he should. After all, he gave up playing football at Cal Poly because of my imminent arrival. Who's to say the football genes hadn't passed to me? But Dad ignored the idea. Not like when I'd say I was going to join the Marines, which caused him to rant and rave about WACS and WAVES, who were apparently the lowlife counterparts of women who went to college to hunt for husbands.

The football gang took me seriously enough, or so I thought. They were mostly sixth-graders, like Bonnie. Ricky Rodriguez and Tonio Sanchez and a kid named Mike who everybody called Alabama were regulars. There was no set schedule: kids just appeared on the field and we started playing. Then Ricky and Tonio changed the rules and ruined the game for me.

One day, for some reason, I walked home from school instead of riding my bike. I'd stayed late to practice my softball throw and chin-ups, the two things that were keeping me from earning a Presidential Merit Award in physical fitness. I was daydreaming as usual when Ricky and Tonio leaped out from behind some trashcans and rushed me.

At first I thought it was a prank or a game. But then their hands were all over me. They were trying to feel me up. I flailed at them and kicked the metal trashcans next to me off the curb, creating a great clatter. They ran away, but I was left flushed with shame and loathing. The rest of the way home I walked briskly, self-consciously,

feeling betrayed and angry. Tears sparked from my eyes and I angrily brushed them away. I didn't get it. They were my football buddies. We were on the same team.

I didn't tell on them, but I did warn Bonnie because she went to school with them. "That's what you get for playing with boys," she said. Or maybe that's just what I remember her saying. Nevertheless, she stopped complaining about me riding my bike to school after that. If I'd been on my bike, Ricky and Tonio wouldn't have been able to assault me.

After a while, I gave up sports altogether. Being on a girls' team at school was the same as not being on a team. People came to the boys' games and the scores were in the newspaper. The girls played to an audience of each other and no one cared who won. If you couldn't play with the boys, why bother to play?

I meet Glenn and Abby at the Blue Building on the morning of our first performance of *Where on Earth?* They want to film the crew putting together our elaborate set, which features the command center of Venus on stage left and the prison yard on stage right. And they want to film the actors, especially first-time actors before the first show, get some dramatic footage of guys going over their lines, fighting backstage jitters. Lt. Mitchell is inside the office talking to the watch commander and we're outside on the steps when suddenly Abby takes the camera out of her bag. Lt. Mitchell joins us and Abby asks if she can film the procession coming toward the Blue Building. It's two officers and an inmate in handcuffs. The inmate is Bryan, our lead, the Robin Williams of the West Facility.

"Oh for God's sake," I say.

Lt. Mitchell gives Abby the okay, shaking her head at the spectacle heading our way. She goes back into the office and comes out with

the scoop. Bryan got caught trying to make a drug deal on the prison phone. He wanted someone to leave some marijuana on the Camp Yard that he'd retrieve later. Now he's on the way to the Hole and our show starts in three hours.

The show must go on. I draft another actor to take Bryan's part. He had a small role in the production until now. He's black so Thad, who's in charge of spraying purple airbrush paint onto the Venusians, has a challenge making him purple. The new actor studies the script until we go on. The first show is a little rocky, but the actors quickly find their stride, and the new V-00711 is good at physical comedy, but not the perfect fit like Bryan.

We do several performances and the warden's office even requests we add a performance for any staff member who'd like to see the play. The vice principal of Education, Mr. White, writes me a letter congratulating me on the play, which he found funny and uplifting, "instilling a message of peace and harmony." He went on to add, "It's quite amazing what you can do with a group of inmates that many have given up on." It's music to my ears, and further confirmation that I have the best job in the institution, maybe the best job in the city of San Luis Obispo. I put his letter in the bottom drawer of my desk with the Toblerone candy bars and lighthouse kites. I can hardly wait to start on next year's production.

Not long after I receive his letter, Mr. White calls me from the warden's office and requests that I come there immediately. This is either very good or very bad. Very bad, it turns out. The mailroom had intercepted a package addressed to me from a woman I've never heard of. The package contains a cassette tape, vacation pictures, and a note to me that says Jimbo, my worker, had instructed her to send these things.

Mr. White gently questions me, with the warden listening. I tell him I'd only given Jimbo permission to have his colleague, a professional musician, send a CD to Arts in Corrections, but I know

nothing of the woman who'd sent the cassette. I guess Jimbo figures if it worked the first time, he can get around prison regulations and have other friends send stuff to him through me.

The warden lets me know that a letter of instruction will be put in my file, outlining the violation of Title 15 I have committed, under the section called "Transactions." This section prohibits employees from trading, bartering, lending, or otherwise engaging in personal transactions with inmates. I had crossed the line without realizing it until now. I should have known better.

Mr. White and I ride in the shuttle back from the warden's office on the East to my office on the West. I am blindsided by Jimbo's betrayal. My face burns with shame and humiliation. Why would he do this to me? Jimbo has—or had—a dream job, a reason to get up in the morning, a place to practice his art and make an impact on the culture of the prison. I cannot fathom this. Later I will ask Lt. Mitchell why he would do this. She will tell me, simply, "He wanted to feel special." Like he had a privileged relationship with me.

When we get to my office, I unlock the cabinet where I keep all CDs and videotapes and DVDs. I look for the CD from Jimbo's colleague.

"Where's the CD?" asks Mr. White.

"I don't know," I say, frantically searching the collection.

"We'll search his dorm," Mr. White says.

I stop looking, stand up, and face him.

"Okay," I say.

Blindsticka.

XIII
WHO ARE YOU TALKING TO?

My dream team has dissolved. Jimbo got reassigned to a different job, working in the kitchen, after they found the CD in his dorm locker. Gabriel paroled and I wrote a memo so that he could include his song "Here at Camp Snoopy" as part of the property he could send home from his Arts in Corrections work assignment. DJ took a job in the Blue Building. And now Thad is about to parole. He comes to see me when he is two weeks "to the house," prison lingo for going home.

"What are you going to do?" I ask him. He's been in prison most of his adult life. He's a convict, not an inmate. This can't be an easy transition.

"I already have a job lined up," he says.

"Well, that's great! What is it?"

"Removing wings from dragonflies. For scientific analysis."

"Is that a joke?"

"No, really, Ms. Tobola. I guess there's something about dragonflies that can help humans."

"Besides sewing their eyes, ears, and mouths shut?"

"Apparently."

I'd like to say, *Well keep me posted*. But contact with paroled inmates is forbidden under the California Department of Corrections rules and regulations.

Of all of the inmates who have worked for me, Thad has been the steadiest and one of the most trustworthy.

"Good luck," I tell him.

Not long after Thad paroles, DJ comes to see me. "Have you seen the news?" he asks me.

"Yes." I know he's talking about Victor, his friend who worked in the Blue Building before he paroled.

DJ and Victor had a few things in common. They both had problems with women in authority, each was arrogant in his own way, and they were imprisoned on similar charges—DJ for rape, Victor for assault to commit rape.

Tall and thin with wavy hair, Victor was standoffish toward other inmates. Last year, he enrolled in my poetry class, but then dropped out. He told me he wanted to audition for the Music Ensemble, but would do so only if there were new reeds for the saxophone. He informed me that communicable diseases could be spread through the reeds. I called the medical clinic on the West Facility and a nurse confirmed Victor's claim. I purchased new saxophone reeds, but Victor never showed up to audition. Just as well. I couldn't see him collaborating with the rest of the ensemble. And he made me uneasy.

"He told me he was innocent," DJ says, referring to the assault charge he'd been sent to CMC for. "He said he was at the Sky Bar at LAX and picked up a woman and told her he was a movie producer. They had sex and then he told her that he really wasn't a producer. She got pissed and filed rape charges. It was a he said/she said."

"Right. And now look what's happened. He has a new victim. Maybe she would have said the same thing, but she can't. Because she's dead."

For the past week, Victor's face has been all over the TV news. Less than a month after he paroled, he'd been arrested for the murder of a twenty-one-year-old aspiring actress. He is currently in jail

awaiting arraignment. Her decomposing body had been found by hikers in the Hollywood Hills, where she had agreed to meet him for a photo shoot. The promise of a role in a movie or an entrée into the entertainment business was Victor's MO. On our local news, the newscaster always notes that the suspect was recently released from the California Men's Colony.

The news accounts have also been summarizing Victor's previous crimes, which range from writing bad checks to false imprisonment and attempted rape. Somehow he was able to plea bargain down to lesser charges, serving probation instead of prison time, even though in one case he broke into a woman's home and tied her to her bed. After the jury deadlocked, Victor pled guilty to false imprisonment and received probation instead of a prison sentence. Finally, he was convicted of assault to commit rape and sent to CMC, where he served just over three years.

"You never really know who you're in here with, do you?" DJ says, clearly rattled, a departure from his usual smart-ass demeanor.

I look at him. "No."

California prisons are becoming more crowded every day and soon institutions will run out of space to house new inmates. By 2004, prisons had begun "double-bunking" inmates in six-by-eight-foot cells and using gyms as makeshift housing units for hundreds of new arrivals.

Much of the overcrowding comes from California voters' passage of the three-strikes law in 1994. Three strikes mandated twenty-five years to life in prison for anyone who had two prior convictions. People convicted of receiving stolen property, possession of drugs, and shoplifting have been sentenced under the three-strikes law, to serve a minimum of twenty-five years, while people like Victor have been released after serving a few years because he hadn't committed crimes that were counted as "strikes."

Overcrowding is also the result of determinate sentencing,

enacted in 1977. Until then, California operated under a system of indeterminate sentencing. Sentences were handed down in a range of years, such as five years to life. In an effort to make sentencing fairer and address racial bias, determinate sentencing standardized sentences for crimes and instituted "mandatory minimums."

Determinate sentencing had unintended consequences. It filled prisons with inmates who in the past, at the discretion of the judge, may have been placed on probation or fined, especially for a first offense. Under the old system, inmates had more motivation to prove they were rehabilitating themselves. With determinate sentencing, nothing an inmate did in prison would hasten his release.

Now inmates churn through the system, almost three-quarters of them coming back to prison after they parole. Victor is headed back. He'll never get out. I keep thinking about the beautiful young woman he murdered, and the other women he terrorized. Prisons should be reserved for predators like Victor, people too dangerous to live among us. Instead they are warehouses for people with substance abuse problems, people who commit crimes to support drug habits or make terrible decisions while under the influence.

One night when I was fourteen, I discovered something I didn't want to know. I thought I might die that night, and I realized that in desperate circumstances, a person is alone. If a person were to die, that would be the time she would be most alone, no matter how many other people were there.

My friend Crystal had a date and she asked me to take her place at her regular babysitting job. Although I was an experienced babysitter, I'd never gone far from home. My regular job was babysitting the Sherwood kids down the street. But Crystal's babysitting gig was in Paramount, a neighboring city. I begged my mother to let me go,

partly as a favor to Crystal, and partly for the money. My mother finally relented.

The mother—Carla—came to my house to get me in a pickup truck. She told my mother she'd be out until around 2:00 a.m. Paramount was physically close to Downey but culturally a world away. I got in the truck with Carla. On the way to her house, we came to an intersection under construction and she seemed unable to avoid hitting the orange safety cones in the road. I was nervous.

My nervousness turned to anxiety as I entered her house. It was small, dirty, and devoid of any touches to make it homey or comfortable. In the small box of a living room, there was a nubby green couch, a battered coffee table, a television, and a rocking chair. Carla was gone in a flash, leaving me with my charges: a baby and two toddlers. On the kitchen table were the remains of some long-ago lunch: moldy bread and moldy jelly. The refrigerator was pretty much empty. There was no milk for the baby. No diapers, either. The kids' beds had bugs in them. If there had been a phone, I would have called home. Six hours until Carla would return.

I turned on the television and sat down on the couch with the kids, all boys. Eventually I got the children to sleep, after brushing the bugs out of their beds. The baby was still awake, so I sat with him in the living room.

Instead of a peephole, the front door of the house had a tiny door that opened, which must have had glass in it at one time. When the doorbell rang, I cracked open the little door and saw two teenage boys on the other side. One of them I recognized as a kid who'd been kicked out of our school and sent to continuation high school, which is where they put juvenile delinquents. He asked for Carla and I told him she was out. Then I closed the door and went back to the baby on the couch.

Apparently these guys didn't care whether she was in or out. A long arm reached in through the little door and unlocked the door.

They let themselves in, turned off the TV, and sat on the couch, asking me my name, my age, and where I went to school. My heart was hammering. I told them Carla didn't want me to have people there. The one I recognized—Ronald Blue, I remembered—laughed.

"Carla's my sister. She don't give a shit what happens here, as long as she's having a good time," he said.

I thought about that and decided to try a different tactic. "But my mother doesn't allow me to have people over when I babysit," I said.

Ronald Blue laughed again. He sauntered into the boys' room and woke them up. They seemed happy to see him. He and his friend, who said his name was Steve, pulled beers from the paper bag they'd carried in. They lit cigarettes and made themselves at home.

"Hey, watch this," Ronald Blue said to his friend. "Hey, Jimmy, come here," he called to his oldest nephew. Then he handed him his cigarette.

"Smoke it," he said.

The kid just stood there.

"Smoke it. Come on, Jimmy."

The little boy, no more than three years old, tried, smiling and choking. Ronald Blue and his friend found this hilarious and next gave both boys some beer.

I didn't speak but my mind was racing. *It must be about 10:00 p.m. I've been here for two hours. That means it'll be another four hours before she's home.* There was no clock in the room, or in the kitchen, and I wasn't wearing a watch. Ronald Blue and Steve didn't wear watches either, but they told time in a different way.

"Out of beer," Steve announced.

"Come on," Ronald Blue said. "We're going to the store," he told me. "We'll be back."

While they were gone, I thought about what I should do. I prayed that they wouldn't come back. I wanted to be home—never had home seemed so safe and full of good will. I tried to soothe myself by

convincing myself they weren't coming back, but then I heard them outside the door.

Ronald Blue sauntered in and offered me a beer, which I politely declined.

"Gotcha something," he said, reaching into the paper bag. He withdrew a newspaper and threw it on the coffee table. It was an *LA Free Press* and the headline read, "Fourteen-Year-Old Babysitter Raped and Murdered." He and Steve laughed as I read the headline. I didn't say anything.

They didn't do anything, really, besides drink beer and smoke cigarettes. But I was aware in the moment that this night could have a couple of different endings. Something told me not to act scared, to be cool, to hide, at any cost, the hysteria that was building inside me. I sensed that fear would affect them like an invitation.

When it became obvious they weren't leaving at all, I calculated the best way to protect myself. I took the baby to the rocker and sat with him, rocked him, as the night wore on and on and turned to morning. The baby was my shield, my weapon, my only hope. Because Ronald Blue was his uncle, I figured he wouldn't hurt this baby, his blood.

Somewhere between 3:00 a.m. and 5:00 a.m., I dozed off, still clutching the baby. I awakened to see fingers of light coming through the window. Ronald Blue and Steve were still there, bookends asleep on the couch. It was morning and Carla was nowhere to be seen. She was worse than late. Maybe she would never come back. Something inside me gave way. I didn't want to leave the kids with these guys who made them drink beer and smoke cigarettes. But I couldn't hold back my fear much longer. I tiptoed into the boys' room and put the baby in his crib. Then I slipped quietly out the front door and into an alley and ran. I ran like I'd never run the six-hundred-yard dash at school.

I ran blindly because I didn't know where I was. I was too far away to walk home, even if I'd known how to get there. I cursed my terrible

sense of geography. I cursed the darkness from the night before that had led to me not knowing where I was. I ran until I found a convenience store with a pay telephone and, trembling, put a dime in and dialed our phone number. The minute Bonnie said hello I became hysterical. I told her the story in gulps, ending with the cross streets and the name of the store.

"Mom and Dad aren't here," she said. "They're at Brad's Pop Warner game."

That had never occurred to me—that my parents would be at a stupid football game while I was being traumatized.

"I'm calling Nonny then," I sobbed.

But Bonnie said, "She's with them."

So I called Tom, my boyfriend, who promised to help me.

"Wait there. What's the number?"

A few minutes later he called back and said his parents didn't believe him. All I could do was cry at this news.

"Let me ask my sister," he said. "Wait there."

I waited and waited, half afraid that Ronald Blue and Steve would come looking for me. Finally the phone rang again and Tom said, "Sharon and I are coming. Stay there."

My relief at seeing Sharon's car made me cry even harder. I felt lucky to have Tom Barnes for a boyfriend. He believed me. He'd come through for me and I could rely on him. His sister Sharon worked for a lawyer. She was smart and tough and funny, and I admired her in the way teenage girls admire sophisticated adult women.

Sharon reassured me and then told me we had to find the house again even though I didn't want to.

"We have to," she said.

Somehow I directed us back to the house. Sharon went to the door and knocked. Jimmy answered and Sharon disappeared inside. When she came out, she motioned Tom and me to come in.

The boys were awake and looking for something to eat. The baby

was still in his crib, awake but not crying. Ronald Blue and Steve were gone.

Sharon turned to us and said, "I'm going back to the store and I'm calling the police. I want you to stay here."

When she returned, she had donuts and juice for Jimmy and Cal and milk for the baby. While she was gone, Tom and I improvised a dishcloth diaper and changed the baby. The police pulled up a few minutes later. They came in, took pictures, and wrote things down.

"Where's your mommy?" one of them asked Jimmy, who just shook his head. Carla had probably told him the same thing about cops that my mother told me about strangers. The police told us we could leave, and we were getting in Sharon's car when Carla pulled up in her pickup truck, six hours late.

When she figured out what was happening, she turned in our direction and screamed, "You little bitch! Goddamn you, I'll get you for this!"

A few days later, I was home alone with our dog Higgins, who was in his usual spot on top of the couch, looking out the picture window. I looked up and saw Carla's white pickup truck cruise slowly down the street and then back up again. I felt a rush of adrenalin; my heart pounded in my head. I realized that I might not even be safe in my own home. If Carla was out to get me because I called the police on her, she could do it anywhere: at home, at school, anywhere.

Years later, I realized that it was unlikely that Ronald Blue and his friend Steve would have committed murder. The worst that could have happened to me was rape. But when I was fourteen, rape and murder were twin evils in my mind—if you were raped, you were murdered. When Carla cruised past the house, she was probably trying to scare me. What could she have done? But at the time, all I knew was that she was a desperate woman and I had provoked her rage, and the window separating us seemed to be a delicate, easily shattered piece of glass.

Most of the inmates I encounter don't scare me. They have wronged people, including themselves, and many speak of their circumstances with regret. What I love about my job is how the artistic process allows my students to see themselves and each other more fully. When collaborating on a play, or reading poems in poetry class, or playing music for graduation ceremonies, the inmates are more than their CDC numbers; they are fellow artists on a grand adventure together. I am certain that I am the right person to lead them as they reimagine their lives and their futures.

But I also contemplate how many violent sexual predators are on the West Facility right now. Are any of them my students? This experience with Victor has clearly rattled me too. I have no desire to help *them* discover the joys of artistic expression, reimagine their futures. But in order to do my job well, I must see the good in the inmates who come into the program and affirm their potential. As DJ said, I'll never really know who I am in here with. I read the files of inmates who work for me, and of the men cast in the play each year. But after three years I have come to realize that many men have committed more—sometimes far more—crimes than the ones detailed in their arrest record. Even if I think I know what a particular inmate has done, I must admit to myself that I really don't know. And I just have to live with the not knowing, do the best work I can, and hope for divine protection.

Victor haunts me. A few months after he paroles, I have a nightmare about him. It is so jarring that I write it down. Then I turn it into a poem.

Who Are You Talking To?

I. January
Isn't your last name Eastern European?
he asks me when he drops out
of class. A Greek, an aristocrat,
he's here by mistake: bad checks,
vindictive women. Now he has to suffer
the tattooed masses. I'm glad
to see him parole.

II. February
Hikers, modern-day messengers
of death, discover her body
and the rope. It's his face I see
flashed on TV, the prime suspect
with a history of tying up women,
beating them, raping them.
And writing bad checks.

III. March
In the dream, I am on the phone
in my prison office when I sense
someone standing in the doorway.
Who are you talking to? he asks.
Just before I startle awake, he raises
his writing hand, a length of rope.
Bad Czech, he says.

XIV

IT'S ALL GOOD

W henever I tell people that I do theater in prison, they want to know if it's Shakespeare. A reporter even asked me once why I never did Shakespeare's plays. I explained to her that I couldn't resist the opportunity to stage original work, the stories of the people imprisoned in the largest incarceration boom in human history.

But this year, 2005, I've surrendered—sort of. It happened by acci-dent. I held a playwriting contest, inviting inmates to submit one-act plays on the themes of crime, punishment, or redemption. In the end, I decided to knit the disparate acts of the play together with a unifying character.

That's how *It's All Good That Ends Good* came about. I took the phrase "Shakespeare behind bars" literally and put the bard in prison for plagiarism, identity theft, Internet fraud, and transporting stolen goods across state lines. The character of Shakespeare, a.k.a. Frank Bacon, Jr., would speak Shakespeare's lines from various plays.

In the play, the authorities mistakenly lock up not just an innocent man, but a man who's a recognized genius—the greatest writer of all time. The play starts with Shakespeare, or Frank Bacon, on a rigged game show called "No Chance in Hale," where Judge Hale calls up the accused to speak on his own behalf. He asks Shakespeare if he has anything to say and the character implores the judge to go easy

on him, saying, "The quality of mercy is not strained. It droppeth as the gentle rain from heaven upon the place beneath: it is twice blest. It blesseth him that gives and him that takes."

Judge Hale calls to the stage twelve contestants, who act as jurors, to debate Shakespeare's fate. In the end, the writer spins the wheel of fortune to find out where he will end up—Hawaii, New York, Paris, Siberia. One of my new workers, Sam, made the wheel and weighted the needle so that it always lands on Siberia. Although he's sentenced to serve an indeterminate sentence on the frozen tundra of Siberia, our Shakespeare refuses to admit his guilt, refuses to conform to prison culture. Despite ribbing from other inmates in the Siberian prison, he holds on to his identity and decides, on the advice of fellow inmate Dostoyevsky, to write a masterpiece, set in prison. As the play continues, the masterpiece is stolen by another inmate, Christopher Marlowe, but everything is resolved in the third act when our hero learns that his mother was artificially inseminated with the DNA of a famous dead person, so he is "genetically endowed with talents of the bard." Shakespeare's descendant recovers his stolen script, concluding that "all's well that ends well." Another character, Big Hungry, corrects him with, "No, no, no bunkie. Remember what I told you! It's all good that ends good!"

Creating the script was challenging but rewarding. I loved finding the perfect Shakespeare lines for our main character. The play is a zany comedy, but serious themes underlie the fun. Shakespeare's vow to use his prison time to write a play reflects some inmates' desire to make constructive use of their sentence and resist the steamroller of conformity to the prison code. And he is adamant about preserving his identity. As he says in Siberia, "I must become a borrower of the night for a dark hour or twain," with the implication that he will not let prison change who he is.

We've just started rehearsing and the inmate playing Dostoyevsky is great—tall, imposing, even regal. He doesn't get the Russian accent

right until I finally tell him to try Count Chocula from the cereal commercials on TV. Now he's got it dialed in. Still, we have some logistical issues. How do we get from the set of the TV show to a prison in Siberia, and then, in the third act, to an apartment in Hollywood?

I spend my lunch hour on the grim task of writing a memo to the warden explaining how my URL got hijacked by a porn site. I've just moved from Morro Bay to Santa Maria and I had to change my Internet service and my cell phone and landline numbers, along with my physical address, and through all those changes, I missed the notice that my domain registration was expiring. My website, deborahtobola.com, had some of my poems and a link to the children's book I coauthored. Nothing flashy. Which is why I was horrified when I logged on one day to find "Back Street Bangers" on my homepage featuring naked men and women fornicating in various positions. Hard-core porn. I immediately called my Internet provider who explained that women's domain names that expire are often snatched up right away and used for this purpose. After a few days of investigation, they let me know that the company who acquired my domain name was a Russian firm. There was nothing I could do but pay the ransom, which in this case involved buying back my name for $500. Then I took my website offline.

This morning Liza, however, my friend and now supervisor, has told me I have to write a memo to the warden informing him of what happened.

"I really have to?" I asked her.

"Yes," she said firmly. "Immediately. You don't want someone else telling him before you do."

She's right, of course. I struggle to put the whole sorry story into the memo—how the website was mine, but wasn't mine, that someone had taken my name and I had to buy it back. On my dinner break I will deliver the memo in person to the warden's office. I hope he

realizes that I am a valuable staff person and that this sort of thing could happen to anyone. I hope he doesn't laugh when he reads it.

When I was ten, I took ballet lessons offered in the apartment complex rec room where we lived in Merritt Island, Florida. I quickly *pliéd*, *élovéd*, and *arabesqued* to the head of the class. We also practiced tumbling, where I mastered the backbend, crab walk, splits, head-stands, handstands, and cartwheels. I was barely upright, it seems, except for when I was in school.

Cartwheeling upside down and in succession, I became a starfish, a windmill, all limbs and motion. Living on the second floor of the apartments didn't deter me, although the people downstairs couldn't have been pleased with the thumps and thuds I made. My mother did not forbid me, or even scold me. Maybe she was happy to see me doing something that took me out of books for a change.

I was practicing cartwheels one day in the courtyard—the grassy area between our building and the next one—when some kids I barely knew came by. They were talking about blow jobs and I overheard every word. So I ran upstairs and asked my mother, "What's a blow job?" She told me and, once launched, told me everything else, too, more than I was ready to hear.

The only thing I knew about bodies and sex at that point was what I'd gleaned from one of Dad's college textbooks, called *Art Today*. There I'd found naked statues and paintings of scantily clad people, usually women. But there was no clue in that book about how the bodies went together. I was stunned at what Mom told me. It was obvious that my parents had done this thing at least four times. She was kind enough to let me know that she actually enjoyed it, but that didn't help. Finally, I said, "I'm going to adopt." I knew about adoption because my cousins Kimmie and David were adopted. I'd always

suspected that Aunt Diane was the smartest woman in the family; this suspicion was now confirmed.

I cartwheeled away from that talk at the dining room table. But how long could I escape my fate by making myself upside down? My friend Hilary, who was nine, already had breasts, although she called them "milk sacs" and said they feel like superballs. Once she offered to let Bonnie and me feel them, but we didn't want to.

All the horror stories I'd ever heard came back to me in a rush. There was the one about Nonny in her glamour days being photographed for a postcard while waterskiing, and how a huge wave whipped off the top of the strapless suit—click. I wondered why she wasn't dead from embarrassment. She acted so normal, like it never happened. A girl at school once screamed in the bathroom and two teachers went rushing in. When they came out with her, she was hysterical and didn't come back to our classroom that day. Other girls whispered something about a curse. I didn't know what they were talking about. I'd never heard my mother say the word *curse*, although I'd heard my father curse—often.

Dad was in construction, working on rocket launches at the Cape, and often brought friends home with him. One evening he came home late with Finn Ralston in tow. Of all Dad's friends, Finn was my favorite. He was tall and thin and bald; he wore glasses and golf sweaters and his front teeth protruded slightly. Finn Ralston moved with a grace my father didn't possess. In fact, he was more like my mother: they were both reserved and big on manners. Finn Ralston was the kind of man who sat down at the table and immediately took the napkin to his lap, meticulously peeled the skin from his chicken before taking a bite, frowned when an adult said the f-word in front of children.

One of my jobs at home was to fix drinks for Dad and his guests— scotch and water for Dad, the same for Finn, only lighter. I didn't always like this chore because it reminded me of being a servant, like *I Dream of Jeannie*, but I didn't mind mixing Finn's drinks as much

because he didn't treat me like he expected it. Another reason I liked him was because he was married to Elsa, who looked older than him and was very motherly, although they had no children.

One night when he was visiting, I decided to get in a few more cartwheels before bed. I had a trick of doing cartwheels in my nightgown and holding the bottom of it taut at the ankles so that when I turned, the gown stayed at my feet, just like if you turn a paper doll upside down. There were only two places I could do them: in the hallway or the living room. I chose the living room. I knew there was a risk because the trick didn't always work, that my nightgown could fall down. But I wasn't worried about it. It usually worked and why wouldn't it work now?

Finn Ralston was sitting on our blue couch with flowered bolsters, a blue skyline painting above his head. My mother and father were sitting there too. He was minding his own business, drinking his scotch and water when I cartwheeled in front of him. And then it happened: my trick failed me, or I failed to defy gravity, and the nightgown fell in folds around my neck. It was Nonny who told us to never sleep in our underwear. She didn't say why this was bad, but we never questioned her instructions. She knew about these kinds of things. Some of my father's friends would have enjoyed this spectacle—perhaps too much. Finn Ralston was not one of them.

I first glimpsed his face in an upside-down blur, and then I righted myself, blushing in shame but strangely exhilarated. In utter shock and with no small amount of revulsion, his mouth dropped open and his hand flew up to meet it. For a while he didn't say anything, but then he began to blush and said my name. My mother gained her equilibrium sooner than Finn or I did by going into the kitchen to get a tray of chips and California onion dip.

My parents told me years later that people laughed; they couldn't help it. But I don't remember that—only the gasps. "Guess what Debby did?" went down the sibling line from Bonnie to Brad in seconds

flat. It flew over the telephone wires to Grandma and Grandpa, then Nonny, and there was some pleasure mixed with the pain of that. I had done something that everyone talked about. I was a risk taker. The feeling was new, but destined to be repeated, although not ever with the same degree of delicious agony.

When my work crew returns from lunch, they have a solution. The inmates in the Plant Operations programs of Carpentry and Mechanical Engineering have agreed to build a revolving stage, as long as their supervisors give the okay. I speak to the staff supervisors and *voilà!* construction begins. This makes me smile, not just because we've solved the problem, but because my workers told me the guys in Plant Ops look forward to our annual plays and they want to be a part of this year's production.

The prison is its own city, so almost anything can be built, fixed, or maintained. We have our own locksmith, plumber, architect, as well as doctors, dentists, psychiatrists, and psychologists. In addition to Plant Ops, there are vocational instructors who teach inmates a variety of skills, including landscaping, auto repair, auto body repair, janitorial services, electronics, and machine shop fabrication. Some of the programs, like shoe repair, sewing machine repair, and dry cleaning, are dinosaurs that will eventually be eliminated.

Our building is located next to Janitorial Services, a popular vocational program. Mr. Poindexter, who runs that department, asked me yesterday day if he could borrow the Arts in Corrections etching tool. I told him sure. We use it to mark items "AIC"—Arts in Corrections. He said one of his inmates told him we had one and he needs to label some of his equipment to prevent theft. You can't just bring things into prison without a memo authorizing the item, so it's easier to procure what you need from inside.

"I'll get it back to you within the week," Mr. Poindexter, promised. "No problem."

"Thanks so much," the usually taciturn, rather formal man said. "Let me know if I can do anything for you."

This is probably the longest conversation we've ever had. I greet him when we cross paths, but that's about it. I've kept my distance from Mr. Poindexter because he's tight with the scandalous Mr. Norman. Rumor has it that Mr. Norman has stolen money from the teachers' union and supplies from the prison. He's the king of union grievances and also 115s, the form staff members use to report inmate misconduct. I write a couple of 115s a year. Mr. Norman, an academic teacher, writes several in a week. This causes a lot of grief for the inmates, of course, but also for the administration, which must review each complaint, investigate it, and decide whether further action must be taken. But Mr. Poindexter is my colleague after all and I want to keep our relationship cordial. Someday I might need something from him.

The afternoon passes quickly and my workers are still talking about our revolving stage—how many men it will take to turn it, how they're going to have practice and get it dialed in. I release them for chow and prepare to go to the East Facility, my memo to the warden in a sealed envelope, burning a hole in my pocket.

As I'm locking my office, my phone rings. It's Officer Torkelson at the work exchange, the guard booth where inmates are searched on their way in and out of the Education complex. He asks me if I gave an engraver to an inmate. No, I tell him.

"I'll be right down there," he says.

When he gets to my building, he shows it to me. I explain that I'd loaned it to Mr. Poindexter yesterday.

"Yeah, we talked to him first, because it was one of his students who had this."

"And what did he say?"

"He said that you gave it to the inmate."

I blanch. Giving things to inmates can cost you your job. What could an inmate do with this tool? Turn it into a stinger to cook food? A tattoo gun?

"I didn't," I tell Officer Torkelson.

He lets me know in a roundabout way that the officers already know that Mr. Poindexter did it because he's had a history of shady dealings. I don't know what they are and I don't want to know.

"Thank you," I tell him and wait for him to leave. I've been betrayed by a colleague and I want to burst into tears, but I can't. I have to get to the warden's office before it closes and deliver my bombshell.

I want him to know who I am, not just who people think I am.

XV

THE BORDER

In the summer of 2006, three years after Alejandro was deported to Mexico, his poetry teacher from juvenile hall calls me and gives me Alejandro's email address. "He'd love to hear from you," he tells me. I email Alejandro and he says he's fine. We exchange poems and occasional emails. I can't imagine how he's done it, but in February 2007 he writes that he's working at a manufacturing plant but has also opened up an Internet café and hopes to have poetry readings there. He has computers and an Internet connection but is having trouble finding the coffee machines and supplies. He also tells me he had a girlfriend and was thinking of marriage, until he saw her with another guy. "We tried to work it out. I wasn't able to so I just broke it off," he writes.

By August, he's closed the café. And he's quit his job, thinking he'd go to Cancun to find his brother. He's been out of work for almost three months now and he's getting desperate. The thought of going back to his old ways has crossed his mind, but his heart isn't in it. I email him back, telling him that I'll pray he finds a little light in the darkness. His poems are still being read at the prison graduation ceremonies on the West Facility. "I believe in you and your talent," I write him. "You are meant for greater things . . . I'm going to come and visit you one of these days."

In the next email he sends, Alejandro says he's taking a temporary job until something else pans out. He's got two job interviews lined up. But the despair in his earlier email lingers. I need to see him, see for myself that he's okay. I feel motherly toward him—he's one month older than my son Joseph. I know Emily has maternal feelings for him too. He was her student first, and then she sent him to me.

During lunch in my office, I propose the plan to Emily. Tijuana is just six hours away if there's no traffic.

"He's not a parolee," I tell her, anticipating her objection. Prison staff are not allowed to have contact with parolees, unless given permission by the warden. "He's the citizen of another country. He'd be off parole by now if he'd stayed here."

"Okay," she says. It isn't a hard sell. One thing Emily can't resist is traveling, and another thing is adventure. I email Alejandro and tell him that Emily and I are coming for a visit. We plan to meet for coffee at a hotel coffee shop in downtown Tijuana. It's midday on a beautiful October Saturday when we arrive at the hotel on Avenida Revolucion. Alejandro is now a very handsome man, with a mustache and goatee and a neat haircut midway between the shaved head and the wavy hippie locks of the past. At his side is a beautiful woman, his new girlfriend, Elena.

After we have coffee, Alejandro says, "I want you to meet José. He's a poet." He drives us into the slums of Tijuana, past shambling pastel houses with chain-link fences. We stop at one of these houses and pick up his friend José, who's waiting in the street for us. Then we go to Alejandro and Elena's apartment, sparsely furnished but clean and neat, with one room full of computers from the failed Internet café. "He doesn't speak English," Alejandro explains. "And my Spanish isn't that good—but it's getting better." Like many prisoners deported to Mexico, Alejandro came to the United States when he was a baby. He never learned Spanish. When he was working for me, I encouraged him to at least use Spanglish in his poems.

"Elena will help me if I get stuck," he says.

José, who looks twelve but is actually seventeen, pauses after each line so Alejandro can translate. Elena assists. The shy poet reads love poems, simple and eloquent.

"He's a poet," I pronounce when José is finished. Alejandro translates. José beams. This is what we drove here for. We have baptized a new member of the church of poetry, a church that knows no boundaries of geography or language.

I didn't finish college on my first go at it, and by the time I returned, I was almost thirty. Joseph was in kindergarten when Dylan was born, and I was a student at the University of Montana in Missoula. My writing teachers were wonderful and my poems blossomed during that time. My father had just come to visit me in Montana. He flew in without my mother, just to see how I was doing. I took him to a few of my classes, introduced him to my favorite professor. I had been researching our Czechoslovakian roots, which amazed him. I was the only child of his who had the slightest interest in his paternal heritage. I was in junior high school when the Czechs, clamoring for freedom under Communist rule, ushered in a series of reforms that came to be known as Prague Spring. I remember how distressed my father was when the Soviets invaded with tanks and troops in 1968 and the US and its allies did not back Czechoslovakia, letting the Soviet Union tighten its grip on the country. "I'm going there someday. I'm going to find our relatives," I told him. At the time, neither of us could imagine that, within a year, Czechoslovakia's Velvet Revolution would end Communist rule, making travel to the country possible for people from the West.

At the university, my friend and fellow poet Liz and I started a group called Poetry for People, which sent poets into nursing homes, battered women's shelters, and schools.

Then we dreamed up a literary conference called "The Life of the Poet: Developing a Social Conscience." We wanted poets who would serve as role models, poets of witness, and social action. We first settled on Carolyn Forche, who also had grandparents from Czechoslovakia, and who had recently returned from El Salvador and published the powerful collection *The Country Between Us*, about El Salvador's civil war. Next was Etheridge Knight, who began writing poems while in prison for armed robbery. Finally, we chose C.K. Williams, whose passionate, often political poetry won him great recognition. The trouble was he lived in Paris, so maybe he was a long shot. But we applied for grants and invited our top-choice poets, asking them if they would be willing to give readings, conduct workshops, and serve in a public forum. The poets all accepted our invitation. Our grants were funded—it was on! Around this time, I had a dream that I was in a church, sitting near the altar when the priest, who was giving communion, asked me to help him. Panicked, I explained that I wasn't even Catholic. He told me to give the people poems instead of communion wafers. In my dream, poems were holy.

Part of our strategy for the conference was to get the poets out in the community instead of cloistering them on our university campus. After all, Poetry for People was about taking poetry out into the world instead of making people come to school to hear it. We decided the poets would give their readings in community settings. Etheridge Knight read at the courthouse. C.K. Williams, who had worked as a psychotherapist, read at a mental health center. Hundreds of people came to hear the poetry, hear the poets speak on social consciousness, on the black writer, the poetry of prison, the poetry of witness, poetry as therapy. On the night of the last reading, Liz and I sat together, flushed with success but still numb. *We'd made it come true!* We sat on pews in the Episcopalian Church, and Carolyn Forche stepped up to the podium in front of the altar and began to read. She read a poem about her Slovak grandmother before reading her newer

poems about El Salvador. When she recited the words, "The heart is the toughest part of the body. / Tenderness is in the hands," I felt like she was speaking directly to me.

Our trip to Tijuana is primarily to make sure Alejandro is really okay. He is more than okay—he's thriving. One of his job interviews panned out. He has just landed a good job in the purchasing department of a corporation that manufactures high-end audio equipment. The despair I sensed in his emails has turned to joy. I can see he's in love with Elena. Emily and I both like the young woman immediately. She is beautiful, smart, independent, and also seems to be smitten with Alejandro. We have a few days to spend in Alejandro's new old country. Over meals and walking around Tijuana while Emily shops for gifts for her grandchildren, Alejandro fills in some missing pieces.

He didn't start the fight that sent him to the Hole five years earlier. There were no weapons. An older Northerner had engineered a dispute between his people, the Northerners, and the group Alejandro had belonged to, the Southerners. That guy, ironically, stayed out of the fray, escaping punishment. Once on the East Facility, Alejandro was spotted by former gang members who need to "punish"—i.e., maim or kill—others who drop out. Alejandro sought refuge in the mental health unit. "They gave me a form and I checked yes on every box . . . have trouble sleeping . . . yes . . . do you hear voices . . . yes . . . are you suicidal . . . yes." I remember that day on the East, when I encountered him with long wavy hair. "All poets hear voices," I told him then.

With a mental health counselor, Alejandro had the safe space to shed his armor, peel back layers of self-protection, and explore the trauma that fueled the rage of his younger life, the first step toward healing. He gives me an essay he has written:

In the Beginning

I joined a street gang at age twelve. The gang became my family. My homeboys always took care of me. I always had a place to stay, food to eat, clothes and girls. I was rarely home. I came to trust my homeboys with my life. If they said something was right, then I knew it was, because I believed they would never do anything to harm me. So when they introduced me to a lawyer who happened to be a pedophile and who later molested me, I accepted it because my older homeboys said, "All the homies do it." But part of me knew it was wrong.

I was troubled inside. The rage grew so fast. I wasn't exactly innocent before, but now I was out of control. I was capable of anything. At the age of twelve, I had GTA (grand theft auto) cases stacked against me, car chases, stabbings, a few assaults. I started getting high and began to build a reputation. The other homies would come to me for favors, for cars, or to collect. My childhood was gone, snatched from my hands. I became suicidal and stared death in the face many times. I wasn't scared to die because inside I was already dead. I was an empty shell, running around enemy territory hoping a bullet would end my pain and put me to rest. I wanted that big funeral with all my homies there and my best homies carrying my casket. I imagined that people would cry and that finally I would feel that love I wanted so badly. Someone had to love me, because I hated myself.

I never got killed, but I did lots of juvenile time. While inside, the encounter I had with the lawyer would always pop up in my mind. I would hear other guys talk about how they had sex with their girlfriends and I would tell similar stories, but in my mind I knew that my only sexual experience was with this old man who molested me. I felt so much shame. I used to imagine that

on Judgment Day when I stood in front of God, he would ask me why I was with this old man, and all the people standing in line would gasp when they heard. I felt so small and embarrassed.

When I was released, my mom moved back to my hometown, not where my gang was located. I was fresh out and wanted to do good. I asked my mom to enroll me in school. She took me to the school district, but they said they couldn't allow me on their grounds because of my record. So we went to a probation school and everything seemed cool until the lady at the desk saw that there wasn't any social security number on my enrollment form. She asked my mom for it, and my mom explained that I didn't have one because I was born in Mexico. The lady was ignorant and began to yell at my mom like she was retarded. She said something about how we were illegal immigrants and that Proposition 187 had just passed. My mom tried to stand up for me, but she spoke English with this big accent, and I was embarrassed and asked her to leave with me. My mom wanted to fight for me, but I said, "Let's just go."

I felt this old rage building up inside. I told my mom that I wanted to do good but the system was against me and that I had decided to just keep doing what I did before. This decision led to a lot more trouble, more cases, and more juvenile time. But this time I did have girls. One in particular, who became the mother of my two kids. She was only a few months pregnant with my son when I went back in. I had to do fourteen months. I was sent to Camp Fred Miller.

By this time, I had stopped claiming my old neighborhood, for obvious reasons. Upon arriving at camp, I was assigned to a bed next to one of my former homeboys. Though I kept it cool with him, because I wanted to get out as soon as possible, I considered him my worst enemy. One day he invited me to the DreamYard poetry writing class. I was like, "Poetry?! To hell

with that." His ego was tested and he said, "Nah man, I just go
to pass the time. It's cool to just kick back for a while." So I went.
I never thought that someone from the same group of people
who took my life would one day hand it back to me . . . in the
form of a pencil and composition notebook.

I marvel at Alejandro's courage and self-possession. It takes many gang members decades to figure out what Alejandro did at the juvenile facility: that they are pawns in service of a large, evil business, that "family allegiance" is just spin. I've encountered prisoners who have come to this recognition in their forties and fifties, but none at Alejandro's age. After dropping out, survival is an issue, which is why there are "soft" yards like the one at CMC. Alejandro has survived the juvenile camp and prison in dropout status. But he had a few more tests, he tells me.

Upon finishing his sentence in the California prison system, he was placed on a bus headed for the border. Because the bus also contained about fifteen members of his former gang and he was a known dropout, he was secured inside a metal cage for the ride. He says they didn't say anything to him, just talked among themselves.

When the California Department of Corrections and Rehabilitation bus—called the Gray Goose by inmates—reached the border of San Ysidro and Tijuana, they opened the door of the bus onto the door for the border crossing. They handed him a box containing his belongings and gave Alejandro, barefoot, a ten-minute head start before releasing his enemies and the other deportees. On Avenida Revolucion, near the hotel we met him at, Alejandro walked behind a restaurant and fished his sandals from the box. Then he found a phone. His mother had given him the phone number of a grandfather he'd never met. He called the man, who came and picked him up. "I stayed one day," he says. I don't ask him why he didn't stay longer but imagine his grandfather was doing something Alejandro wasn't comfortable with.

He had to find a way to make it, and learn the language as quickly as possible. Luckily, his poetry mentor from his days in the juvenile system was able to line up a job that included room and board at an orphanage in Tijuana. That's where Alejandro spent the next three months. After that, he bounced around for a while, haunting the city's human resources department in search of a job. "They kept shutting the door because I could do better than most of the work they had, but they never told me how to do better."

They were trying to protect him, encourage him by not giving him jobs that were beneath his education and abilities. Finally he got on the production line for a DVD/CD manufacturing company and worked his way up to assistant plant manager before he quit. Now he has a chance to start over with the new company.

Alejandro met Elena at her small video store. He asked her what DVD she recommended. When he came back to return it and rent another, he said, "So are you going to be my girlfriend or what?" Although their relationship is new, they seem to be devoted to one another.

If Alejandro crosses the border back into the US, it's a third-strike felony for him. Will he ever see his mother, his children again? I can't imagine that painful separation. Or I can imagine it, but I don't want to.

Midnight, days before Christmas, I sat up in my hospital bed and ate the decorated sugar cookies my husband, Bram, left for me. I couldn't sleep because I was in awe. I had just given birth to a perfect human being who was now asleep in the nursery. Even though it was a brutal labor and delivery, with every possible medical intervention and postpartum hemorrhaging, I was ready to get pregnant immediately so I could do this again. I felt like standing on my hospital bed and

yelling for joy. I felt like asking everybody I saw, "Did you see that beautiful little baby in the nursery? I made him. He came out of my body this morning!"

Normal women glow when they're pregnant, after they get over morning sickness. After they have the baby, they get depressed. But me? I hated being pregnant—swollen instead of glowing, constantly eating or eliminating what I just ate, emotionally out of kilter, a nine-month prepartum depression that disappeared when Joseph's head crowned. Giving birth, difficult as it was, made me ecstatic.

I was in a small hospital in Victorville, California. They'd already released the other new mother. I was alone, with a room of my own. No visitors. Bram had to go back to work. While I fed Joseph, I listened to Yoko Ono call for one minute of silence to honor John Lennon. The silence was broken only by the sucking sounds Joseph made. I looked at his face. I couldn't see a trace of Bram in him. He looked like my father, my grandfather, my brother, me.

I realized that I knew everything I'd ever need to know about philosophy, politics, religion, literature. I knew this because I'd just pushed a human being from my body into the world, where he took his first blue breath. There was nothing of importance compared to this. *So You Want to Be a Writer* was the title of a book on my desk back home. There should be a book called *So You Want to Be God*, and it would be about this. It would be about ultimate creation: perfection, truth, and beauty.

It didn't matter anymore that the context Joseph was born into was as flawed as he was flawless. Not just the world at large—crazy people taking hostages in Iran, a crazy person murdering John Lennon outside of his apartment, voters electing a cowboy–movie star president, but the immediate environment, too, as my marriage to his father was in trouble. But nothing mattered except Joseph himself—Joseph surviving the perils of early infancy, like crib death and colic and diphtheria-tetanus-polio.

When I left the hospital a few days later, I was a different woman, a woman who held the secret to the universe in her arms, in her heart, in her womb.

On Sunday, Alejandro and Elena pick Emily and me up from our hotel room in Tijuana. We've been invited to Elena's parents' home for brunch. We are warmly welcomed by her father, a dentist, and her mother, a doctor. They prepare a delicious meal of many courses. Our hosts are so gracious, and Alejandro and Elena treat us with such deference that Emily and I inhabit some kind of enchanted space, a space where teachers matter. At the breakfast table, Alejandro talks openly about the pedophile lawyer and his struggle to overcome the burden of that experience. He's seeing a counselor in Tijuana. Emily and I exchange glances. "Good for you," our eyes say.

Along with the whole family, including Elena's sister and brother, we pile into the family van and drive to an arts festival in the sleepy border town of Tecate. Despite the poverty that surrounds us, the whole countryside seems to ring with the possibility of poetry as we travel east on the highway. When we arrive, vendors are just packing up their outdoor booths, battling a brewing wind that's filling the sky with yellow smoke. We duck into a bakery of thousands of pan dulces and eat again. Back on the road, fire trucks pass us as the sky darkens. It's time to go home.

As Emily and I leave, it seems the fires chase us, first the Harris Fire that started near Tecate, then the Witch Creek Fire in San Gabriel. Interstate 5 closes just after we leave it for the 101, where we encounter the Sedgewick Fire, closer to home in Santa Barbara. But we seem to glide, protected, on the highway that will take us back home, and the next day to prison.

XVI

THE GREEN WALL

I'm in the middle of a long workday when the phone in my office rings. It's the new chief deputy warden. Mr. Robinson has retired, much to my dismay.

"Ms. Tobola, do you have a suicide in your play?" this new guy barks at me.

"Yes," I reply.

"Not anymore, you don't." And he hangs up.

The play, *Last Call*, was written by one of my workers and is set in a nightclub called the Joint. The main character, an up-and-coming singer named Dream, is about to leave the Joint. He has to choose between offers from Parole Records and his old employer, Gangland Management. The companies are metaphors, of course, for the choices many inmates will have to make when they leave prison. Will they go back to a life of crime or try to make it on parole? In our play, other singers are competing with Dream for a contract with Parole Records, including Robbie, a guy who says he's been at the Joint too long and doesn't see a clear way out. After he learns that his mother just died, and has a fight with his brother on the phone, he hangs himself.

One of our actors came to rehearsal a few days ago with a home-made noose. I put it with the other costumes and props, which are

kept in the Blue Building and inventoried twice a day—before I take them to Arts in Corrections and after I bring them back. The actor made the noose by tearing an old T-shirt into strips, then dyed it with coffee.

The lieutenant working on third watch doesn't like my program and must have raised hell with the captain, and now it had apparently gone up the chain to the chief deputy warden. Later I would learn that the chief deputy and one of his colleagues in Administration had tried to eliminate theater from my program permanently, effective immediately. But Mr. Benedict, the associate warden, stopped them. Mr. Benedict had been my associate warden since I started at CMC. He'd seen the theater program kick off with *Blue Train* and watched it evolve over the years. Thousands of inmates by now had either acted in or seen at least one play. He champions what I am doing because it gives inmates hope for the future, as well as life skills that are organic to any theater production.

I'm still scowling at the phone when Emily comes into my office.

"What's the matter, Tobola?" she asks.

"Our new chief deputy warden just told me to take the suicide scene out of the play."

We decide to go to dinner. The teachers finish up at 4:00 p.m., which is when my hour-long dinner break begins. I work a four-ten schedule, from 10:00 a.m. to 9:00 p.m. Monday through Thursday. Since it takes about half of my dinner break just to get in and out of the prison, I often stay in the building and eat something I've brought from home.

But today, I have to get out. Our first show, for inmates, happens tonight and now I have to figure out how to replace the suicide. Emily agrees to help me brainstorm possible solutions at our favorite Mexican restaurant.

I lock the building, unlock the gate that lets us out of the Education

complex, and relock it after Emily comes out. We walk past the Blue Building and into Control, the secured area where we turn in our keys and alarms. When the officer working behind the window leans down to hand me my chits, I notice the tattoo on his neck.

After Emily turns in her keys and alarm and takes her chits, we begin the long walk to the parking lot down the dog run. "What is up with that?" I say.

"Lots of officers have tattoos," she says, shrugging her shoulders.

"But not on their necks! And those officers who shave their heads. I hate when staff people act like inmates!"

There are two kinds of people who work in prison: custody (correctional officers and administrators) and non-custody (everyone else). Custody always outranks non-custody. I haven't seen many non-custody staff emulate inmates. Mostly it's custody adopting inmate ways.

The restaurant is only a few miles away, but we take separate cars because Emily will drive home from there and I'll be coming back to the prison.

Over nachos, I complain to Emily. "You know, everyone signed off on this play, including him."

I'd even brought up the suicide with Mr. White, the Education supervisor who had taken our friend Liza's place when she retired. And with beloved Officer Torkelson, who shepherds us in Education. No one seemed too concerned.

"Well obviously the chief deputy didn't read the play," Emily said.

"Probably no one did," I said glumly. "Now what?"

"You could cancel tonight's performance," she suggested.

"I will not!" I retorted. "Maybe the character could just go catatonic instead of hanging himself."

"That could work."

"Yeah, but it's so lame."

This is our first theater-in-the-round production. We decided to

put the nightclub in the middle, with the audience sitting around the actors. Aside from this last-minute change, it's a strong play, with three gifted singers playing the parts of the nightclub stars.

I am aware that suicide is a touchy subject right now for the California Department of Corrections and Rehabilitation. The suicide rate in prisons has doubled in the last seven years. And that's just one of the problems plaguing the Department. Prisons are severely overcrowded and under federal receivership. The budget to run the state's thirty-three prisons is now more than $10 billion. Inmates are suing the state right and left for inadequate medical and mental health care. And up and down the state, the Green Wall scandals are adding to the mix.

The Green Wall is what people who work in the prison system call the officers' code of silence. Officers wear olive green uniforms, in contrast to inmates' blues. I thought the Green Wall was just a nickname until someone told me that the term originated with a group of officers at a prison north of us. Apparently they started their own gang, complete with logos, tattoos, hand signals, and parties with green beer.

The California prison system often makes the news, but usually it has to do with how much taxpayer money is going to support it. Before I started working at the California Men's Colony, there was a big story about the prison in Corcoran, which has housed some of the state's most notorious inmates, including Charles Manson, Sirhan Sirhan, and Juan Corona.

In the mid-nineties, Corcoran officers were accused of holding "gladiator days," releasing known gang enemies—usually blacks vs. Mexicans—into a prison yard and letting them fight, sometimes to the death, betting on who would win. On some occasions officers ended up shooting and killing inmates to break up a gladiator fight. The *LA Times* and *60 Minutes* both covered investigations into the gladiator days, which were hampered by the officers' code of silence.

Eight officers were brought up on charges of federal civil rights abuses and they were all acquitted.

But apparently the Green Wall is a statewide phenomenon. The new director of the California Department of Corrections and Rehabilitation (Rehabilitation has just been added) mandated that the almost fifty thousand employees of the department would be told in no uncertain terms that CDCR will not tolerate the code of silence that covers up for wrongdoing. Any staff member who sees another staff member act in a way not consistent with the department's code of ethics must report his or her colleague, or risk losing employment.

The Education staff was presented with this information, featuring a video presentation with the new director of CDCR. Emily and I sat next to each other. After the video, with its dire warnings, we exchanged glances. It was not lost on us that we had our own Green Wall—and it has to do with going to Tijuana. I raised my eyebrows, telegraphing, "It's not technically wrongdoing." She lifted her chin and pursed her lips in reply, as if to say, "I ain't snitching."

At this meeting the new warden informed us that he didn't believe in education in prisons, citing an old study that "nothing works" in rehabilitating inmates. The author of that study ended up committing suicide after he realized the political machine he had helped put into place created the massive revolving-door incarceration that defines the United States.

We, the educators, left this in-service training angry, depressed, dispirited. We are not getting tattoos on our necks, shaving our heads, sneaking in cigarettes, drugs, or cell phones. We are (for the most part) trying to light up the darkness.

"It will be great. Your shows always are," Emily says now.

"Because the inmates are used to having the rug pulled out from them," I tell her. "No one is going to like this, but it won't stop the show. As if that matters in the big scheme of things."

"It matters," Emily says. "May the force be with you."

Grandma Tobola, my father's mother, told me once, "You can tell me anything and I will always love you." That may have been the greatest gift I received in my life. My grandmother always had an aura of sadness around her. Just before she died, when I was sixteen, she told me that her mother had died when she was twelve. But worse than that, it was she who'd discovered her, hanging from a rafter in the attic.

I couldn't imagine my mother doing something like that, and it was hard to fathom what had made my great-grandmother kill herself.

Forty-six years later I would discover, through online research, that my great-grandmother suffered from encephalitis lethargica, or "sleeping sickness," as portrayed in the movie *Awakenings*. This disease affected about one million people between 1917 and 1926, leaving many of them in a catatonic state, driving some of them to suicide. Researchers think it's a rare form of streptococcus, which prompts the immune system to attack the brain. Many victims are left in a zombielike state—often for years, or even decades.

Although my grandmother told me about the suicide, no one in my family talked about it, in the same way they didn't talk about my great-grandfather Frank's "farm accident," which turned out to be a beating from a fellow Bohemian that sent him to the insane asylum for the rest of his life.

There's a Green Wall on my mother's side of the family as well. My mother's father joined the Army during World War II. He never saw combat in Europe. He was stationed in Texas for some time, and wrote my mother once, promising to send her cowboy boots. She checked the mailbox every day for months, maybe years, but they never arrived. He never arrived. He abandoned the family and died in Connecticut, but my grandmother Nonny always covered for him,

talked about how charming he was, not about how he left her with two children during the Depression and how she struggled for the rest of her life to support them.

The actor goes catatonic instead of hanging himself. It's not nearly as dramatic, but we get away with it because the rest of the play is so strong. What happened at Corcoran would never happen at the California Men's Colony. But the virus of the Green Wall has spread over the state, like a flu, and some people are coming down with it. I know that what I do is not appreciated by many custody staff. I want to help people—inmates—get free, using the vehicles of poetry, music, art, and theater. Maybe the Green Wall needs a poetry workshop. Maybe they need the liberation that comes with speaking the truth about their lives.

It works for the inmates.

Hummingbird in Underworld

While the prison band sings *I Shall Be Released*,
a hummingbird hovers near the barred window
sucking through its needle-beak nectar from
the fuchsia's red mouth. The sax player
makes his instrument cry, a sound sadder

than the kid weeping in Receiving & Release.
Anyone can fashion a shank from a toothbrush,
use a piece of wire or tin to terrorize his fellow man.
It's easier to give in to *ennui*, to believe you've got
nothing coming, nothing to give, than to pick up

brush or horn or pen and begin. Some people
will journey only with a cross-hatched map,
unlike the hummingbird, who travels flower
by flower, heart beating twenty times a second,
flying sideways, backwards, straight ahead.

A prison poet reads his eulogy for the young man
lost in Viet Nam, voice breaking
forty years of bondage. Men can't live without
war, just as the hummingbird can't live
without flowers. There's a compass

in its head, magnetic particles pulling it back
to its sweet home. In one legend, the god
of music and poetry became a hummingbird and
flew to the underworld, where he learned
the secrets of transformation. A prison artist

paints Jesus in yellow, halo askew, one hand
clutching his robe, the other cupping a red petal
of blood. The artist loves Jesus and the blood
flowering in his palm, and the paint
that makes him creator. When Aztecs see

a hummingbird, they see a quick-hearted warrior
who beats back the darkness with iridescent wings.
Hummingbird sucks the evil out of men, leaves them
with a thirst for beauty and the trick of flying
while appearing to stay perfectly still.

XVII
YESTERDAY'S NEW ARRIVALS

Working in the prison system is like living inside a Kafka novel. Back when I first started, a few officers came into my building and started taking art off the walls—poster-sized paintings created during my predecessor's time. The pieces were mounted in acrylic "frameless" frames.

"What's happening?" I asked one of the officers.

"We're confiscating these," he growled.

"Why?"

"Inmates can make weapons out of them. They can melt the acrylic into real sharp knives."

"Okay," I said. I was a fish, what did I know?

But what would an errant inmate do? Leave my building with a large painting encased in acrylic, walk through the gate where he would be searched by a guard, and take it home to his dorm so he could melt it? Or take the picture off the wall and start melting it in my building? It was hard to imagine either scenario.

What about my tool room, full of things like saws, hammers, staple guns, and razor blades? What about the inmates walking around the prison all day with all manner of tools that could be used instantly, that didn't require melting or any other refashioning? I learned later that inmates didn't have to venture out of their dorms

to make weapons: lock in sock, rocks in sock. And it's a lot easier to melt a toothbrush than a piece of a picture frame.

After a while I got used to the idiosyncrasies of the system. In my first year at CMC, a teaching artist, Raphael, came to the prison in the wrong color clothes. You can't wear blue or green or khaki because you don't want to blend in with inmates or officers, in case of an incident. If shots have to be fired, officers need to be able to know who to shoot at. Instead of turning Raphael away, he was issued an orange jumpsuit and allowed in to teach his class. Orange jumpsuits are what newly arrived inmates wear, along with those being transported in and out of prison, to medical or court appointments.

Raphael lived quite a distance from the prison, so I was glad he didn't have to turn around and go home without teaching his class. Maybe the officers liked him. He was a soft-spoken, serious guy. Or maybe they didn't. Maybe they saw this solution as a way to humiliate him, to remind him who was in charge. Maybe they didn't care if he was accidentally mistaken for an inmate if a fight or a riot went down. I didn't quite know what to make of it. Seven years later, I still don't.

There's a dreaminess to life here during tranquil times. Part of that has to do with the absence of cell phones and Internet. People communicate the old-fashioned way, through face-to-face conversation or on an old-style phone. My office phone is a rotary dial beige model that could have been here since my father's days.

Time is slow, except when there's a crisis. Then time is like a gunshot. If I accidentally set off my alarm, by hitting the button on the corner of a table, as I once did, a herd of officers arrives within minutes, panting and ready to defend me from danger. If a drug-sniffing dog detects contraband in a dorm, inmates' belongings are "tossed"—searched in a devil-may-care fashion—and the guilty party is taken to the Hole in the blink of an eye.

Otherwise, days bleed into weeks, months, years. There are

seasonal rituals—inventories, ordering supplies, TB and hepatitis tests for prisoners and staff alike. Adding to the time warp is the fact that inmates parole, are gone for a few months or years, and then they're back. In California 60 to 70 percent of inmates return to prison within three years, compared to the national average of 40 percent. And most have not committed new crimes. They're locked up again on parole violations, which include failing a drug test, neglecting to inform the parole officer of a new address, or failing to keep an appointment with a parole officer.

The recycling of inmates keeps the prison system fat and the inmates thin on hope that they'll ever be able to stay out. This year's play tackles that subject. *Yesterday's New Arrivals* is based on the story of Rip van Winkle. The main character, Richard Rippington—Rip, for short—paroles after twenty years of "sleeping" through his prison sentence. He's learned no new skills in prison, hasn't taken any classes or joined any self-help groups. Finding his old neighborhood transformed by strip malls and unfamiliar technology, Rip must decide how to fit into a world that's left him behind. After involving his son in criminal activity, he ends up on his way back to prison.

At first when I heard inmates talk about coming back on a parole violation, I was puzzled by the lingo. One inmate who came to our audition explained his return to CMC with a shake of the head. "I caught a new case," as if he'd caught a cold or the flu. Now I understand. You don't have to commit a crime to end up back in prison; you don't have to actually *do* something.

Things must have been so different when my father worked here. I wish I could talk to him. He died seventeen years ago, a year after the Velvet Revolution in Czechoslovakia and the election of playwright Vaclav Havel as president. But within months of Havel's election, my father was diagnosed with congestive heart failure. I had graduated from the University of Montana and was living in Alaska with my husband and sons, Joseph and Dylan.

The darkness of Alaska winter closed in like the shutter of a camera, the days rushing toward solstice. My father had been to the doctor, who told him, "Charlie, if there's anything you want to do, do it." He gave my father six months to two years to live. Dad's heart was giving out and he wouldn't survive surgery, the doctor told my mother.

Dad called and said he and Mom would be up for Thanksgiving. I'd been feeling his departure for a while. For his last birthday, I'd made him *kolaches*, the Czech pastry my great-grandmother Anna used to make, and sent them with a letter. When I met my parents at the airport, I knew it would be sooner than two years, sooner than six months.

The old Dad talked about politics and pounded his fist on the table and lectured me on literature and told offensive jokes and teased the children. This Dad barely had enough energy to breathe. He sat. He didn't say much, although he roused when Joseph, ten, played guitar and sang "Kansas City" for him. Otherwise he drank his Scotch, ate a little, and tried to sleep. He couldn't sleep lying down, so he dozed in the recliner. My mother and I went into the small bathroom off the kitchen and cried, twice.

One afternoon Mom and I slipped out to take five-year-old Dylan sledding in the little park next to our house. In the cold, white afternoon, we pulled sleds up the small hill. Dylan and I rode together and every time we shouted "yeehaw," we tipped over. Mom was on her own; she beat us up the hill every time. After a while, holding Dylan's hand at the foot of the hill, I watched her come down. Time did a somersault and I saw her as she must have been as a girl back home in Massachusetts on a snowy day—nervy, determined, flying off the hill into whiteness.

I wondered if I really knew my mother. All these years, while I'd

been so focused on my father, she had been there, never wavering once, never turning away. Did it hurt her, the way I'd taken her love as my due? I wondered if she'd been like me when she was a girl. What did she dream her life would be like?

Suddenly, we had to go back into the house. We'd been laughing and shouting, exhilarated, forgetting for an hour that inside my father was dying.

At the airport I hugged Dad and kissed him goodbye. I knew I would never see him alive again.

The lucky inmates are the ones who are in between prison sentences when a parent dies, so they can be present in their father's or mother's final hours. For so many of the men who came through my program, it didn't happen that way. They were called to the unit office for a prearranged phone call from a family member who gave the inmate the news while custody staff looked on. Sometimes, not even that, but a sergeant would tell the guy, "Your dad passed."

I imagine the inmate struggling with every fiber of his being not to react in front of the officers.

Often inmates would come to my office after news like this and ask if they could just sit there for a while. What could I offer but Dylan Thomas's "Do Not Go Gentle into That Good Night," or Elizabeth Bishop's "One Art," or my own poem about losing my father.

Possible Light

Clouds disperse a rain of birds,
ravens in a sky white
with dread. I am as far north
as you can go
without leaving the country,

the future inscrutable
as the hours before solstice,
where people disappear into the darkness
of the darkest day, leaving
boot prints on the snow
or machines idling in clouds
of white smoke.

My firstborn son suffers from seizures
and genetic grief, electric eyes
go blank sometimes, like the eyes
of the frozen boy found
on the riverbank in Nome.
He cannot contain the grief
of losing his father, he is lost
in blurry memory, waiting for me
to take back his birth
and give it to him new,
without pain, without darkness.
I tell him some of us
are born this way:

My tears are a hundred years old,
ask the child who drew
ten breaths and died at his mother's breast,
ask the mother who fed her children
lard and bread sandwiches.
Each cell of my body carries
the grief of my ancestors, the DNA
of the woman hanging by a belt
from the rafters in her attic,
the man locked up for speaking

in another tongue.
The air is heavy with it,
it pins down their limbs, my limbs.

Sometimes I cannot bear it:
the failure of the sky
to accept light, earth frozen in shadows
until the bloodbath of sunset.
Circling the corpse of the dead
season, each mountain
is impervious to love. And grief is taller
than these mountains,
longer than our dark season.
It is not personal: it is
a blue glacier dividing, dividing.

My father will not live
to see another winter like this,
the early darkness slowing the beat
of the heart, the late awakening
to a day that is never delivered.
His funeral is certain as fireweed
announcing winter,
always too early,
and grief steals minutes each day
until I am left with five hours
of possible light. You know why
we keep candles, slender red torches
and squat red stubs in our cottage kitchen:

It can happen any time, the power
lost, the children afraid of this kind

of darkness hover near each other,
shadows of themselves. What else
is there for comfort? Sometimes
a dust of crystalline glitter falls
instead of rain or snow,
particles lit purely by mercy.

Sometimes my job seems too hard to bear. I feel like a lightning rod, the element standing between the inmates and the system, absorbing the grief and misery coming from both directions. And although I have become accustomed to the recycling of inmates, I don't like it. What's the point of anything any of the Education staff does to help inmates prepare for life on the "outs" if they are doomed to come back? What difference can we possibly make? I'm sure there are success stories, but I don't hear about them. After inmates parole, continued contact is forbidden, so the men evaporate as soon as they step foot out of prison. I still wonder about Opie, the gentleman robber. The only ones I hear about are those men who commit new crimes, like Victor, who raped and murdered the aspiring model.

Then out of the blue one afternoon, I get a call from a parole officer. We're two rehearsals away from performing *Yesterday's New Arrivals* and I'm working on the program, which I will print on my office computer, which will take hours. More than seven hundred inmates have signed up to see the play.

The parole officer suggests that I go to the San Luis Obispo Little Theater, where a ticket to their current production is reserved for me, compliments of the director. When I call the theater, the director tells me that Thad, my former student and worker, had presented himself there, volunteering to paint backdrops for the play. During the interview, Thad said he had a background in theater, but "it was all at CMC."

Thad was the steady artist on my dream team, the one who'd lined

up a job removing the wings from dragonflies before paroling a few years ago. He'd spent most of his adult life in prison, where he discovered his talent for painting. When he came to my program, I put him to work doing set design as well. In one of our plays, his backdrops got as much applause as the actors. Before he paroled, he told me he'd never thought of himself as anything but a criminal. But he'd begun to imagine a different sort of life.

In Arts in Corrections he'd learned to collaborate. He acted as well as designing and painting sets. And he dipped into our literary library. He even began recommending novels to me.

"Ms. Tobola, you haven't read *The Trial* by Franz Kafka?" he'd asked me one day.

"No, but I read *The Metamorphosis*," I'd answered, somewhat defensively.

He'd shaken his head. "You've got to read it!"

I never got around to it.

I write a memo, requesting approval to go to the San Luis Obispo Little Theater and see the show, where my paroled former worker will be present. In the memo I detail the call from the parole officer and my conversation with the play's director. I'm thrilled when my request is approved.

After the performance I shake Thad's hand, grateful to him for giving me this window into his life beyond prison, an affirmation that the work I do really matters.

The next day at work, I pluck *The Trial* out of the Arts in Corrections literary library and begin reading it on my lunch hour. A certain passage strikes me to the core. It seems to describe my very situation at work, even though it was written almost one hundred years ago:

One must lie low, no matter how much it went against the grain, and try to understand that this great organization

remained, so to speak, in a state of delicate balance, and that if someone took it upon himself to alter the dispositions of things around him, he ran the risk of losing his footing and falling to destruction, while the organization would simply right itself by some compensating reaction in another part of its machinery— since everything interlocked—and remain unchanged, unless, indeed, which was very probable, it became still more rigid, more vigilant, severer, and more ruthless.

I lay the book down and cry.

XVIII

SOMETHING'S ROTTEN
IN DENMARK

Last year, in 2007, I attended a prison education conference in Europe. Although I gave a slide presentation on theater in prison at the California Men's Colony, I paid for the trip myself and took vacation days to attend. My new supervisor kept referring to the trip as "my vacation." Nonetheless it was inspiring to see what my counterparts in England, Ireland, France, Spain, Denmark, Hungary, and other countries were doing. The arts are an integral part of prison programming in most countries. I didn't meet any arts practitioners who felt like the stepchild working on the margins of Education, the way I did.

Mr. Denton, my supervisor now, is a vocational teacher who worked his way up from mopping floors to managing people and paperwork. He lets me know at every opportunity that the state of California is wasting money in funding Arts in Corrections, although our entire statewide budget is a fraction of the total CDCR budget. The reason it's a waste of money, Mr. Denton says, is because being in a play doesn't translate into getting a job when an inmate gets out of prison. Learning teamwork and collaboration might help you keep a job, though, I want to say. I could rattle off a whole host of

reasons why the arts are important to the inmates, but it's useless to argue with Mr. Denton.

The conference was just what I needed to affirm the value of what I am doing. I met three other artists who are teaching and facilitating theater in prison—an American who does Shakespeare behind bars, an Irishman who stages original work, and a Dane who likes experimental theater. It was wonderful to see examples of their work and talk about the challenges and rewards of putting on plays inside.

One of the men, Petter from Denmark, was so impressed with the actors I showed in film clips in my presentation that he offered to come to CMC and do a workshop at no charge. "I have connections to the Danish royal family," he'd confided to me. "Funding is never a problem. I went to university with Anne-Marie, you see."

"Anne-Marie? I'm sorry, I don't know who she is," I'd said.

"The queen's sister. She's the princess of Denmark and queen of Greece, although she hasn't lived in Greece in ages, after that nasty business her husband got involved in, the coup and all that. They live in England now."

"Oh," I'd replied, taken aback. Petter, a dumpling of a man with a handlebar mustache, was a whirlwind of ideas, gossip, and plans. We'd talked about scheduling the workshop for the following spring and exchanged contact info.

I've been looking forward to Petter's arrival from Denmark for months. We've kept in touch through email and a few phone calls. He's created a new experimental theater piece for my students to perform, he tells me. And he's attracted the interest of other notable people in Denmark who would like to join us on this groundbreaking project. I am thrilled!

I can't help but fantasize that this production will somehow save Arts in Corrections statewide. As California's prisons get more crowded and the budget bloats, politicians in Sacramento have their butcher knives sharpened, looking for fat. The Arts in Corrections

program is a likely candidate to get carved out of the Corrections budget. Maybe this international theater piece will attract such good press that the budget butchers will spare us.

Also, I'm looking forward to Petter's company. Ever since we lost funding for the contract artists we supervised five years ago, I've been a one-woman department. I relish spending a month with a like-minded person, someone who believes in the power of theater in prison as much as I do, someone so devoted to his craft that he's willing to travel here on his own dime. And he's doing something in Denmark I've been thinking about doing here for a long time. He's created a program for men who have paroled and want to continue with theater on the outside. I can't wait to pick his brain. It's a dream come true.

When Petter finally arrives, my dream quickly turns into a nightmare. I discover within a few days how high-maintenance he is, demanding and narcissistic. Apparently he is used to the royal treatment back home—since he runs in the queen's sister's crowd. Petter constantly drops the names of Danish royalty, which are, of course, meaningless to me.

By the end of Petter's first week, I don't like him much at all. I'm not crazy about his experimental theater piece either. It's an amalgam of well-known passages from famous poets. He's calling it *The Centre Will Not Hold*, after Yeats's line in "The Second Coming." Although I love the poem, it's a clunky title and kind of depressing.

Petter's guest artists aren't coming until the last two weeks of the rehearsal and performance schedule, so during our first two weeks together, I endure long ten-hour days. Our routine has been to break for dinner, where I gravitate toward nachos, fish and chips, or thin-crust pizza. He seems to subsist on salted licorice candy, which he keeps in the left pocket of his Captain Kangaroo–style coat. As I eat, he rambles on about the Danish monarchy. I stopped listening after the first day. I pray for this to be over, for God to remove this man from my life in a way that involves as little bloodshed as possible.

In my eight years here, I have worked hard to develop a calm and steady presence in my little corner of the institution. I treat people with respect. I don't argue with custody staff. I don't throw my weight around with inmates. My normal method of operation is soft-spoken diplomacy. I can, however, get passionate about a poem or a play, and have overridden inmate choices on music, for example, because I felt sure I had the perfect song, including, yes, "Jailhouse Rock" in our play *Blue Train*. And I have no problem kicking an inmate to the curb if I feel he's endangering our program.

It's obvious that Petter doesn't operate the way I do at his prison in Denmark. He radiates contempt toward our custody staff, as if the rituals of entering and leaving prison were some kind of random nonsense being inflicted upon him. One morning when the officer at the dog run asked to look inside Petter's briefcase, Petter glared at him as he opened it.

As we made our way down the dog run, I explained that it's all standard procedure. He wasn't being singled out. Petter sniffed, "They don't do that in Denmark. They use dogs."

"Dogs?"

"Yes, dogs," he said impatiently. "If they were really serious about finding drugs, they'd have drug-sniffing dogs at the entrance. But they don't, do they? That's because most of the drugs come in with the officers, of course."

The inmates seem to like him better than I do. It's a very physical show and Petter challenges them to meet his demands. He has them doing push-ups, the perennial prison exercise, as well as lunges, squats, sword fighting with imaginary weapons, and building human bridges and pyramids.

He's at once flattering and imperious with them, promising to get them an audience with the queen of Denmark. One of the actors in the cast is a big white guy, maybe six foot five, with long blond hair. Petter calls him "my Viking." Some white guys are getting a

particular thrill out of this. They identify themselves as Odinists, or believers in old Norse mythology. It is common knowledge that the Odinists are largely members of white supremacist gangs. When I explain this to Petter and ask him not to use the "my Viking" nickname, he rolls his eyes at me. "Really, Petter, things are not the same over here, as you can see."

This sets him off and running on the prison system in Denmark.

"Do you know that the US imprisons ten times as many citizens per capita as Denmark?" he asks. Not waiting for my answer, he goes on. "We don't have these walls, these fences, these pattings-down by the brutes you have here. And how many of your prisoners come back?"

"We have a sixty to seventy percent recidivism rate," I tell him sheepishly.

"Seventy percent!" he barks at me. "In Denmark, only twenty-seven percent come back. And do you know why? We believe in normalization, not retribution!"

I find myself in the odd position of defending my prison, the California Department of Corrections and Rehabilitation, and my country. "Well, we do have areas of normalization, and I think Arts in Corrections is one of those. As well as many education classrooms, and vocational classrooms, and the chapels, too."

Once I've named all of the points of light in the institution, Petter just snorts.

There is one inmate who does not like Petter and refuses to be in the play. The rest of my work crew is in the production, along with other inmates who have signed up. "Why?" I ask Elijah Wright. "He's come all this way from Denmark to work with you guys." Elijah just shakes his head and says he wants nothing to do with the play, or with Petter.

Every day is given over to rehearsal. If Petter could bring a whip into prison, which he would be delighted to do, he would enjoy

cracking it, admonishing the inmates to push harder, go deeper. Petter doesn't want Elijah to come to Arts in Corrections if he isn't in the play. "Only the actors should be here," he tells me.

"He has to be here, Petter. It's his job assignment. And he's my lead clerk." A lead clerk is a right-hand man. I've had good ones and bad ones. Elijah Wright is one of the people I respect most here. Respect, that gold standard in prison, is easy to detect. Elijah has earned it with inmates and staff alike. He has singled himself out in a way few inmates can do. He has transcended his prison blues and become fully human in an environment where that's nearly impossible. I am not about to let him go.

Petter pouts and I'm afraid he will throw a tantrum. This guy is an accident waiting to happen. I wish I could send him back to Denmark, but I don't quite know how. The idea that I control my own destiny has just gone out the window. Someone can appear out of nowhere—or Denmark—and send you flying into the unknown.

I'd been working three years at the prison in Tehachapi when it happened. My life had a certain rhythm. I loved teaching my creative writing classes—I was also working at North Kern State Prison in Delano, about an hour away from Tehachapi. I'd just joined with a group of women artists in our small town—a singer, a painter, and a graphic designer. We were all single mothers with children in elementary school and junior high. I grew flowers and vegetables and rode my bike around town. I'd been publishing poems regularly, which is how I prefer to see my name in print. Instead my name appeared in a newspaper article with the dateline WILLOW SPRINGS: "A Tehachapi woman escaped serious injury Monday afternoon when her car was struck from behind by a tow truck."

The ambulance took me to the Antelope Valley Hospital in

Lancaster. I'd suffered a concussion and whiplash. My mother, who worked in Lancaster, brought me home with the instructions to give me Tylenol and to wake me up every hour and ask me my name, my address, and who the president was. Despite the Tylenol, my head pounded like an out-of-sync orchestra. Sleep was my only escape from the pain. After several of these quizzes, I snapped at my poor mother: "I've already answered these questions!"

The Highway Patrol report of the accident read: "The tow truck driver was going northbound on 90th Street West traveling like a bat out of hell. The tow truck struck the car and knocked it out into the intersection, where it burst into flames, continued north and ran off the road, striking a tree."

I learned the tow truck driver was a self-employed meth addict desert rat. He didn't have insurance. But he was also the one who pulled me out of my burning car. I was shaken that he'd almost killed me, but grateful that he saved me. It was the same kind of mixed feelings I had working with my students in prison. I could be horrified by their crimes, but awed by the beauty in their writing.

The Highway Patrol report said, "She thought she was on her way home, but was not sure." I was not sure of a lot of things after the accident. For a few weeks I couldn't walk straight. I went to a chiropractor at first every day, then every other day, tapering off to twice a week over two months.

I couldn't talk right either. I couldn't say the word *Topanga*, which happened to be the name of our cat. Worried and knowing I was a word person, my son Joseph gave me quizzes. Once he said, "Mom, Lacsar!" It took me a few minutes, but I finally caught on and replied, "Rascal," the name of our beloved dog.

Perhaps the most distressing result of the accident was a feeling that my spirit had been knocked a little to the left of my body. I have no other way to explain it. I just knew that my life was different now. The site of the accident haunted me.

Willow Springs is about twenty-five miles from Tehachapi, half-way between my house and the cemetery in Lancaster where my father was buried. Hundreds of years ago, Native Americans went to the springs for water. Later, stagecoaches stopped there, and eventually a resort was built. In the 1950s, Grandma and Grandpa Tobola leased the small café. I'm not sure how long they had it, but according to family stories, my grandfather gave away too much food to make a go of it. It seemed portentous that Willow Springs could have been where I died.

I had been keeping a dream journal for a while. In one dream I had a few months after my father died, Frank Baum, author of *The Wizard of Oz*, appeared beside my bed and told me that someone wanted to talk to me. "It's my dad, isn't it?" He nodded and I followed him to a place where I found my father, not young or old, but perfectly healthy and at peace.

We sat at a little square table, a little like the table in *My Dinner with Andre*, a film I loved and made my father watch with me. "What the hell is this?" he'd asked after the movie was over. "All they did was have a conversation."

"That's why I thought you would love it," I'd replied. "That's all we've ever done."

In the dream we didn't talk about *My Dinner with Andre*. We **were** *My Dinner with Andre*. Somehow my father was able to impart to me the secrets of the universe. It was like learning geometry or Greek in one sitting. But finally I comprehended the complicated formula that made everything tick. Of course, when I woke up, I remembered everything except the secret formula.

So I would have to go on as I had, without the certainty of the sublime, the knowledge that there is an ethereal perfection just out of reach. I would have to return to what we call real life. But now real life seemed tenuous, something that could be undone in a moment.

When Petter's entourage arrives, I've got real trouble. They are Astrid, a post-ingénue Danish actress looking to be discovered in America; Stephan, a handsome broody percussionist; and Hilda, an older, distinguished pianist from Iceland. Petter has persuaded them to travel to the US and help him put together the show in the prison. I'm not sure how much he is paying them, or how he is funding this adventure. It's not coming out of my budget, that's for sure.

Petter has infected them with his devil-may-care attitude. They too disrespect custody on their way in and out of prison. They romp around my building like toddlers looking for the newest toy—except for Stephan, who is serious about his craft. There are so many rooms in my building that I can't be sure what's happening in the ones I'm not in.

Later I will hear tales of Hilda getting her toes sucked by a randy inmate. And that Astrid, whose husband was sterile, propositioned Joaquin—about to parole soon. Would he be the father of her child? How do you know what's real and what's an inmate fantasy?

I consider going to the prison administration and telling them, "I've made a terrible mistake." But after the phone call from the chief deputy warden about the suicide in *Last Call* a few years ago, I feel like they're looking for any excuse to shut down my program. I'm not sure who I can trust. The line between custody and non-custody is like neon flashing. I have good relationships with a few prison administrators, but will that outweigh the brotherhood they have with each other? And now with Arts in Corrections on the chopping block statewide, I don't want to add fuel to the fire.

Plus, I have a problem asking for help. Part of it comes from being the eldest child in a family that was often on autopilot. I felt responsible if things went wrong with my younger siblings, even if it was out

of my control. And part of it is pride. I don't like admitting defeat, especially with something that was my idea in the first place. Not actually my idea—it was Petter's. But I enthusiastically signed on. Now I grit my teeth, determined to see this out.

It all ends with the performance. Petter has done a live radio interview with a local station and despite being cautioned by the warden and the public information officer that prison performances cannot be advertised, he issues an invitation to the community at large. I get a phone call from the public information officer while the interview is still going on. What can I say? I was with Petter in the same room, the warden's office, when he'd agreed not to do that.

So now we have a room full of curious people, many who are not usual visitors to our prison. The administration relented and let them come, after they'd submitted clearance paperwork. They could have said no, but state prisons are funded by taxpayers, after all, and people might complain that they heard this thing on the radio and then the warden wouldn't let them in. A rapt audience, they watch an inmate orate, "Turning and turning in the widening gyre / The falcon cannot hear the falconer; / Things fall apart; the centre cannot hold." On the phrase "the centre cannot hold," the human pyramid that cast members have built suddenly falls apart.

The inmate formerly known as "my Viking" interjects with, "So much depends / upon / a red wheel / barrow / glazed with rain / water / beside the white / chickens."

Then the actors are sword fighting, and in a chorus reciting, "Flash'd all their sabres bare, / Flash'd as they turn'd in air / Sabring the gunners there, / Charging an army, while / All the world wonder'd: / Plunged in the battery smoke / Right thro' the line they broke."

The audience is enthralled with the spectacle. I am not. I find one thing to be grateful for: learning of the Danish poet, Inger Christensen, whose work Petter has brought into the production. Her lines speak directly to the inmates, I think: "Already on the

street / with our money clutched / in our hands, / and the world is a white laundry, / where we are boiled and wrung / and dried and ironed, / and slicked down / and forsaken / we sweep / back / in children's dreams / of chains and jail / and the heartfelt sigh / of liberation." And she speaks to me. Liberation. That's what I want too.

XIX
BLACK AND WHITE

The lighthouse that is Arts in Corrections is losing its source of illumination—dollars. The governor, Arnold Schwarzenegger, had promised to "blow up the boxes" when he got reelected two years ago in 2006. He's blowing up something, and it seems to be the prison system. He just announced that the state is $8 billion short of cash, money that a federal judge decreed was necessary to improve medical care in state prisons, where an inmate was dying each day.

The atmosphere in prison is dark and brooding. Maybe on some level everyone knows the jig is up. The state of California can't just keep building prisons and incarcerating everybody and his brother. We can't afford it. Maybe we're all waiting for the axe to fall, even the officers whose $60,000 annual pay is far higher than officers in other states.

One place the state can cut is Arts in Corrections, less than one-tenth of 1 percent of the budget. Never mind that the program has proven to be cost-effective in terms of recidivism; it's an easy target. Correctional officers' children don't get arts programs in schools, so why should inmates?

There are strange occurrences in the David Lynch–like atmosphere of prison these days. I have a window in my office that I leave open on most days so I can enjoy the hummingbirds that stop and

sip at the blue potato vine just outside the window. It must have been an Education student or a Vocational Landscaping worker who climbed in that window one day when I was gone and stole tea and a Toblerone dark chocolate bar from the bottom drawer of my desk.

Then six harmonicas disappeared from the music room and appeared for sale on the yard. One of my workers told me that an inmate named Wolf was selling them. Wolf was one of Petter's pets, the inmate he charged with composing music for *The Centre Will Not Hold*. Wolf probably grabbed the harmonicas during one of our rehearsals, paying himself for the music he composed. I ended up going dorm to dorm on the Two Yard trying to find them, but only recovered four when I asked the dorm officer to search Wolf's locker.

I've decided my time here is up. I've been thinking about it for a long time. I will retire at the end of the year, after nine years of managing the Arts in Corrections program and teaching at the California Men's Colony. I want to start Poetic Justice Project, the country's first theater project for formerly incarcerated people. I've already gathered a board of directors.

Part of my motivation for starting the nonprofit program is to give paroling inmates a chance to experience what inmates in Arts in Corrections have experienced. But another powerful impetus is to get the work we've been doing in Arts in Corrections out into the world.

Each year, I've been able to invite a handful of community members to our annual performance. Except for Petter's audience, invited on the radio, the guests had to know about the play somehow. That meant they were usually friends of mine or Emily's, or theater people in the community. By and large, our outside audiences have been astonished by the power and beauty of the performances. If only the general public could witness our plays, hear the inmates in the talkback speak about how the process has changed them. Glenn and Abby's documentary will help accomplish that. It's been four years

since they filmed rehearsals and performances of *Where on Earth?* The documentary is in postproduction now, with the working title *Prison: The Musical.* In the meantime, Poetic Justice Project will introduce Central Coast audiences to ex-con theater.

But now we're rehearsing our last play, *Checkmate*, a drama about race politics in prison. In the play, young Pedro has fallen in with homeboys who educate him about adhering to the prison code. Increasingly uncomfortable with the rules that restrict his contact with inmates of other races, he turns to his cellmate, Hector, for advice. Hector offers another view, using chess as a metaphor. In the end, Pedro declares his independence by giving food to a black inmate.

Although the play was written in a collaborative playwriting class with my clerk Elijah Wright as the lead writer, I must put my imprint on everything we do. As usual, I have a battle on my hands. The men resist my idea that we need choreographed movements during the fight scenes on the yard. "Ms. Tobola wants us to do ballet!" the actor playing Pedro exclaims.

"Well, not ballet, exactly, but yeah . . . sort of *like* ballet." Elijah Wright rolls his eyes. I smile at him. "I must insist," I say sweetly. Eventually they all come around. Their graceful movements serve as a powerful counterpoint to the ugly yard violence we are all accustomed to. The actors love the show because they believe in its message. They respect Elijah Wright for his leadership.

When Elijah first started working for me, I couldn't figure out why he wouldn't talk during our morning meetings, where all of my workers gathered and we plotted out our day or brainstormed new plays or talked about issues that needed troubleshooting, like missing harmonicas.

Finally I'd called him into my office and closed the door. "Mr. Wright," I'd said, "how come you don't talk during our meetings? You're very intelligent and I know you have strong opinions. I don't get it."

He'd said nothing for a moment and then finally confessed, "Sorry, I haven't really talked to that many white people."

"What?"

"I mean, in the store or gas station, yeah. But you know what I mean."

"Oh."

I hadn't known what to say. Suddenly I'd been transported back to Florida where I'd gone to elementary school, where there had been no black children in my classes except for the super-athlete Roland. I'd recalled being on safety patrol in third grade when I'd seen a white man driving a car with a black man slumped in the passenger seat beside him. Racial hostility had been so palpable in the '60s in Florida that I'd been sure the white man had done something to hurt the black man in the car, and I'd ran to the principal's office to report it.

"Okay," I'd said. "I get it. But I just want to encourage you to speak your mind. You have a lot of good ideas."

After a month or so, he started talking in our meetings. Now he's also walking the track every day with an actor in *Checkmate*. The actor is white and I'm thrilled by this turn of events. We are in a season of racial healing!

My work crew consists of four black inmates, two white inmates, and one Hispanic inmate. Elijah is still my lead clerk. He and Denny Gray and Bones Bailey, also black inmates, have an easy rapport with one another. They do not share this rapport with Jack Brooks, whom they call white even though he's as black as they are.

"He talks like he's white," Denny tells me one day when I finally confront them about it.

"He act like he white," Bones adds. Elijah says nothing.

"Do you mean he's not street? That he went to college? And that makes him white?" I ask them.

"Yeah," they all say, but not at the same time.

"There's a problem here," I tell them. "It's about education. You can't reject people because they've pursued a college education!"

"When does educated mean you talk like a white person?" Bones asks.

"Well, I don't know the answer to that, but I just ask that you appreciate Mr. Brooks and his accomplishments." I leave it at that.

The white guys who work for me, Mo Murphy and Pete "Panther" Perry, are both artists who aren't overly talkative. Joaquin Alza is an actor and a thinker, someone who chooses his words carefully. He is as intelligent and deliberative as a judge, which I'd cast him as in one of our plays. I told him during that production, "I can see you as a judge. Or a professor. You can be anything you want to be." He thanked me, but I'm not sure he believed me.

I've just finished teaching a six-week seminar on race and culture. Black, Hispanic, Native American, and white inmates attended. Every week, I'd play an episode of *Black. White.*, a reality TV show produced by Ice Cube and R.J. Cutler. In the program, a black family becomes white and a white family becomes black, through the magic of makeup. The camera follows both families as they go to work, school, poetry groups, a shoe store, a country western bar.

After watching each episode, we discussed it. I brought in handouts, too, articles exploring culture wars, encroaching technology, mass incarceration, and universities' abandonment of humanities. My students were riveted by the television episodes and energetic in the discussions afterward. There was something daring about the whole thing, like we were all gathering in a forbidden enterprise. You'd be hard-pressed to find a place in prison where people of different races sit down together to discuss race honestly.

Plenty of people outside of prison are discussing race and politics now, because for the first time in our country's history, we have a black candidate for president. I have known for four years that Barack Obama was destined for the White House because my mother told me, after watching the televised 2004 Democratic National Convention speech in Boston, "I just saw our next president." Barack

Obama was stumping for John Kerry, but my mother saw Obama as the political lodestar.

On election night, we are rehearsing *Checkmate*. I am directing the rehearsal, but I have to run to the TV studio room, adjacent to the rehearsal room, to get updates on the returns every fifteen minutes or so.

In that tiny room is Pete, my white artist worker, who looks no more than twelve. He entered adult prison as a juvenile offender and was sent to me by my friend and colleague Emily. He grew up in a conservative family who lived in an affluent community. He is sitting next to Jack Davis, who everybody calls Doo-Wop, because of the pastry confections he creates from whatever is available at the Canteen. Doo-Wop, a black man in his sixties, has seen plenty in the realm of race relations.

I run to the TV studio room just after Barack Obama has been declared president of the United States. Pete and Jack are holding hands, tears in their eyes. I tear up too at this unlikely sight, and with hope for the future that awaits us.

Dream/Time

In the dream, I'm showing someone the grave where
My father is buried. *There, under the willow tree.*
I turn to look at the person I'm talking to. It is my father.
Which father is my father? The live one standing next to me
or the dead one, buried beneath the willow tree?
They are both my father, of course. What I mean is—
which time is real? The time when he was alive?
Or the time when he's dead? No, that's not right.
They are both real time. But which time is the now?
Am I standing with my living father, dreaming of
a time after he dies? Or am I looking at my father's grave,
dreaming of a time when he was alive? I can't decide.
I don't know which time is now or if the times

could somehow co-exist. You know, it's because
I'm dreaming. *What are you still doing here?*
he asks me. I think he's asking why I'm still living
in my small desert town. *I can't leave—I love my family
too much,* I say. They are not far away—a few miles,
a few hours, a half-a-day away. *You need to get your work
out into the world* he replies. A few weeks later,

driving home, I stop at the red sign midway between
the cemetery and my house. I'm not thinking about
the dream. Probably, I'm fooling with the radio. I decide this later,
because my neck is not broken. Because I do not brace
for the impact. I never see it coming. Cranked-up tow truck
doing 60 rear-ends my car, catapulting it across
the intersection. On the other side, I hit a Joshua tree and
a telephone pole and then the pale yellow Pontiac
bursts into flame, a cactus blossom. I don't remember any of this.
My clock stops. I lose the crash time, the driver who hit me
pulling me out time, the cops searching the desert
for the body of my son time, the ambulance ride time.
In the hospital, after a few hours, I get time back. Once I can
say my name, what day it is, they send me home,
where I am awakened every hour, asked the same questions,
beginning with *Who are you?*
By morning, I realize that when
my father said *here,* he meant earth.
You want to know if the cops found my son's body.
But maybe he wasn't with me in the car.
Maybe I couldn't remember if he was with me or not.
Maybe I'm standing next to him now, asking him what
he is still doing here, urging him to get his work done.

XX

RED DOOR

One reason I know it's time to leave the California Department of Corrections and Rehabilitation to start Poetic Justice Project is because of impending budget cuts. The state is billions of dollars in the hole, and Arts in Corrections will probably be eliminated.

Another reason I know it's time to leave has to do with Cody. He was a musician who appeared in a documentary about prison music before he paroled last year from the California Men's Colony. The film was shown at the San Luis Obispo Film Festival. After the viewing, the filmmaker and I held a talkback with the audience. I was surprised to see Cody there, and even more surprised when he stood to make a comment. "I was in that film and I just want to say thank you for doing this."

In 2008, not that many people out themselves as recently paroled ex-cons. But this man was so proud of his musical accomplishment that he stood up in a roomful of film lovers and proclaimed his gratitude and solidarity for his fellow musicians who were still locked up.

But while I know it's the right time to leave, I have mixed feelings. For one thing, our economy seems to be in freefall, in a state which will later be dubbed the Great Recession. Not an auspicious time to strike out on my own with a nonprofit program. And ex-cons are not

exactly the most sympathetic population to ask people to donate to. But my retirement is less than four weeks away, set in motion months ago. And I have faith in President Obama. Pundits have been speculating that he might resurrect Roosevelt's WPA programs. There's even an online petition urging him to dedicate 1 percent of his stimulus package to employing artists. What if he decides to bring back the Federal Theatre Project, which put writers, directors, and actors to work during the Great Depression? If he does, Poetic Justice Project would be a perfect fit. Not only would we help unemployed artists, but former prisoners too!

Less than a month after my retirement, I will write the president a letter:

Dear President Obama:

On election night, I was at work, rehearsing a play in prison. Most of the actors were in the large classroom that doubles as a theater space. But two inmates—a young white man and an older black man—sat in a little studio room off the classroom, watching the returns. "Tell me when he takes Florida!" I said to them. The next time I checked, just as I was opening the door, I heard you declared the 44th President of the United States of America. A great roar went up in the classroom and I danced a little jig.

I'm writing to you because of Elijah Wright, who worked for me for two years. Mr. Wright entered prison as a teenager about eight years ago. He didn't really talk to me for three or four months after I hired him because, he later confessed, he hadn't spent that much time around white people. But engagement in the arts creates bridges between people and cultures. I was privileged to watch Mr. Wright's metamorphosis. Already a gifted musician, he plunged into theater, proving himself as an actor, director and playwright. He studies theology and helps

with services in the prison's chapel. He's a good man, a man of integrity and leadership.

Mr. Wright does not make excuses for himself. He was found guilty of assault with a firearm, but he did not kill or injure anyone. However, he grew up in what could only be called the war zone of urban America. I hope that when he is released next year, he doesn't have a difficult time re-entering society. As you know, 70% of ex-offenders in California return to prison within three years.

It is because of Elijah Wright and people like him that I retired recently from my job directing an arts program in a California prison. For years I've witnessed the power of art to help incarcerated people make profound changes in their lives. Now I think it's even more important to help people find their places in the community and stay out of the revolving door of the correction system. So I've founded Poetic Justice Project.

Thank you (and Michelle) for your courage in taking on leadership of this country at this critical time, and the sacrifices of time and privacy that you've already made. I am hoping that your commitment to arts will include programs that address social justice issues. So much can be accomplished all at the same time: employing artists, giving hope and dignity to people, and invigorating the American culture. I will do anything I can to contribute from here.

Sincerely,
Deborah Tobola

I didn't get a reply from the president or his staff, but I did give a copy of the letter to Elijah after he paroled, and he gave a copy to his mother, which made her happy.

Although my current supervisor, Mr. Denton, doesn't believe that participating in the arts does anything to help inmates survive once

they get out, I know that can't be true. Through theater, inmates—
and anyone, really—can improve their skills, including oral commu-
nication, teamwork, self-discipline, the ability to accept constructive
criticism, flexibility, self-confidence, and dedication.

I will later find, after years of leading Poetic Justice Project, that
my program does even more than I imagined: it creates a sense of
belonging, a sense of connection, first with the parolees themselves,
and then with the community, represented by their audiences. You
can give a guy a job, a car, a place to live, but if he doesn't feel like
he belongs in what inmates call "the free world," he is destined to go
back to prison.

Before leaving my position, I must inventory materials bound for
an Arts in Corrections archive at UCLA. The archive was initiated by
a professor of ethnomusicology there—the same man who filmed the
documentary shown at the film festival. Maybe a lot of people could
see the writing on the wall that read the end of Arts in Corrections.

The program, which started as a pilot project at one prison more
than thirty years ago, had become the global model for fine arts
instruction in prison. Now examples of the work done would have
a home at UCLA, the only legacy we artists could leave, aside from
whatever impact we might have had on our students.

I make a list of artifacts dating back to the 1980s, slides and art-
work left by my predecessor. Among my predecessor's treasures are
audio cassettes of poetry readings by Quincy Troupe and William
Stafford. There are even black-and-white photos from the 1950s,
when my father worked here. One photograph shows an artist with an
easel sitting outdoors painting a landscape. Several feature inmates
performing a play in the Blue Building. Most of the inventory comes
from my tenure: paintings, drawings, props (including a giant papi-
er-mâché cake, with a file sticking out of it), theater programs, and
press clippings. Most important to me are the videotapes of each play
we performed, my legacy.

I wish right now that Liza were still my boss, but she retired five years ago, which is how I ended up with Mr. Denton. If she were still here, she would safeguard my inventory until the archive's volunteers arrived to pick it up. I have no confidence that Mr. Denton cares enough to bother with it. In fact, he has been salivating about the real estate he will acquire the day after I retire. Arts in Corrections occupies the largest building in the Education complex and he wants to grab the space and turn it into another Vocational shop.

My inmate work crew helps me with this process. When everything is assembled and the inventory complete, I lock it in a metal cabinet and tape the contents on the outside of the cabinet. Volunteers from the archive project are visiting each institution and picking up the materials and delivering them to UCLA, but pickup for CMC has not yet been scheduled. If I could take it all home and deliver the contents myself, I would, but that is not allowed. CDCR headquarters in Sacramento authorized institutions to donate to the archives and laid out the procedure to accomplish it.

During the inventory process, I am also grieving. I am remembering Mr. Robinson saying he can feel a spiritual energy when he walks into the building; the Drifters permeating the Blue Building with doo-wop; the cast-off dollhouse that became the Dream Prison; walking the perimeter with my Thelma-and-Louise friend then boss Liza.

I am saying goodbye to the endless treks down the dog run; goodbye to demanding egg-shaped circles, to honor female energy; goodbye to midwifing poetry and plays; goodbye to inmates crying in my office; goodbye to our annual Poetry on the Road touring readings; goodbye to the teaching artists and guest artists who came and taught and played; goodbye to the Grand Jury touring our building each year and writing a good report; goodbye to the Music Ensemble performing at all of Education's graduation ceremonies; goodbye to the days when cats, blue jays, hummingbirds, and dragonflies slunk, hopped, or flew into our building; goodbye to soulful lunches with

my road dog Emily; goodbye to the standing ovations; goodbye to the *real* theater people crying as they left our plays; goodbye to my students' "Eureka!" moments; goodbye to the life I have passionately devoted myself to.

During this time, Elijah drops a letter onto my desk and leaves my office without saying a word. It reads, in part:

> *Personally, I understand your decision, but I just don't agree. I believe Poetic Justice is going to be a great benefit to those getting out of prison, but what about those still here? I don't even know why I'm writing this letter because I feel like I'm talking to a wall. I believe your decision is very, very selfish. After all you've done to help us here, you're willing to turn your back on us and your very successful work all because of a damn budget? You're willing to let this place go, not knowing what's going to happen with the program when you leave? All because you have a longing desire to launch an ex-offender program? The state keeps taking and taking and taking more programs each day and you deciding to just up and leave without knowing the haps on Arts in Corrections doesn't help. It doesn't help us at this point, so why should a program like Poetic Justice help us later? The same letter I wrote to Arnold, your boss, and the Warden, I feel like that I'm writing to you now.*

Mr. Wright is afraid that once I leave, the program will be over. I share that concern because even though I've identified candidates to take my place, none are interviewed, no action is taken. It seems that everyone knows that Arts in Corrections is on the way out, so why bother? I know that Mr. Wright has written this letter in a state of grief. I'm no stranger to grief myself.

My mother was frantic to get out of there, out of the house that would not ring again with my father's singing and laughter, or with his curses. She folded his bathrobe and put it in her carved cedar chest, her hope chest. Around her were boxes, one for the garage sale, one for the Salvation Army, and one for trash. She was getting rid of almost everything, but not Dad's bathrobe. And not her Revelation, the vacuum cleaner Dad used as a demo model so many years ago in Fresno, before he began working in construction management.

She was moving four hundred miles south to the desert, to take care of her mother, Nonny, who had stomach cancer. For once, my imagination failed me. I could not imagine how she could find the strength to go to Nonny's right now, for certainly Nonny's death was on the near horizon. Bonnie, Terri, Brad, and I all suggested she come to our houses. But she would not.

She seemed to move around the house like a ghost, seeing but not touching, focused on some inward vision. Sometimes she was engrossed in a task, scrubbing, sorting, packing. She was far away from us.

My brother Brad and I went through Dad's closet. He held up his brown wingtips and we both fought tears. "Let's give 'em to the Salvation Army," Brad said. "Maybe some bum will get a job wearing these shoes."

At that, we both cried. Brad and I were the children who got the best of Dad and the worst of him. We were united now in grief the same way we were united as the kids who got into trouble. We hugged each other and Brad tenderly laid the shoes aside, muttering, "Goddamn it."

Sorting through a big box of photographs and papers, I found childhood pictures of my mother. There was one of her standing and holding on to a bicycle, one hand on the seat, one steadying the handlebars. She was wearing a white dress and looked graceful, serene.

Another was a close-up of her at seven or eight. My mother's

dark brown hair in this photograph was braided on each side, one braid hanging in front, one behind her shoulder. She was smiling ever so slightly and obviously looking at something, as if she'd been instructed to fix her gaze somewhere for the photographer's benefit. In this photograph, her shyness is evident. You can see that she obeyed her elders. But you can also discern a steadfast strength in her gaze and the set of her mouth.

In another photo she's four or five, sitting next to some plants on the cellar stairs outside a big, white house. She's dressed in a sunsuit, barelegged except for socks and leather sandals. One leg looks like it was caught by the photographer in mid-swing. She's sitting squarely on the bottom step, smiling like she knew a secret and no one could guess. She looks like she owned herself.

Mixed in with her childhood pictures, I found one of her and Dad in Barrow, Alaska, where one of my father's jobs took them. They were wearing parkas, smiling in below-freezing temperatures. Even in that photo, my mother looked young, although she was in her fifties.

"Why don't you make a pile for each of you," Mom said. All these years she'd saved report cards, poems I wrote, drawings—including Terri's lion that won the children's art contest in the newspaper in Florida. I sorted and separated until it was all distributed. Inside the woman who was my mother, who moved around the house, disassembling her life, was still the self-possessed little girl on the cellar stairs, the shy grade-schooler, the graceful young woman. All these years, she'd given us her life, taken care of us. Now Dad was dead and she was giving us away, taking herself back.

"Whatever happened to the relief map of California?" I asked Mom.

"Oh, I don't know. I must have gotten rid of it in one of the moves," she said.

"I remember when Dad cut it out with his jigsaw. I knew he wouldn't let me do that part. But then he started making the mountains out of papier mâché, then he sprinkled it with that stuff, then he

painted it and he made those little labels. I just sat and watched him, and he wouldn't let me touch it. Then I took it to school and got an A. How embarrassing!"

"The next year Bonnie took it and got an A too," Mom said.

We laughed and then she cried.

That's one of the reasons I was there, to say things, to ask questions, to remember, even though this made Mom laugh and cry. It's one of the reasons Mom loved Dad, through all the trouble, through all the years—he made her laugh and he made her cry. With Dad, she went from the steps of that cellar to the Arctic Circle, the top of the world.

Before I leave prison, I must say one important goodbye. I arrange a visit to the East Facility to deliver art supplies to Emily's classroom (where she teaches now three days a week). She has issued a pass to Sal, the art-for-art's-sake painter who has consistently won prison art contests, donated his work to local nonprofits, and defied perceptions of what lifers are like.

When I enter the classroom, he is there, beaming. The last time I saw him, several months ago, he showed me his painting of a man flying over Bishop Peak, visible from the prison, a feather in one hand. "That's me. I'm on the way out," he told me. "My friends tell me not to get my hopes up—they don't parole lifers. But I know I'm leaving." I knew too.

Now he has a date. He is paroling two weeks ahead of my last day at work. It turns out that Sal will be in the first wave of lifers paroled in 2008 after the California Supreme Court decided that not only the viciousness of the initial crime, but the propensity of the inmate to commit future crimes, should be considered. Maybe the decision to release lifers also had to do with prison overcrowding. Many of

California's prisons are over 200 percent capacity, with inmates sleeping in gyms, dayrooms, and hallways, sometimes triple-bunked. "Sal," I say. "I'm right behind you. I've started a nonprofit. We're going to do plays with formerly incarcerated people as actors. No theater experience required. We're on the Internet already. I would love it if you could be a part of this." I write down the words *Poetic Justice Project.*

He gives me a postcard a friend on the outside made of the painting of him flying over the prison with a feather in his hand. I give him a poem to remember me by.

Red Door

Red, I said to the prison painters, who were probably expecting
another beige assignment. *Red?* they said. *Red*, I said.
We have safety red, they said. *Perfect!* So they came back
with the paint, rolled the first coat on. Tomorrow, the red
will be deeper: heart red, circus red, pay attention red,
do something red, red like certain roses, trombone music in
a big parade. An exclamation point against cool institutional
blue, the door invites you to walk through. The door says
there's something for you on the other side. The door says
the emergency is beauty in harsh places.
The painters smiled as they left.
There's something on the other side.
There's something on the other side.

EPILOGUE

I'm glad I listened to my intuition when I booked *Blue Train* during Christmas week, traditionally a dead week in theater, unless you're doing a Christmas play. It was the busy theater's only opening, so I took it. I knew it was a big gamble. How many people would go to a play set in prison featuring formerly incarcerated actors when they could enjoy *A Christmas Story* or *The Santaland Diaries* somewhere else? But now I'm standing in the overflowing lobby of the San Luis Obispo Little Theater during intermission pinching myself. It's our third sold-out show.

Blue Train was the first real play we did in prison in 2003. It's the show that has rap artist Chance in the same cell as old-timer R&B. About halfway through, they discover they are father and son. When Chance gets sideways with heroin addict Weasel, he is killed and R&B, in a moment of magical realism, takes his place, giving his life so that his son may live.

Among the cast are Beau Butler, the big-hearted, big-voiced actor, reprising his lead role as R&B, performed in prison six years ago, and Sal, who did look up Poetic Justice Project on the Internet after he paroled, and is now playing the Native American shaman Night Owl. After getting permission from his parole officer, Sal commuted from his parents' home in San Bernardino County for our twice-weekly rehearsals.

The first year of running Poetic Justice Project has been an education for me. In many ways, doing theater in prison is easier. Inmate cast members don't go away for the weekend (unless they're going to the Hole). They don't have to worry about transportation, homelessness, or the demands of family life.

Finding fourteen formerly incarcerated people interested in auditioning for *Blue Train* was challenging. And once assembled, the cast didn't remain the same. People disappeared, decided they couldn't meet the demands of rehearsal, had an issue with another cast member and left, relapsed, or got a job. My biggest learning curve has been discovering that almost all of my cast members, or potential cast members, are in substance abuse recovery programs. And if they're not, they should be.

And then there's the fear factor. A few of the actors had previous theater experience, but most had never even thought about appearing on stage. I told them not to worry about it. I knew that once they performed before an audience, they would be fine. I laughed when Ram, one of the actors, pointed out that addicts had been acting all of their lives, so what's the big deal? His words were more reassuring to the actors than mine.

No audience member leaves during intermission, I note, as I head back into the ninety-nine-seat theater. After the play, we hold a talkback. Even though there are rough spots in the play, the audience loves it. Some cry as they relate their stories of family members who are in prison. Repeatedly, people thank us for giving a slice of prison life. They live in a prison town—SLO Little Theater is only four miles from the prison. Yet most people who live in San Luis Obispo have no idea of the institution's subculture.

Blue Train has given audience members a glimpse of racial politics, how addiction causes trouble (and not just for the addict), and the reality of older inmates preying upon younger inmates. There's an electricity in the air during the performance and during the talkback.

I am ecstatic. Not just because the audience responded so well, not just because my actors have delivered onstage and moved people in the talkback, but because this represents true reentry. Because of their talent, courage, and honesty about their criminal histories, our actors have been embraced by their community.

And not just that. The people working behind the scenes to make this happen are, for the most part, people who have worked in the system. On my advisory board are Abby, a retired nurse from Juvenile Services; Liza, my former boss, who headed the Education Department; Sam, an actor, director, and formerly the chief medical officer at the prison; and Stephen, who was my favorite third watch lieutenant when I worked at the prison.

Stephen often asked me, "Why don't you do this on the outside?" I don't think he meant do this on the outside with ex-cons, necessarily, but he agreed to serve on the board when I told him what I intended to do with Poetic Justice Project.

They are all here tonight, basking in the success of *Blue Train*. And the frosting on the cake is this: we are the first people in America to do this. By our tenth year, Poetic Justice Project will be one of many theater programs for formerly incarcerated people, who will be rebranded "returning citizens." And in these ten years, my learning curve will accelerate. If I had known on that night what lay ahead, I might have just bowed out after this victory. But then again, I've never been a quitter.

ACKNOWLEDGMENTS

I have been blessed to grow up in a family anchored by love, in good times and in bad. I am most grateful to my mother, who has been unswerving in her belief in me, and to my siblings, for their humor and warmhearted support. My sons, Joseph and Dylan, artists in their own right, have cheered me on, even though anything I create cannot surpass (co)creating them. Years ago, my father urged me in a dream to get my work out into the world. Since then—decades now— my partner, Gene, has continued the clarion call. Here it is, Gene.

My friends Cynthia and Elizabeth shared much of this story as it happened in real time. We still revere our mission: improving the lives of incarcerated people through education. Cynthia and Elizabeth read every chapter as I wrote it, and commented, critiqued, corrected. I am forever grateful to them for this, and for our friendship. Thank you to my cousin Dee, the first one in my family to read the book. And thanks to my friends Sheila and Helen for reading finished drafts, and for their love and support over the years.

Practicing and teaching art in prison has brought me into a community of amazing people, scattered across the globe. Thanks especially to Laurie, Jack, Claire, Leah, Curt, Tom, Jim, and Steve, and to the countless artists who work, or have worked, in prison.

Brooke Warner's expert midwifing, along with her crackerjack

team at She Writes Press, helped this work get born. Artist Guillermo Willie created the perfect frontispiece. Caitlin and Rick of Caitlin Hamilton Marketing and Publicity gave my book wings to fly beautifully into the world.

Some of the writing here, or variations of it, have appeared previously in *Alaska Quarterly Review*; *Art Rag*; *Breaking the Plate* (Pudding House Publications); *DMQ Review*; *Iron City Magazine*; *Kalliope, A Journal of Women's Literature and Art*; *Rattle*; *SLO Coast Journal*; *The Boundaries of Twilight: Czecho-Slovak Writing from the New World* (New Rivers Press); *The Wisconsin Review*; and *Verse Daily*. I am grateful to these editors and publishers for sharing my work with their readers.

I have changed some names, circumstances, and identifying details of people to protect the innocent (and the guilty). I have recreated events and conversations from memory, in an effort to portray the truth of my experience. I realize that not all of us remember things in the same way.

After reading the book, Alejandro sent me the poem I'd imagined glowing inside him seventeen years earlier, when he was placed on suicide watch in the Hole. He emailed me, "I didn't write it. I created it in my mind and kept repeating it until I never forgot, because I thought I'll have a poem when you came looking for me."

been running round the globe
chasing blue skies
never ending hope

surviving storms that keep my bed soaked from nightmare sweats
receiving hell from heaven
at times it seems
my only shelter is under death's wing

I cheat a peek in that black cloud
reach for blue skies
that demolish in the
palms of my hands
leave me wondering
will I ever find peace?

I am grateful to Alejandro and the men I've worked with inside prison who have shown heart, courage, and integrity in our endeavors. You know who you are.

ABOUT THE AUTHOR

© Geri-Ann Galanti

Deborah Tobola is a poet, playwright, and coauthor of a children's book. Her work has earned four Pushcart Prize nominations, three Academy of American Poets awards, and a Children's Choice Book Award.

She graduated with high honors from the University of Montana in 1988 with a bachelor of arts in English. Shortly after earning a master of fine arts degree in creative writing from the University of Arizona in 1990, she found her calling—teaching creative writing and theater in prison. Her students in prison have won writing awards, published their work, and appeared on local and national radio.

Deborah retired from the California Department of Corrections and Rehabilitation at the end of 2008 to begin Poetic Justice Project, the country's first theater company created for formerly incarcerated people. She currently teaches creative writing and theater at the California Men's Colony and serves as artistic director of Poetic Justice Project.

SELECTED TITLES FROM SHE WRITES PRESS

She Writes Press is an independent publishing company founded to serve women writers everywhere. Visit us at www.shewritespress.com.

The Longest Mile: A Doctor, a Food Fight, and the Footrace that Rallied a Community Against Cancer by Christine Meyer, MD. $16.95, 978-1-63152-043-3
In a moment of desperation, after seeing too many patients and loved ones battle cancer, a doctor starts running team never dreaming what a positive impact it will have on her community.

The Art of Play: Igniting Your Imagination to Unlock Insight, Healing, and Joy by Joan Stanford. $19.95, 978-1-63152-030-3
Lifelong "non-artist" Joan Stanford shares the creative process that led her to insight and healing, and shares ways for others to do the same.

Painting Life: My Creative Journey Through Trauma by Carol K. Walsh. $16.95, 978-1-63152-099-0
Carol Walsh was a psychotherapist working with traumatized clients when she encountered her own traumatic experience; this is the story of how she used creativity and artistic expression to heal, recreate her life, and ultimately thrive.

Tell Me Your Story: How Therapy Works to Awaken, Heal, and Set You Free by Tuya Pearl. $16.95, 978-1-63152-066-2
With the perspective of both client and healer, this book moves you through the stages of therapy, connecting body, mind, and spirit with inner wisdom to reclaim and enjoy your most authentic life.

Stay, Breathe with Me: The Gift of Compassionate Medicine by Helen Allison, RN, MSW with Irene Allison. $16.95, 978-1-63152-062-4.
From the voices of the seriously ill, their families, and a specialist with a life-long experience in caring for them comes the wisdom of a person-centered approach—one that brings heart and compassion back into health care.

Think Better. Live Better. 5 Steps to Create the Life You Deserve by Francine Huss. $16.95, 978-1-938314-66-7
With the help of this guide, readers will learn to cultivate more creative thoughts, realign their mindset, and gain a new perspective on life.